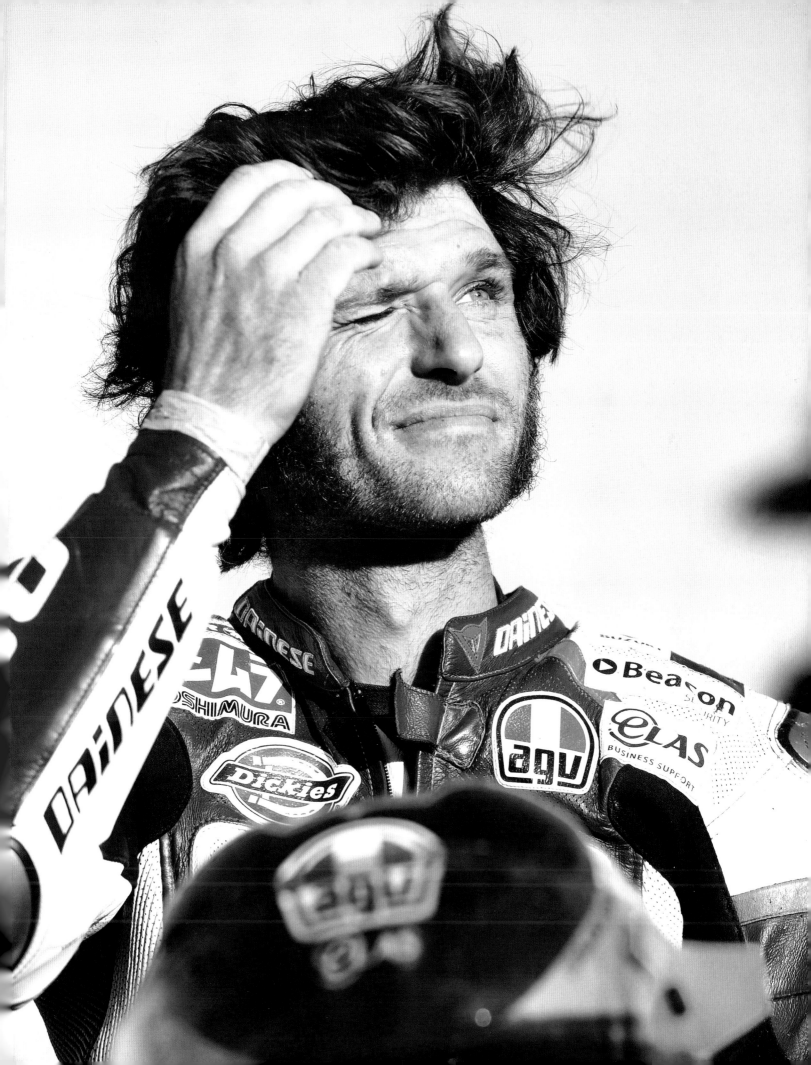

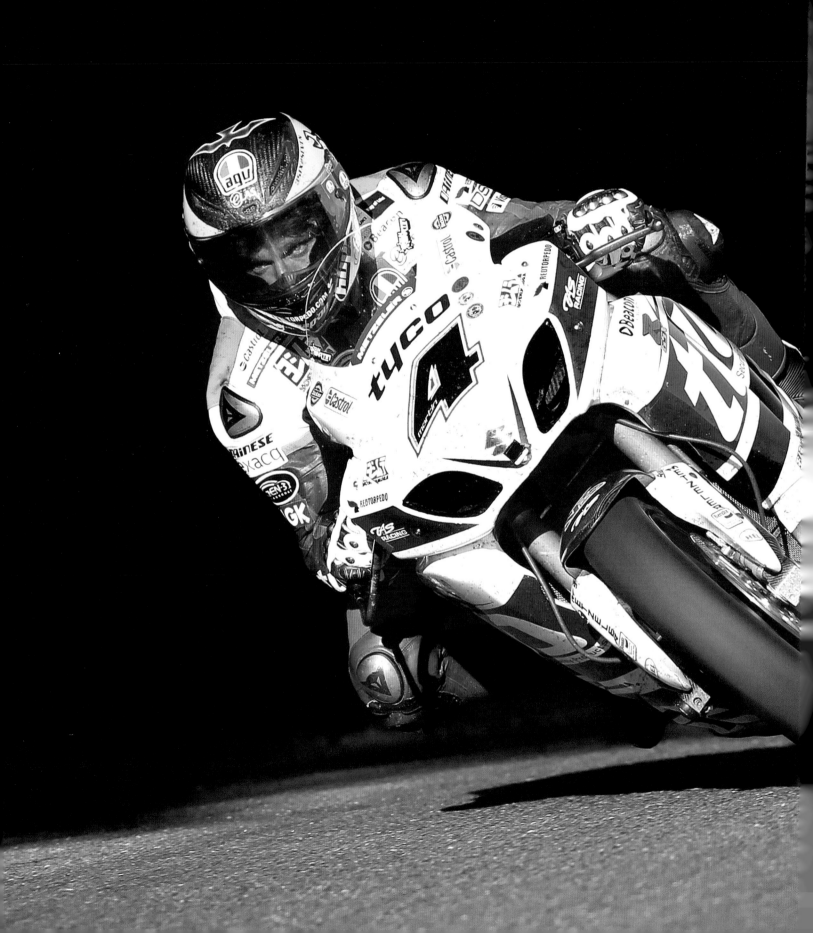

GUY MARTIN
ROAD RACER

STEPHEN DAVISON

·THE·
BLACK
·STAFF·
PRESS

NEVER THE BRIDE

From the moment he appeared in an Irish road racing paddock in 2002, Guy Martin was a sensation. Young and brash, delivering his views on everything and anything at machine-gun speed in a thick Lincolnshire accent, the twenty-year-old made people sit up and take notice.

Most important of all, he was fast – sometimes too fast.

At the 2003 Dundrod 150 his team boss was reduced to jumping up and down on the pit wall in frustration as Guy ignored his frantic signals to slow down and preserve a huge lead. Instead the young man in a big hurry kept his chin buried on the tank, breaking the lap record on every circuit.

And the crowd loved it.

By the end of his first full season on the roads, Guy was an Irish champion, albeit in the 'beginners' Support class.

As with any unexpected arrival, people wondered where he had come from. Word got around about a spat during his British championship days that ended with Guy slamming a laptop shut on the fingers of a race official. The tale only added to his maverick status.

Such attention soon fades unless it is backed up by results. In his second Irish season Guy was racing against the best riders in the country and he managed to hold his own. In September 2003 he won his first senior race, the Scarborough Gold Cup, and the Duke of Edinburgh himself turned up to present the famous trophy.

2004 brought his Isle of Man TT debut and Guy proved his pace by setting the fastest ever lap by a newcomer. A year later he climbed on to a TT rostrum for the first time and the holy grail of road racing achievement – a victory on the 37¾ mile Mountain course – seemed almost within his grasp.

Guy's rise had been spectacular, indecent almost, given the accepted wisdom that TT victories only come after lengthy apprenticeships on the world's most daunting race circuit. But Guy was no respecter of tradition – he was on his way and further glory would surely follow.

And it did, but just not as Guy and most of the rest of the road racing world hoped or expected.

Guy Martin has now stood on the TT podium seventeen times without ever reaching the top step. 'Forever the bridesmaid, never the bride' is the tag that seems certain to define his otherwise brilliant between the hedges career.

Every armchair expert has pondered this failure. Each aspect of his preparation, of his psyche, of his team, of his motorbike, even of what he has for breakfast, has been dissected. How could someone who has come so close to winning a TT so many times not eventually win one? Just one.

Guy himself has been unable to provide an answer. In his autobiography he left the question hanging, perhaps hoping that victory might still come.

None of his team bosses have managed to steer him to a TT victory. But they all remain convinced that if he had followed their guidance, he would have won as many Mountain course races as John McGuinness.

So resolute has the focus been on Guy's TT 'failure' that the rest of his career has often been dismissed, all of his brilliant achievements written off as little more than consolations amongst the sad litany of missed opportunities on that small island in the middle of the Irish Sea.

Although the TT's status as the sport's principal challenge cannot be denied, road racing is about so much more than just those two weeks in June. Since his humble beginnings in Ireland, when the ragged young racer bounced off kerbs and drove his team boss mad, Guy has gone on to win 8 Scarborough Gold Cups, 11 Ulster Grand Prix races, 4 Southern 100 championships and, of course, claimed 17 hard-fought TT podiums. Those achievements ensure Guy Martin's place amongst the elite riders in the history of the sport.

In 2010, while Ian Hutchinson was becoming the first racer in history to win five TTs in a week, Guy had caught the eye of Richard De Aragues, the director of the TT film, *Closer to the Edge*. Guy's starring role in that documentary would bring fame and opportunity from far beyond the road racing paddock.

Snapped up by television moguls who recognised the appeal of his engaging curiosity and unique delivery, Guy has become a major box-office star. Through him the sport of road racing has been brought to the attention of millions of people who have never been to the TT or watched a road race.

As a photographer and journalist, I have recorded all of Guy's triumphs and disappointments over the past fifteen seasons. I have seen him come agonisingly close to that elusive TT victory over and over again. And watched as he beat all of his TT rivals at the Southern 100, the Ulster Grand Prix and around Scarborough's Oliver's Mount year after year.

This book is a photographic account of Guy's road racing career, documenting the Lincolnshire ace's rise from unknown rookie on the Irish roads to the superstar who is now recognised everywhere he goes. It is a celebration of everything Guy has achieved between the hedges, an acknowledgement of the many races he won, not the one victory that never came.

2002

» Enters first road race at Cock O' the North meeting at Scarborough.

» Races in Support class at Kells road races in Ireland. Wins two races and crashes.

2003

» Joins TEAM Racing Suzuki for a season in the Senior Support championship at the Irish National road races.

» Wins championship with victories at Cookstown, Tandragee, Dundrod 150 and Skerries.

» Wins the Cock O' the North trophy.

» Makes debut at Southern 100 but breaks his ankle in a crash.

» Wins first Scarborough Gold Cup.

2004

» Joins Gareth Robinson's team to race Suzukis and Hondas with ex-racer Uel Duncan as manager.

» Wins at Killalane and has regular podium finishes and top-six results at the Irish Nationals.

» Makes Aberdare debut and wins two races.

» Wins first races at Southern 100 but crashes in Solo championship again.

» Makes international debut at the North West 200, TT and Ulster Grand Prix.

» Finishes 7th in Senior TT as the fastest newcomer and the first to lap at over 120mph.

» Wins second Scarborough Gold Cup.

2005

» Remains with Gareth Robinson and Uel Duncan for a second season.

» Competes at Irish Nationals winning Mid Antrim, Dundalk and Killalane.

» Wins third Scarborough Gold Cup and Cock O' the North meetings.

» Takes first TT podium in Senior race, finishing 3rd and lapping at 126.48mph.

» Runner-up in Southern 100 Solo championship.

» Finishes 2nd and 3rd in Ulster Grand Prix races.

» Takes third Scarborough Gold Cup win in a row.

» Macau Grand Prix debut, finishes 12th.

2006

» Joins AIM Yamaha.

» Best finish of 4th at North West 200 and TT.

» Runner-up in Southern 100 Solo championship.

» Wins Dundrod 150 Superbike race and four races at Ulster Grand Prix. Becomes first man to officially lap Dundrod at over 130mph.

» Wins fourth Scarborough Gold Cup.

» Finishes 5th in Macau Grand Prix.

2007

» Joins Shaun Muir's Hydrex Honda squad.

» Finishes on the podium three times at North West 200.

» Runner-up in both the Superbike and Senior TT races and 3rd in Supersport.

» Wins Scarborough Cock O' the North trophy.

» Finishes 2nd in Southern 100 Solo championship.

» Wins Superbike race at Kells.

» Wins Dundrod 150 Superbike race and Ulster Grand Prix Supersport race.

» Wins fifth Scarborough Gold Cup.

» Crashes out of Macau Grand Prix, breaking his thumb and wrist.

2008

» Remains with Shaun Muir, now branded Bike Animal Hydrex Honda.
» Finishes 2nd in North West 200 Superbike race and crashes in Supersport.
» Finishes 3rd in Superstock TT after breaking down in Superbike race whilst leading.
» Wins Scarborough Gold Cup for sixth time.
» Crashes out of last appearance at Macau Grand Prix.

2009

» Third season with Hydrex Honda team.
» Podium finishes in the Superbike and Superstock TTs.
» Wins first Southern 100 Solo championship.
» Runner-up in Superbike race at first Armoy road races.
» Wins Superbike race at Ulster Grand Prix.
» Finishes 2nd in Post Classic race at Manx Grand Prix.
» Wins seventh Scarborough Gold Cup.

2010

» Joins Wilson Craig Honda.
» Finishes 2nd in first Supersport TT before crashing out of the Senior race at Ballagarey, injuring his back.
» Returns to racing at Dundrod 150 and Ulster Grand Prix, finishing 2nd in the Dundrod Superbike race and taking top-six placings at the Ulster.
» Retires from Scarborough Gold Cup race.

2011

» Joins Hector and Philip Neill's TAS/Relentless Suzuki squad.
» Finishes 3rd in both Supersport TT races and the Superstock TT. Runner-up in the Senior after leading.
» Wins Ulster Grand Prix superbike race.

2012

» Stays with TAS team, now liveried as Tyco Suzuki.
» Wins Superbike race at Cookstown 100.
» Best finish of 4th in the Superbike TT.
» Finishes 1st and 2nd in the Superbike races at the Ulster Grand Prix.
» Wins Scarborough Gold Cup for the eighth time.

2013

» Remains with Tyco Suzuki.
» Wins Scarborough Spring Cup.
» Wins Supersport race at Cookstown 100.
» Finishes 3rd in Supersport race at North West 200.
» 4th place finish in Superbike TT.

» Wins Southern 100 Solo championship race for second time.
» Wins treble at the Ulster Grand Prix with victory in both Superbike races and in the Supersport.
» Finishes 2nd in Scarborough Gold Cup.

2014

» Fourth year with the TAS/Tyco Suzuki team.
» Wins Scarborough Spring Cup.
» Runner-up in North West 200 Supersport race.
» Finishes 2nd and 3rd in the Superbike and Senior TTs.
» Wins the Southern 100 Solo championship for a third time.
» Wins Superbike and Supersport races at Armoy.
» Wins Dundrod 150 Superbike race and finishes 2nd in Ulster Grand Prix Superbike race.

2015

» Remains with the Tyco team for 2015 but now with BMW power.
» 3rd in Supersport race at TT on Smiths' Triumph.
» Finishes 4th on Victory electric bike in first Zero TT.
» 4th in the Senior TT with his fastest ever Mountain course lap of 132.398mph.
» Wins the Southern 100 Solo championship race for a fourth time and his third in a row, a record only equalled by Joey Dunlop.
» Crashes out of the lead on the final lap of the Dundrod 150 Superbike race, breaking his back.

2016

» Doesn't race.

2017

» Returns to racing with Honda Racing as John McGuinness's teammate on the new Fireblade. Also rides a CBR600RR for Wilson Craig.
» Crashes out on the first lap of his comeback race at the Tandragee 100.
» Finishes 23rd in both Supersport races at the North West 200.
» Crashes out of the Superbike TT on the opening lap, injuring his wrist.
» Finishes 2nd in the Zero TT on the Mugen Shinden.

FASTEST LAPS

» Isle of Man TT fastest lap – 132.398mph, 2015
» Ulster Grand Prix fastest lap – 133.527mph, 2010
» North West 200 fastest lap – 120.932mph, 2014
» Southern 100 fastest lap – 114.464mph, 2014
» Scarborough fastest lap – 83.898mph, 2013

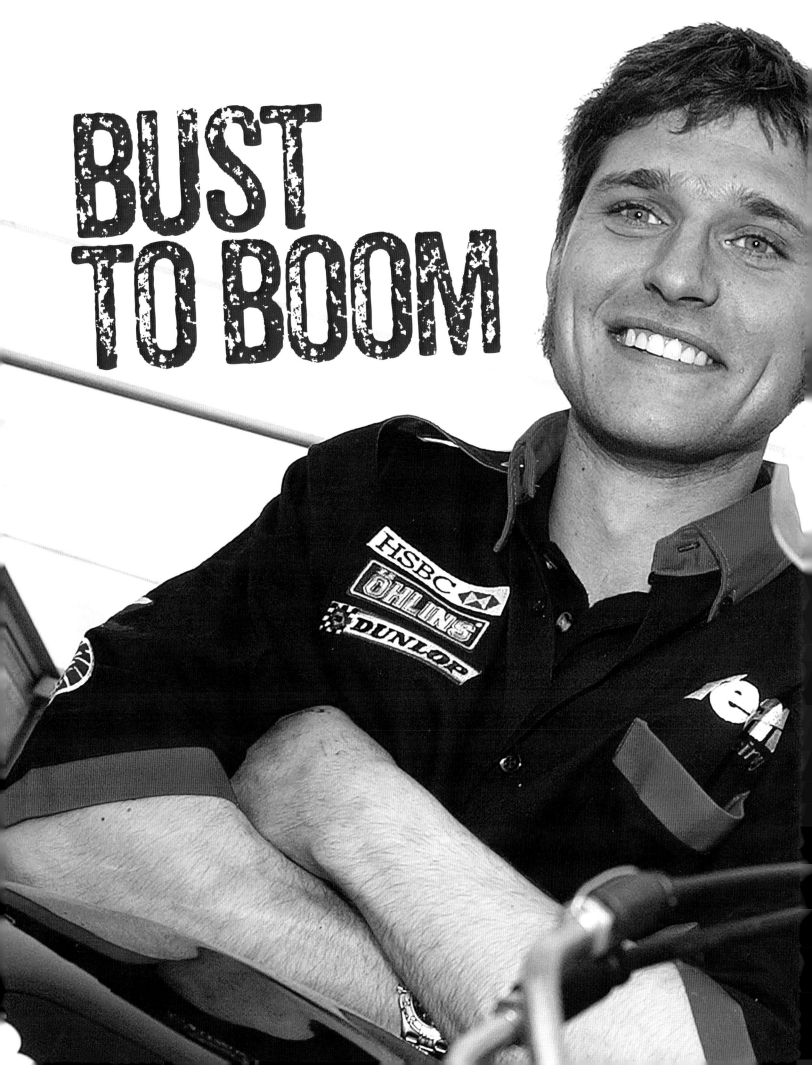

BUST TO BOOM

Guy Martin had spent three seasons racing on the English short circuits before a fit of temper forced the twenty-year-old Lincolnshire lad's move to the Irish roads. Riding a 600cc Suzuki during a British Junior Superstock championship race at Rockingham in June 2002, Guy became angry after being penalised for running straight through a chicane. He let his feelings be known by slamming a laptop shut on a race official's fingers. Unsurprisingly, his outburst led to the suspension of his British racing licence for the rest of the season.

Guy had already entered the 2002 Cock O' the North road races at Scarborough before the suspension came into force and a fortuitous encounter at the Yorkshire venue would offer the young truck mechanic a lifeline.

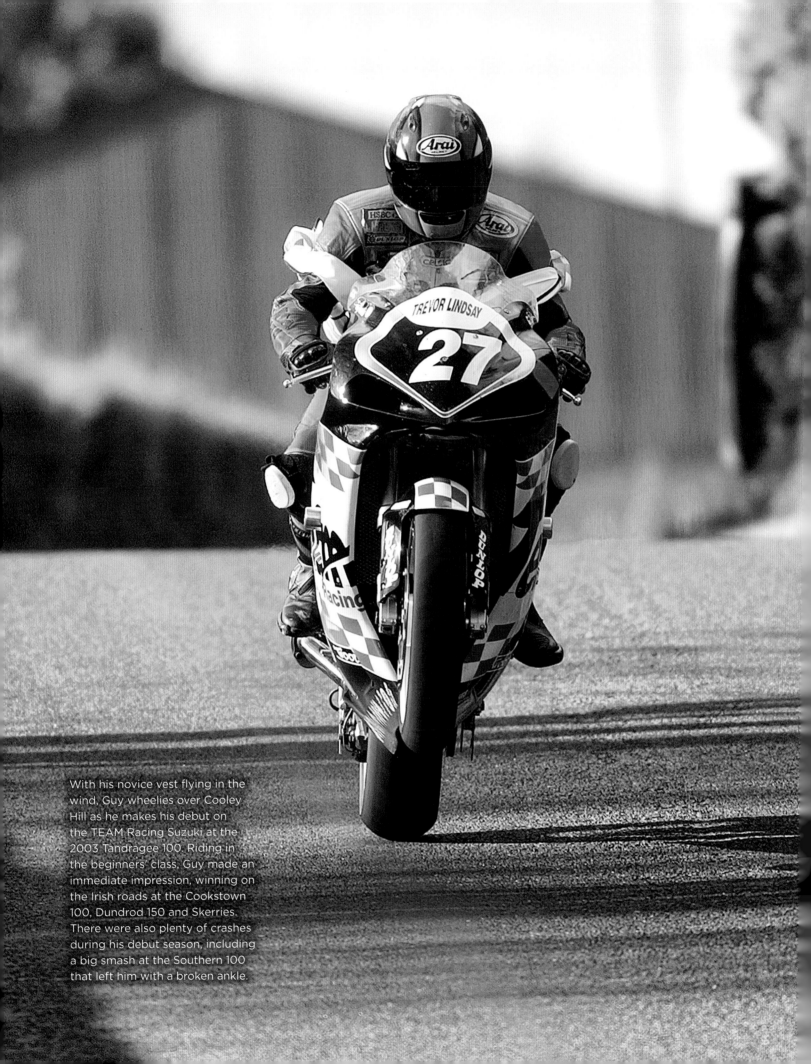

With his novice vest flying in the wind, Guy wheelies over Cooley Hill as he makes his debut on the TEAM Racing Suzuki at the 2003 Tandragee 100. Riding in the beginners' class, Guy made an immediate impression, winning on the Irish roads at the Cookstown 100, Dundrod 150 and Skerries. There were also plenty of crashes during his debut season, including a big smash at the Southern 100 that left him with a broken ankle.

Guy in action on his own 600cc Suzuki during his first Irish road race at Kells, County Meath, in July 2002.

After putting in a creditable performance at the Cock O' the North meeting in 2002, Guy had bumped into Leslie Moore, the editor of *Road Racing Ireland* magazine. Moore suggested he should try his hand on the Irish roads. Guy explained that his licence was about to be suspended but Moore persisted, offering to help him acquire an Irish competition permit.

'Guy was down in the dumps in spite of doing really well at Oliver's Mount that weekend,' Moore recalls. 'He seemed to think that he was finished with racing altogether because of his suspension but I suggested he come to the Kells road races the following weekend and we would get the paperwork sorted.'

A week later Guy made his Irish debut at the County Meath event. Undeterred by a crash, he went on to win two races, impressing the watching Sam Finlay so much that the Northern Irish businessman offered him a job and a bike to race for the following year.

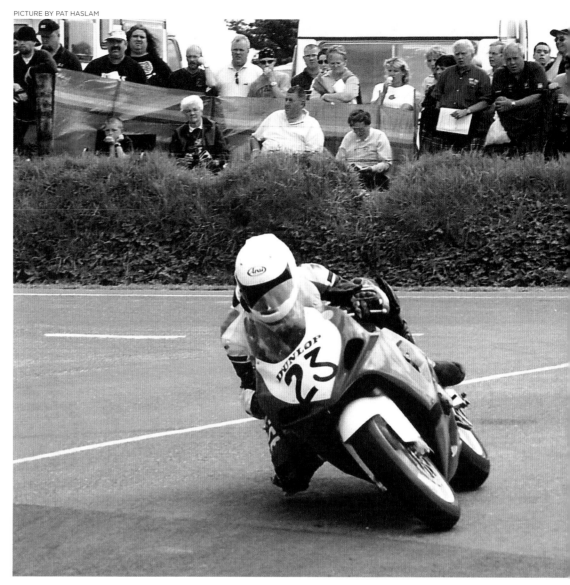

Guy (right) stands alone in the holding area before the start of practice at the 2003 Isle of Man TT. The truck mechanic had befriended Martin Finnegan and he worked on the Irishman's bikes at that year's TT, postponing his own island debut for another season.

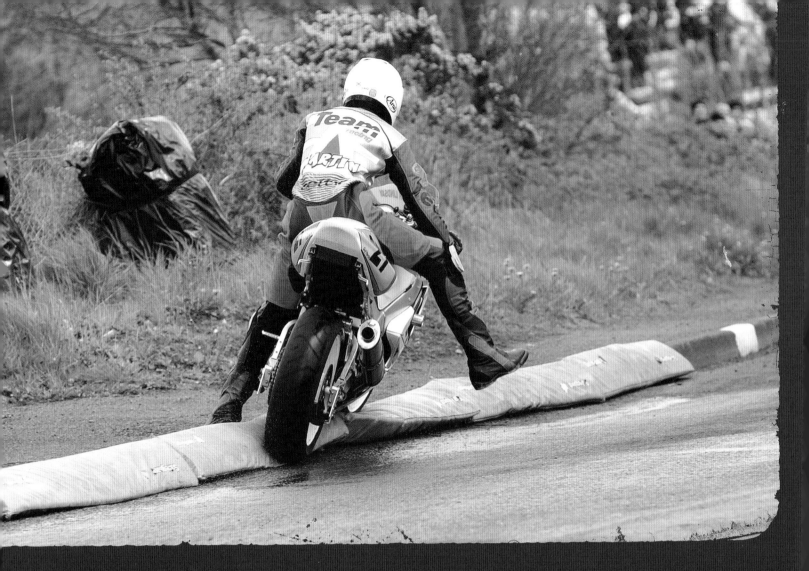

The first time I saw Guy Martin race on the roads was in the season opener at the 2003 Cookstown 100. The exciting new prospect blasted into view, leading the Support race on his Team Racing Suzuki.

Going faster and faster, he built a huge lead in the opening laps that an older and wiser head might have eased off to defend.

But not Guy.

As the race drew to a close Guy's approach to this corner was a bit too hot and he ran out of road on the exit, swerving up on to the footpath in a mass of tangled arms and legs.

Recovering with a shake of his head, he regained control and wheelied away, his lead diminished but still intact!

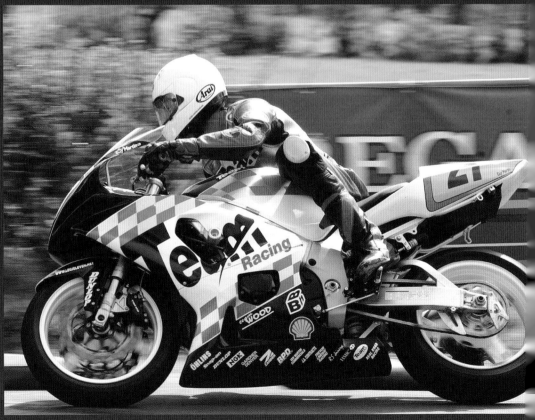

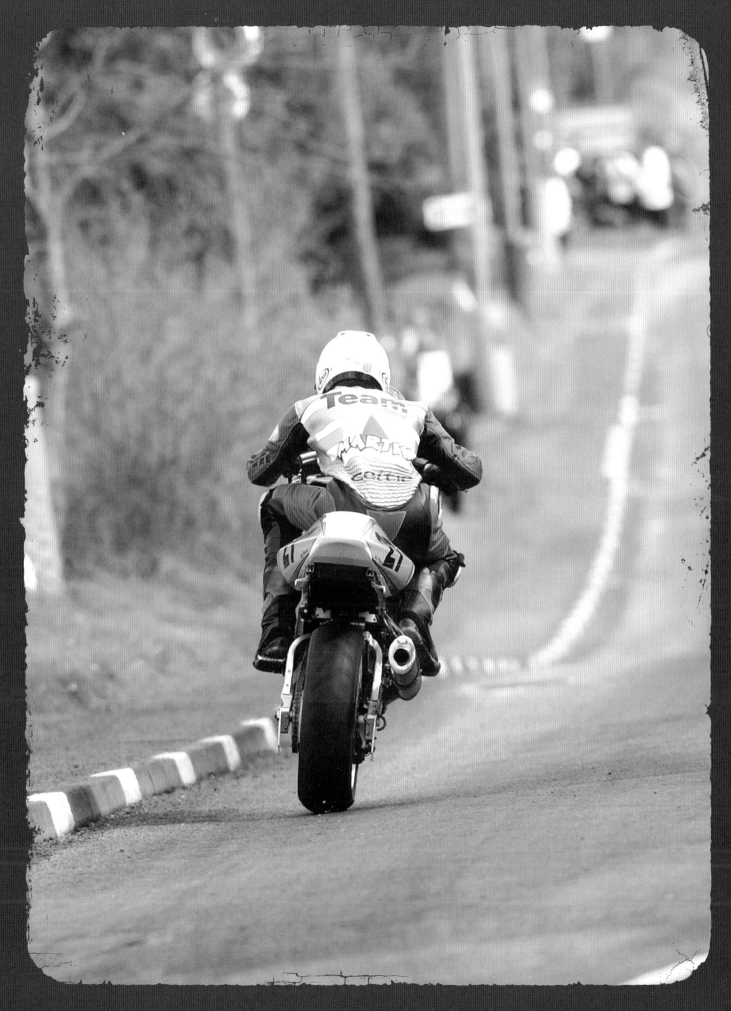

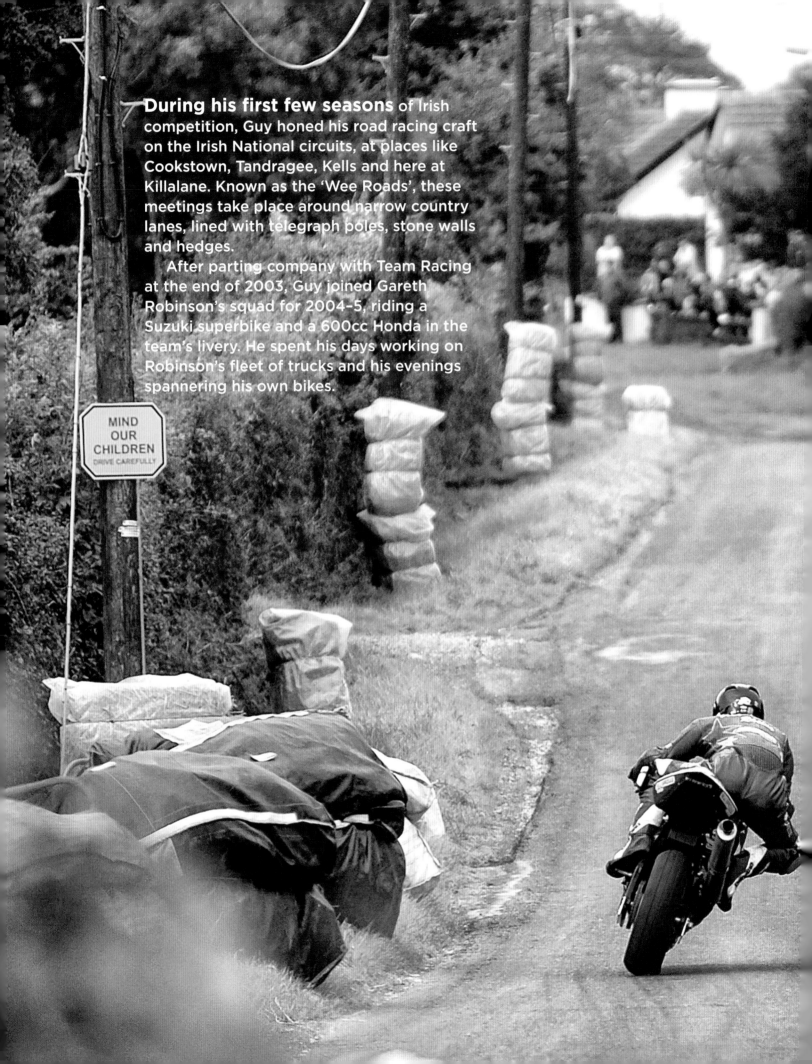

During his first few seasons of Irish competition, Guy honed his road racing craft on the Irish National circuits, at places like Cookstown, Tandragee, Kells and here at Killalane. Known as the 'Wee Roads', these meetings take place around narrow country lanes, lined with telegraph poles, stone walls and hedges.

After parting company with Team Racing at the end of 2003, Guy joined Gareth Robinson's squad for 2004–5, riding a Suzuki superbike and a 600cc Honda in the team's livery. He spent his days working on Robinson's fleet of trucks and his evenings spannering his own bikes.

MIND
OUR
CHILDREN
DRIVE CAREFULLY

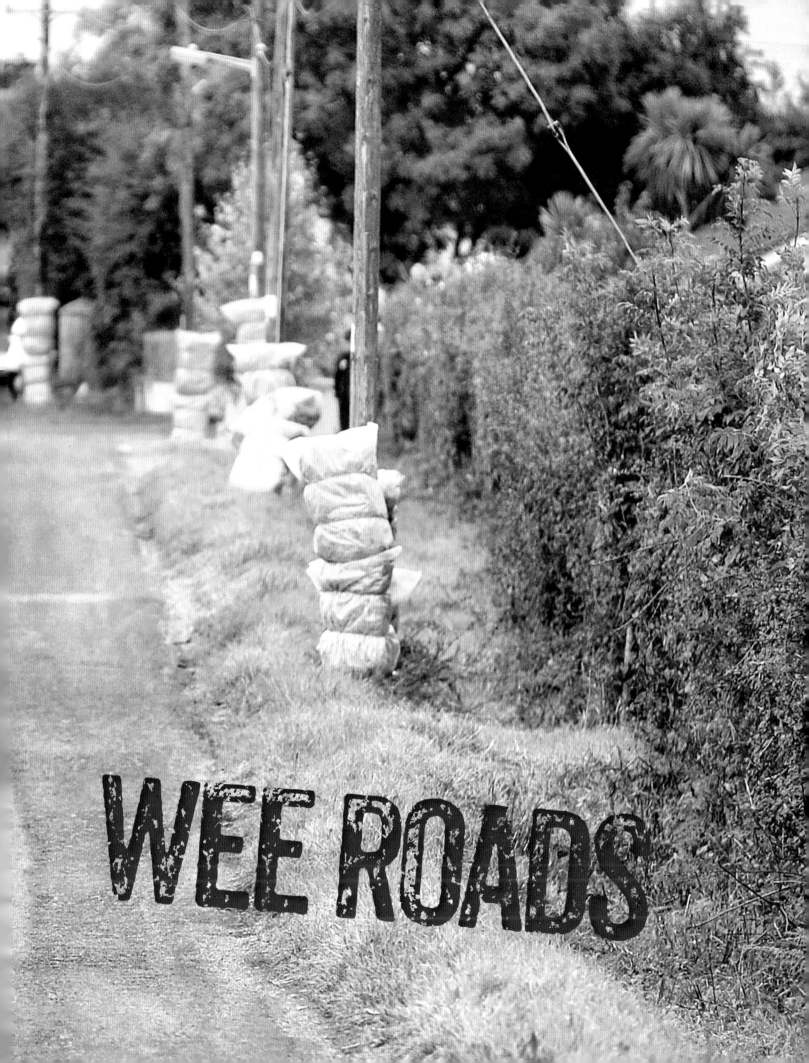

WEE ROADS

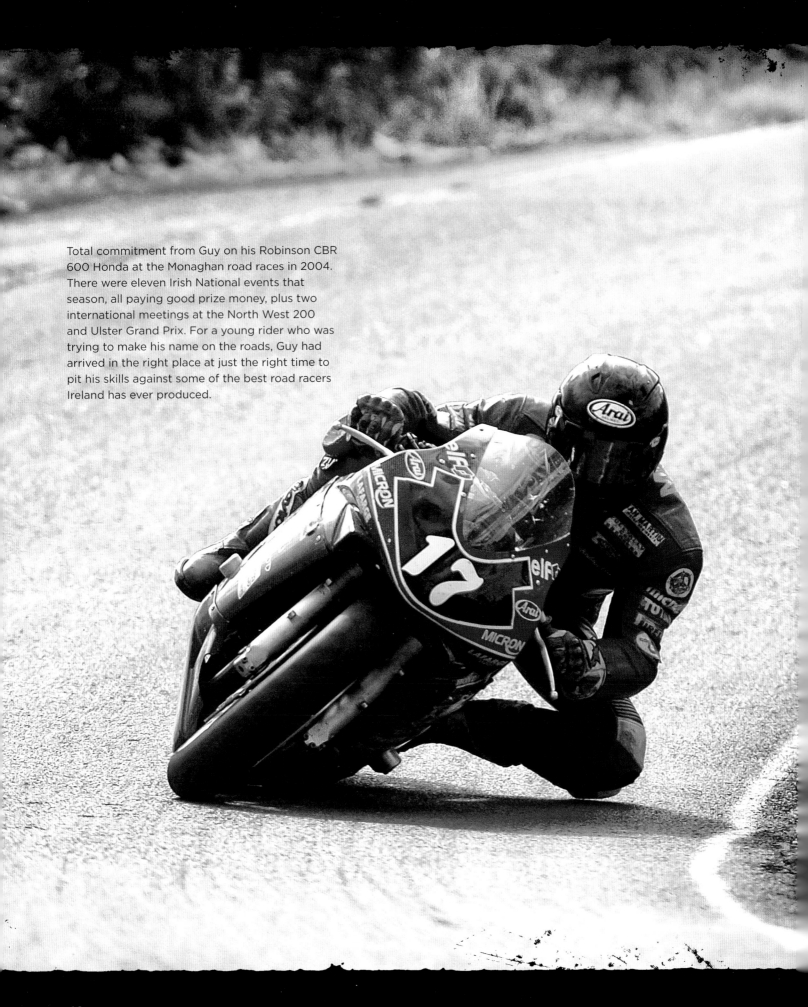

Total commitment from Guy on his Robinson CBR 600 Honda at the Monaghan road races in 2004. There were eleven Irish National events that season, all paying good prize money, plus two international meetings at the North West 200 and Ulster Grand Prix. For a young rider who was trying to make his name on the roads, Guy had arrived in the right place at just the right time to pit his skills against some of the best road racers Ireland has ever produced.

Guy chats with (clockwise from his left) fellow racers Martin Finnegan and Richard Britton, mechanic Trevor Harbinson and team manager, Uel Duncan, at Killalane in 2004. After winning the Irish Senior Support championship the previous season, Guy was promoted into the main classes for 2004. He was now up against Britton, Finnegan, Ryan Farquhar, Darran Lindsay and TT winners like Adrian Archibald.

'Guy loved the atmosphere at Irish races,' Uel Duncan recalls. 'He also liked the way he was treated by the race organisers, especially after how things had gone at British championship racing. He felt he had respect in Ireland.'

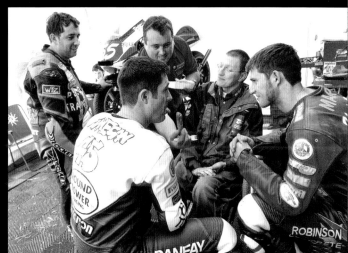

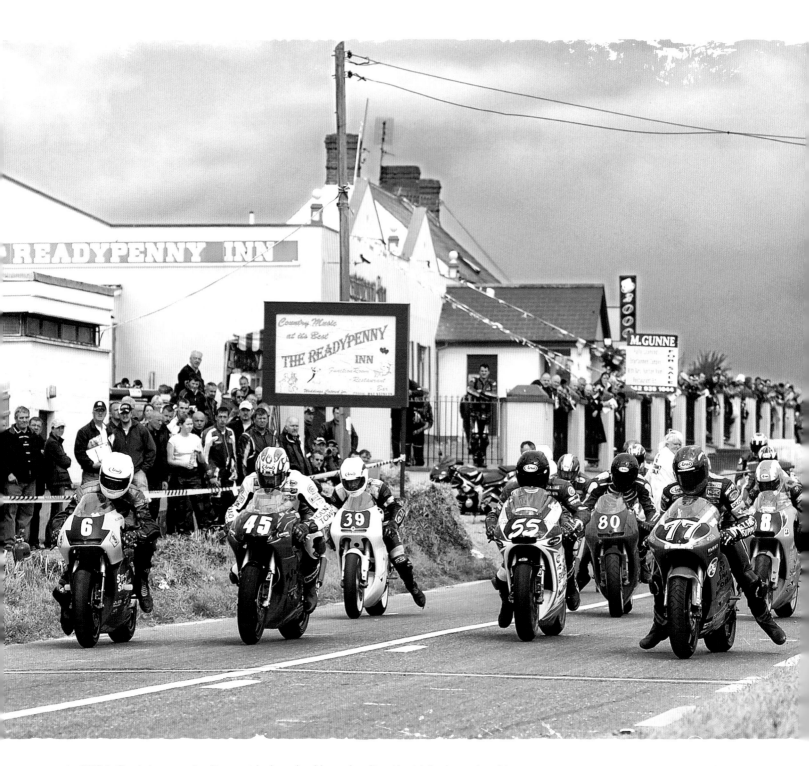

In 2004, Guy's teammate, Darran Lindsay, had been leading the Irish championship before he was injured in a crash. Guy was drafted in to help protect his teammate's advantage until the Irish rider was fit again but at Dundalk in County Louth things did not go according to plan. After a good start, Guy led Ryan Farquhar, Lindsay's arch-rival, on the opening lap. As the pair exited the final left-hander, Guy highsided in spectacular fashion.

Fortunately he was unhurt in the crash and went on to win on the 250 at both Killalane and Scarborough – and teammate Lindsay won the championship!

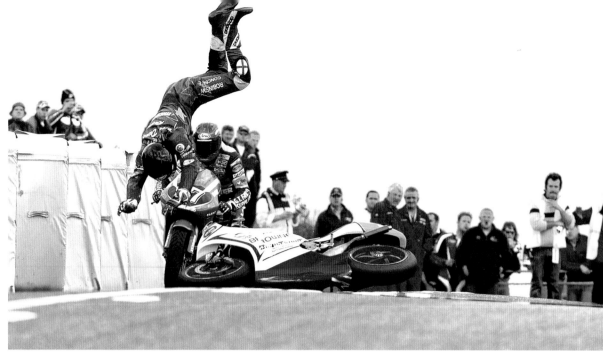

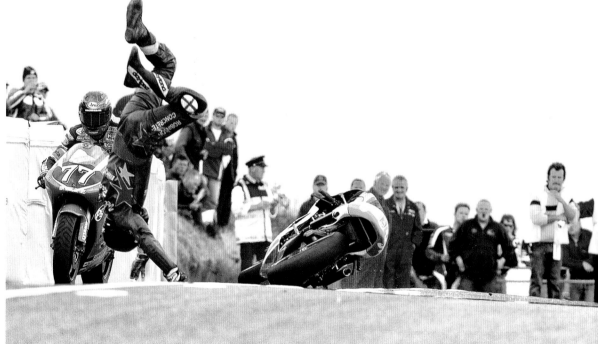

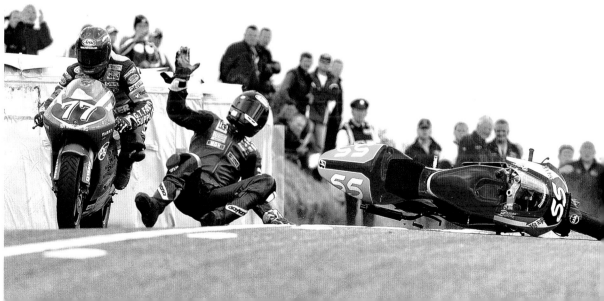

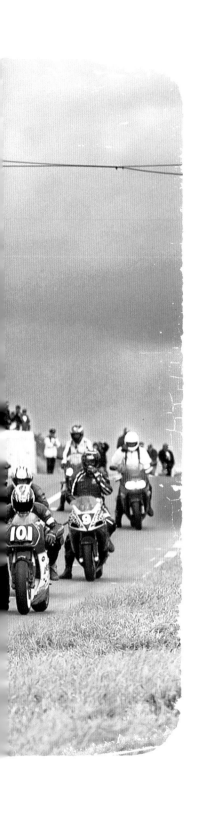

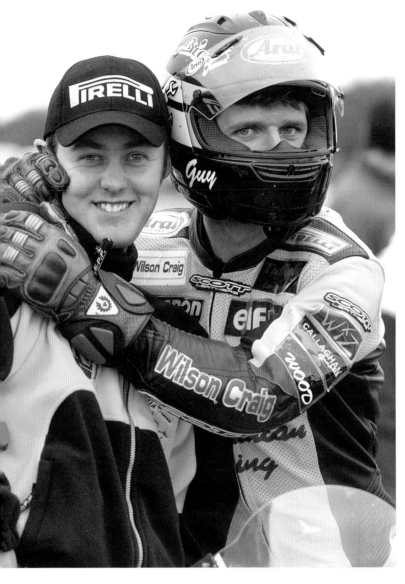

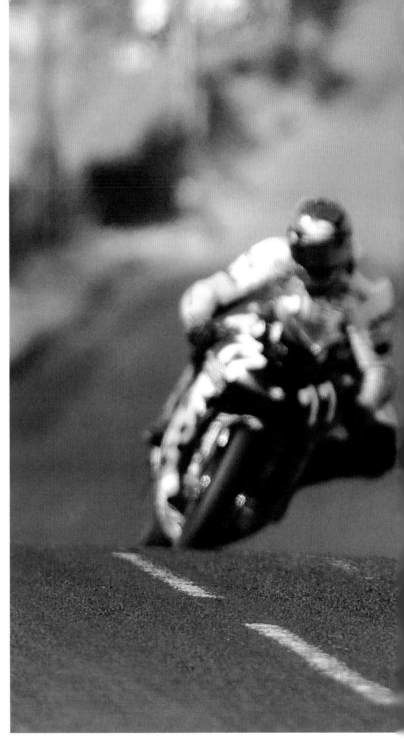

Johnny Ellis had served his truck mechanic's apprenticeship with Guy. 'Trellis', as Guy nicknamed him, followed him to Ireland to work on the race bikes during those early seasons on the roads.

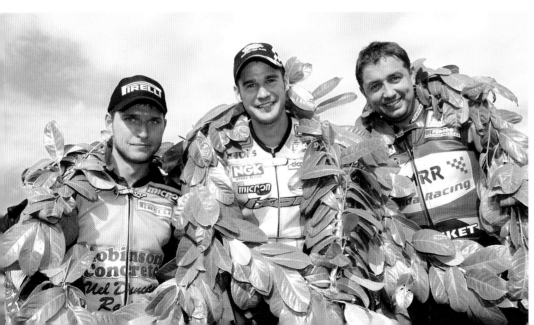

Guy with Ryan Farquhar and Richard Britton at Kells in 2005. 'I remember a young cub with big sideburns and I couldn't understand a word he said,' Ryan Farquhar smiles as he remembers his first encounters in 2004–5 with his new rival, Guy Martin.

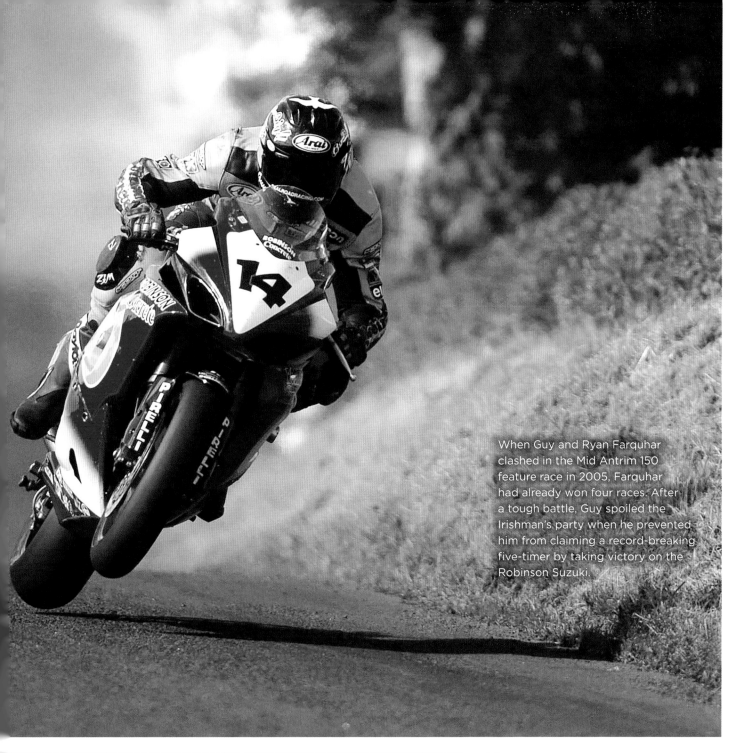

When Guy and Ryan Farquhar clashed in the Mid Antrim 150 feature race in 2005, Farquhar had already won four races. After a tough battle, Guy spoiled the Irishman's party when he prevented him from claiming a record-breaking five-timer by taking victory on the Robinson Suzuki.

During the 2004 and 2005 seasons, home for Guy and Johnny Ellis was often the race truck. The pair travelled up and down the length of Ireland, attending race meetings.

'We were all learning together during those years,' Uel Duncan remembers. 'I learned that if you offered Guy confidence, told him positive stuff, he responded well. I would tell him that he had the fastest bike on the line and that was important to him because he had tuned the engine himself.'

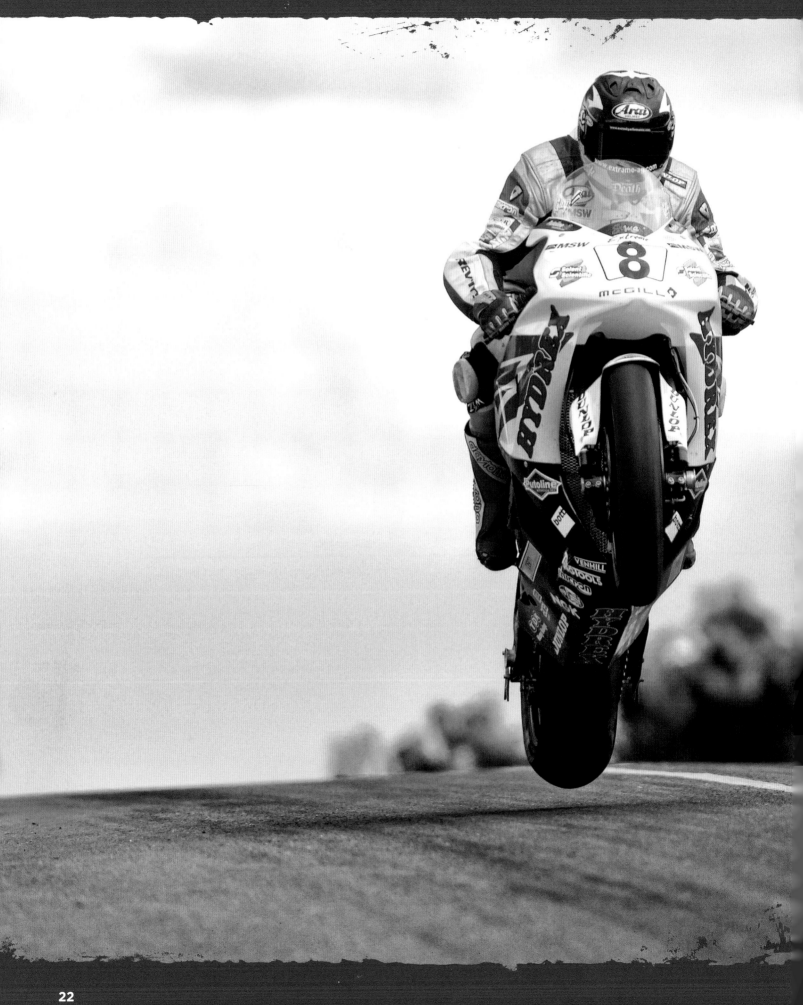

After his departure from the Robinson team to join AIM Yamaha for 2006 and then Shaun Muir's Hydrex Honda team between 2007 and 2009, Guy was unable to compete as regularly in the Irish National events. He still managed outings at Kells though, explaining to his new bosses how much he enjoyed travelling to these grassroots events.

Sadly the dangers of road racing have seen Guy lose several friends and rivals from those early years. Richard Britton, Martin Finnegan and Darran Lindsay all lost their lives in crashes at Irish National events between 2005 and 2008.

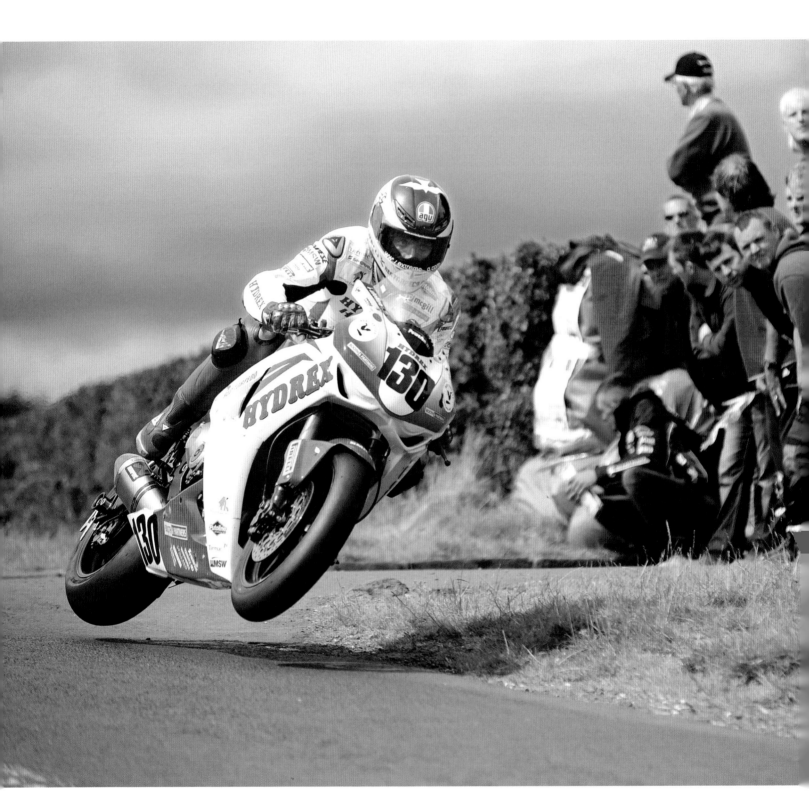

At Acheson's Leap on the Armoy circuit the superbikes literally take off and fly mid-corner whilst they are leaned over for the left-hand crest. Guy rode his Hydrex Honda during the first ever Armoy meeting in 2009. The circuit runs through the County Antrim village made famous by the 'Armoy Armada' – Joey Dunlop, Mervyn Robinson and Frank Kennedy – in the 1977 film *Road Racers*. Guy finished second behind Ryan Farquhar in the feature race.

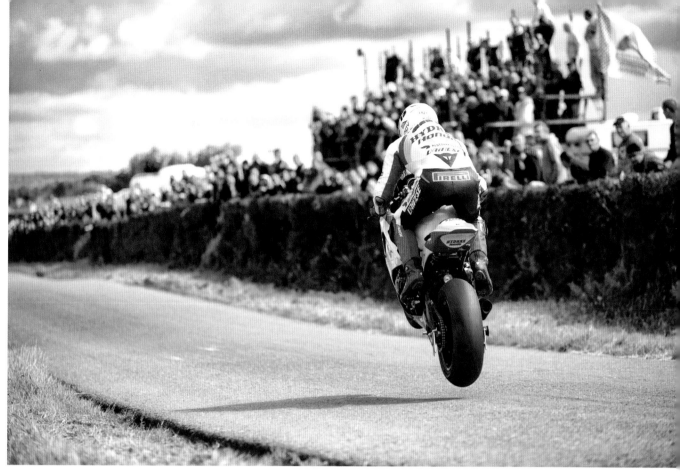

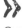 As Guy's popularity grew, his inclusion in the starting line-up became a top priority for race organisers in Ireland and further afield. Racing Shaun Muir's Hydrex Hondas in the British Superbike championship series and in the major international road races, Guy's presence was a huge draw when he returned to events like Kells, adding several thousand spectators to the hedgerows.

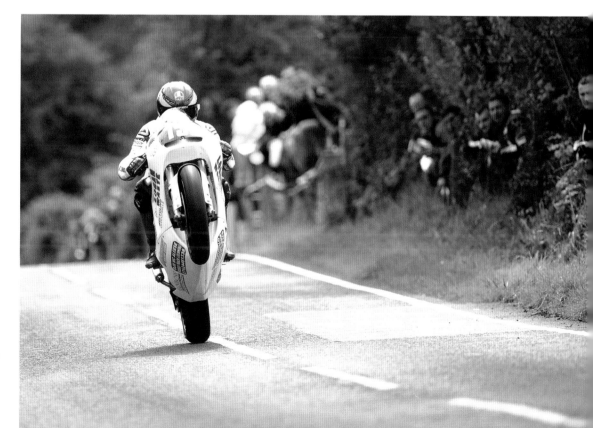

Guy pulls a huge wheelie over Lagge Dams on the Logan Honda during an outing on a 250cc two-stroke machine at the Armoy road races in 2009.

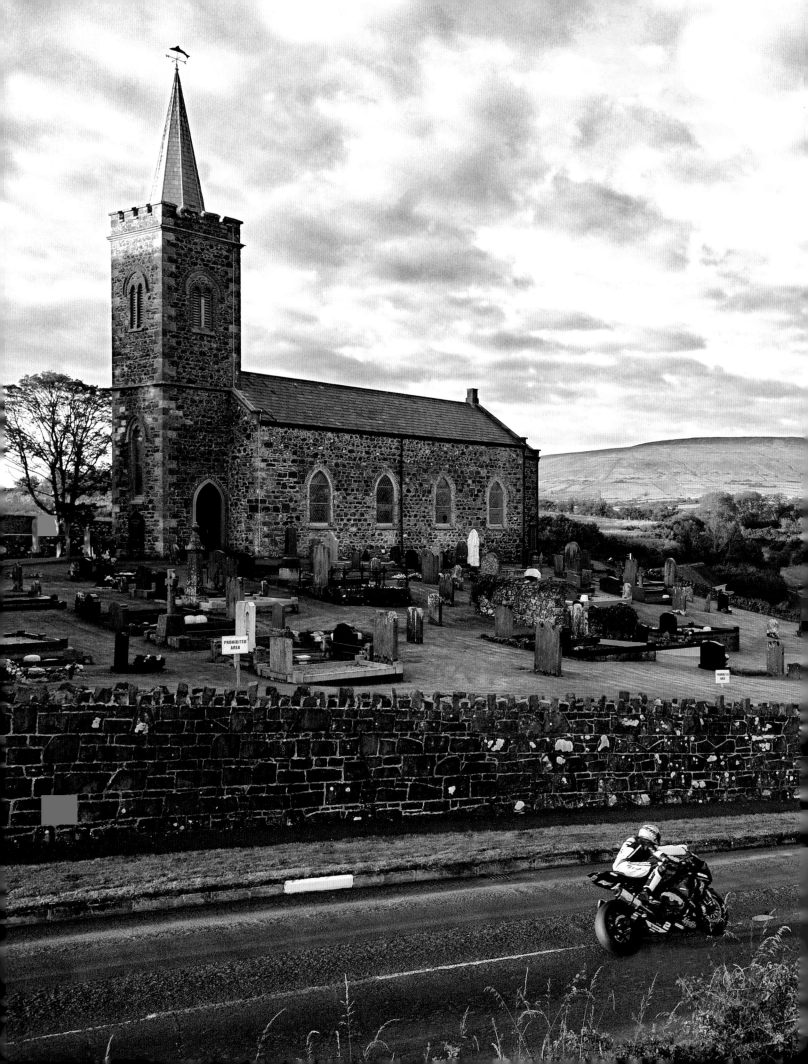

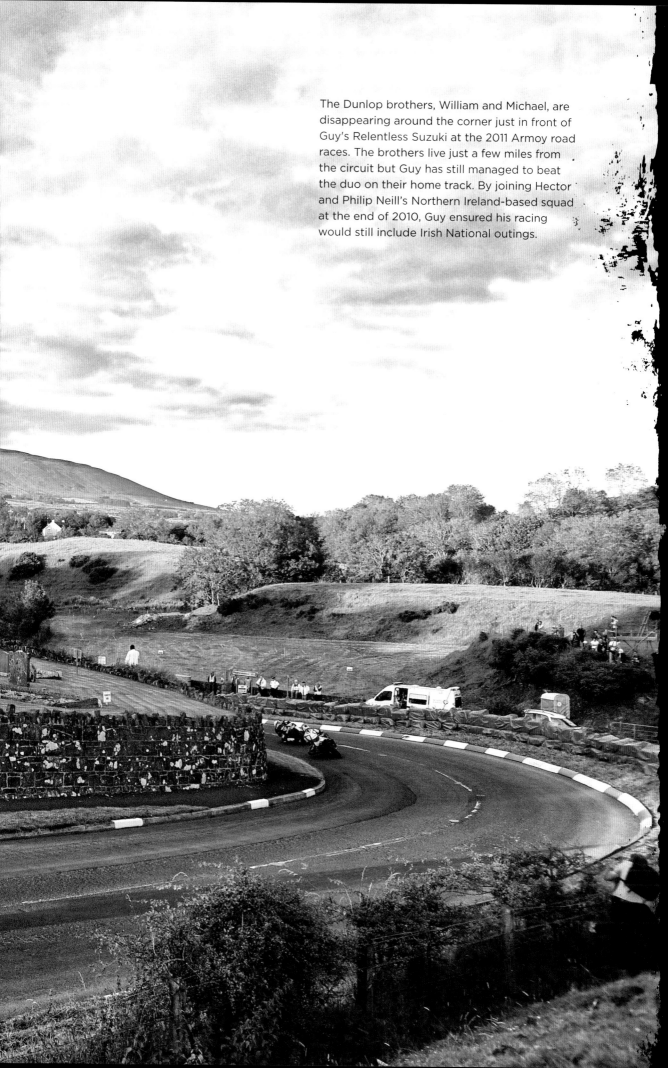

The Dunlop brothers, William and Michael, are disappearing around the corner just in front of Guy's Relentless Suzuki at the 2011 Armoy road races. The brothers live just a few miles from the circuit but Guy has still managed to beat the duo on their home track. By joining Hector and Philip Neill's Northern Ireland-based squad at the end of 2010, Guy ensured his racing would still include Irish National outings.

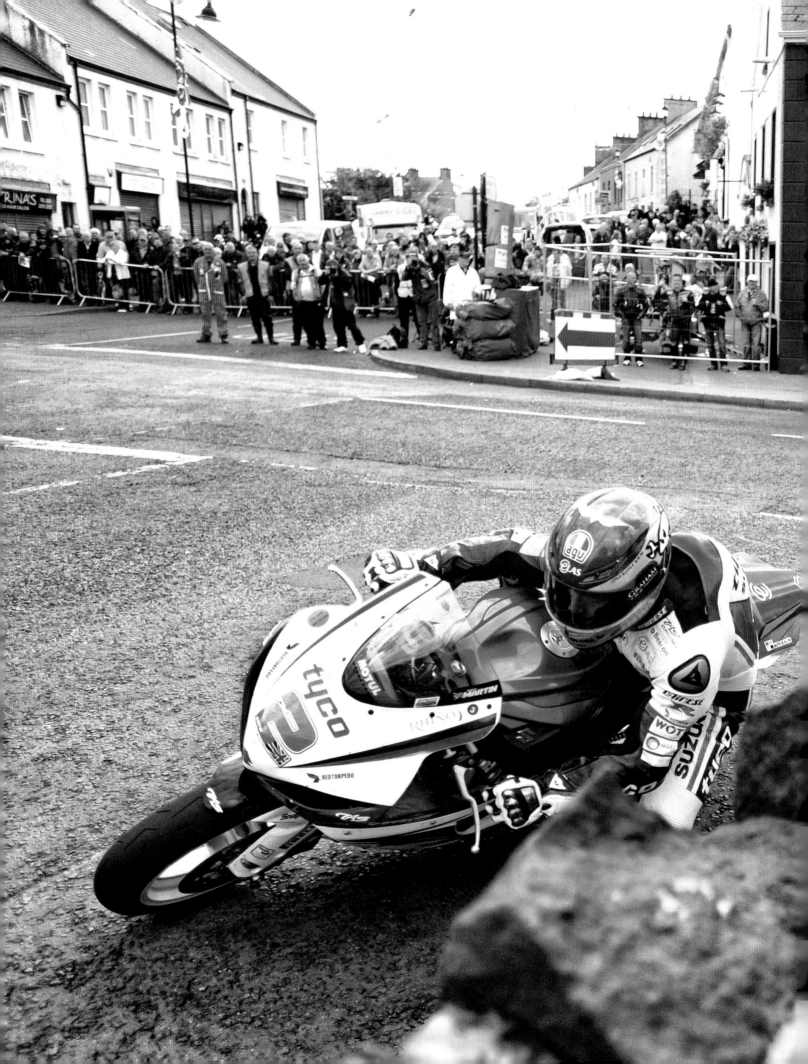

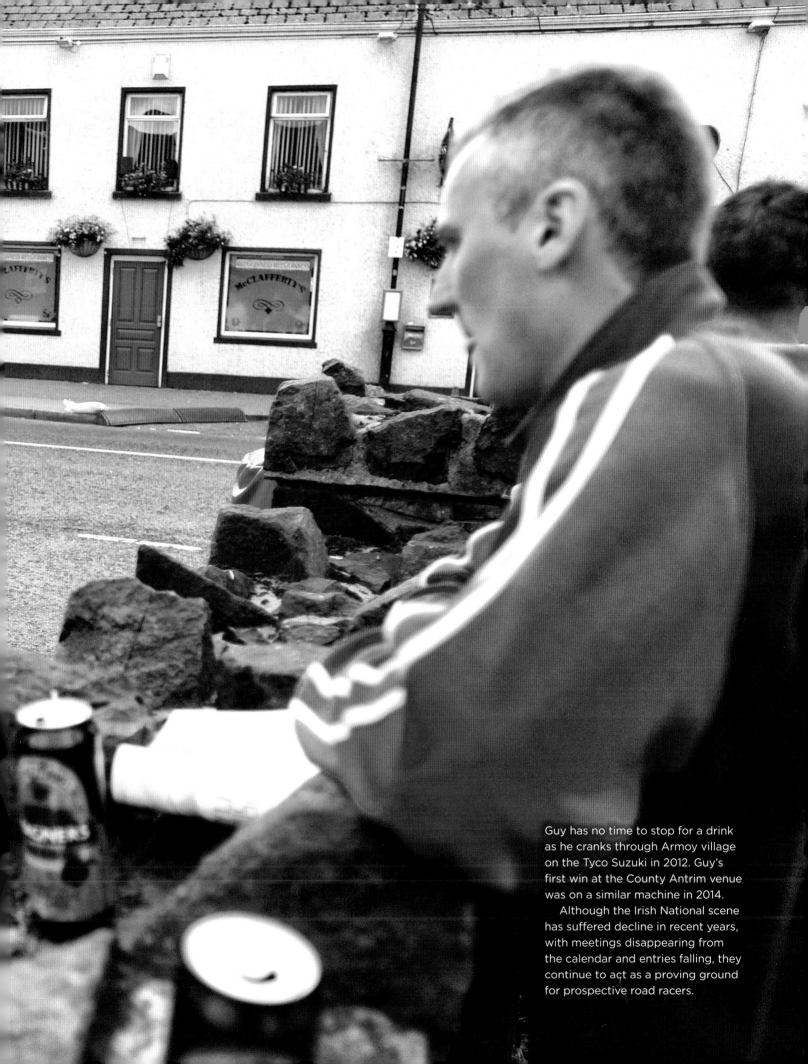

Guy has no time to stop for a drink as he cranks through Armoy village on the Tyco Suzuki in 2012. Guy's first win at the County Antrim venue was on a similar machine in 2014.

Although the Irish National scene has suffered decline in recent years, with meetings disappearing from the calendar and entries falling, they continue to act as a proving ground for prospective road racers.

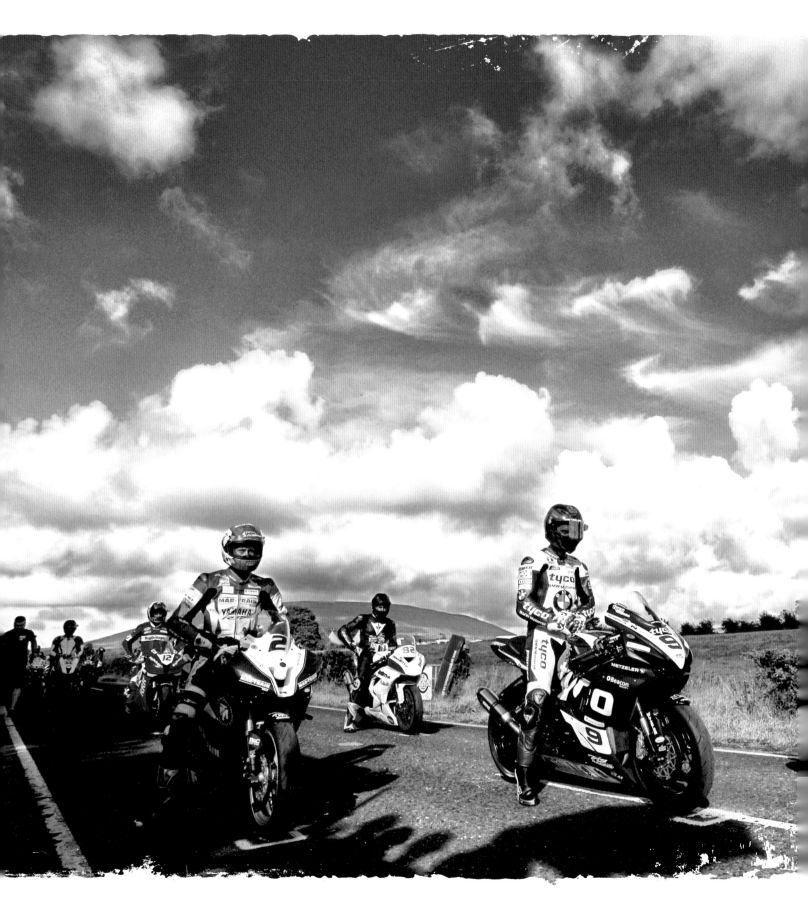

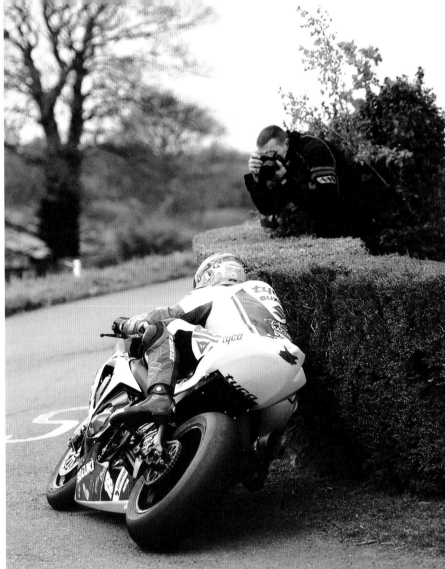

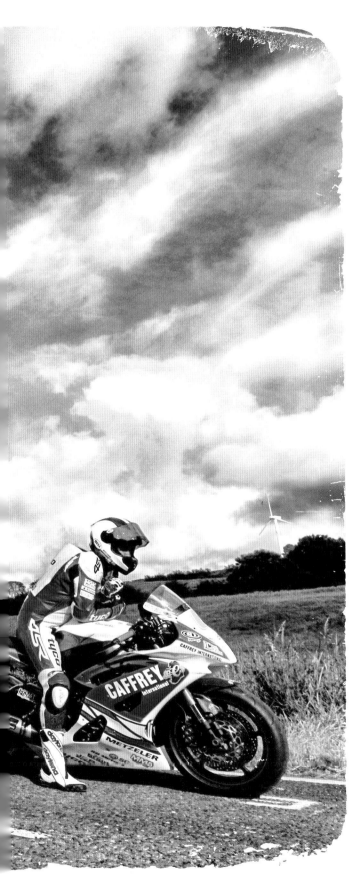

⌃ Part of the appeal of the Irish National scene for fans is how close they can get to the action, as seen here at Mackney's corner on the Cookstown 100 circuit.

Although Guy now races for manufacturer-backed teams with huge budgets and a team of mechanics to maintain the machinery, he often harks back to a simpler time when there was less pressure and he travelled to meetings with his race bike in the back of his van. That connection with the past is rekindled when he competes at these smaller Irish events.

« Guy lines up for the start of the 2015 Armoy Supersport race, sandwiched between Dean Harrison (Mar Train Yamaha) and William Dunlop (Caffrey Yamaha) on his Tyco Suzuki. He eventually finished second, behind Dunlop and just ahead of Harrison.

Guy and William were teammates in the Tyco squad in 2014 and 2015.

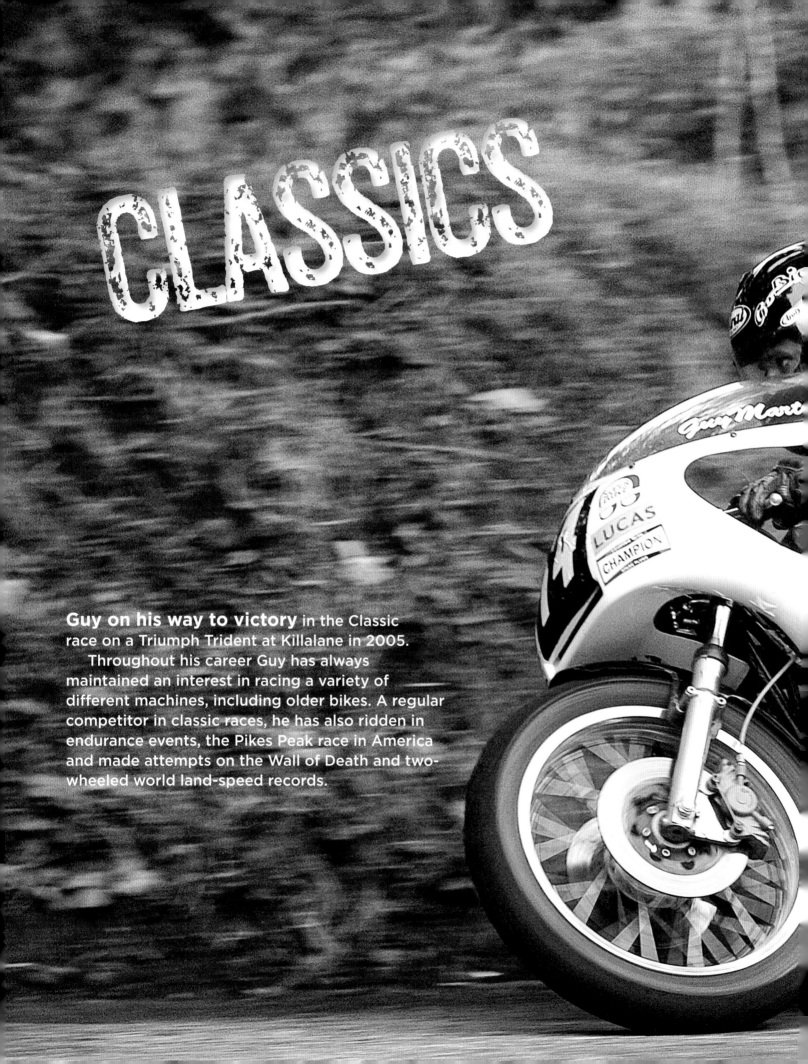

CLASSICS

Guy on his way to victory in the Classic race on a Triumph Trident at Killalane in 2005. Throughout his career Guy has always maintained an interest in racing a variety of different machines, including older bikes. A regular competitor in classic races, he has also ridden in endurance events, the Pikes Peak race in America and made attempts on the Wall of Death and two-wheeled world land-speed records.

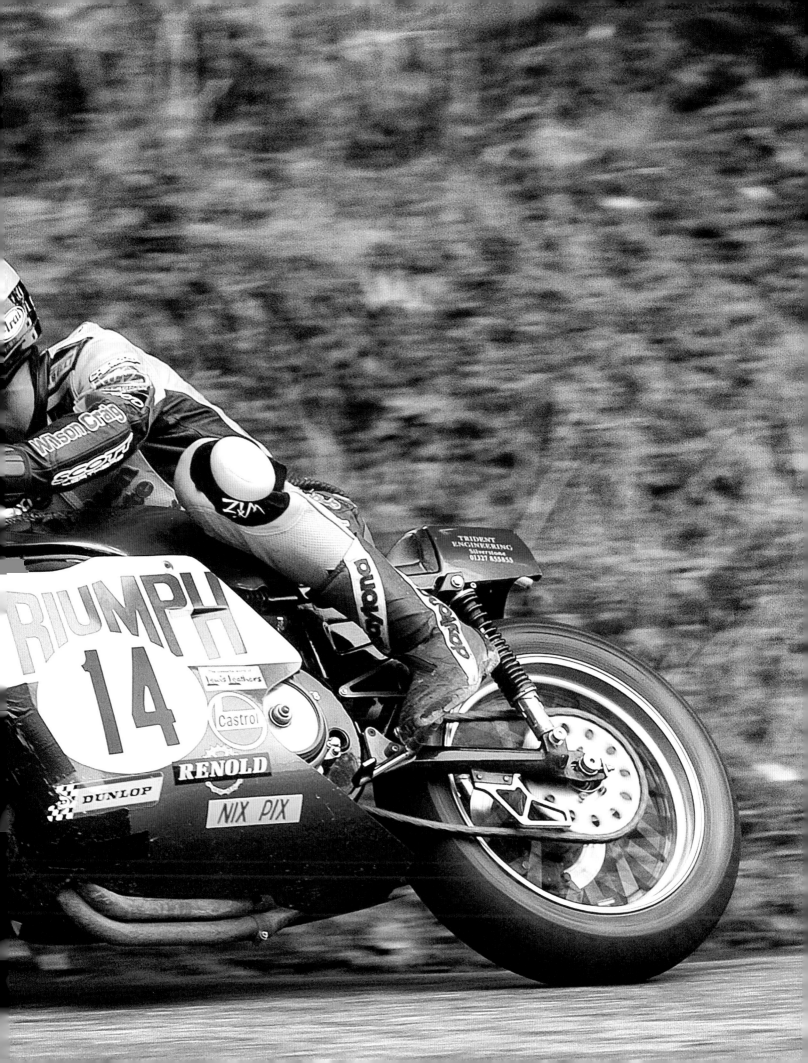

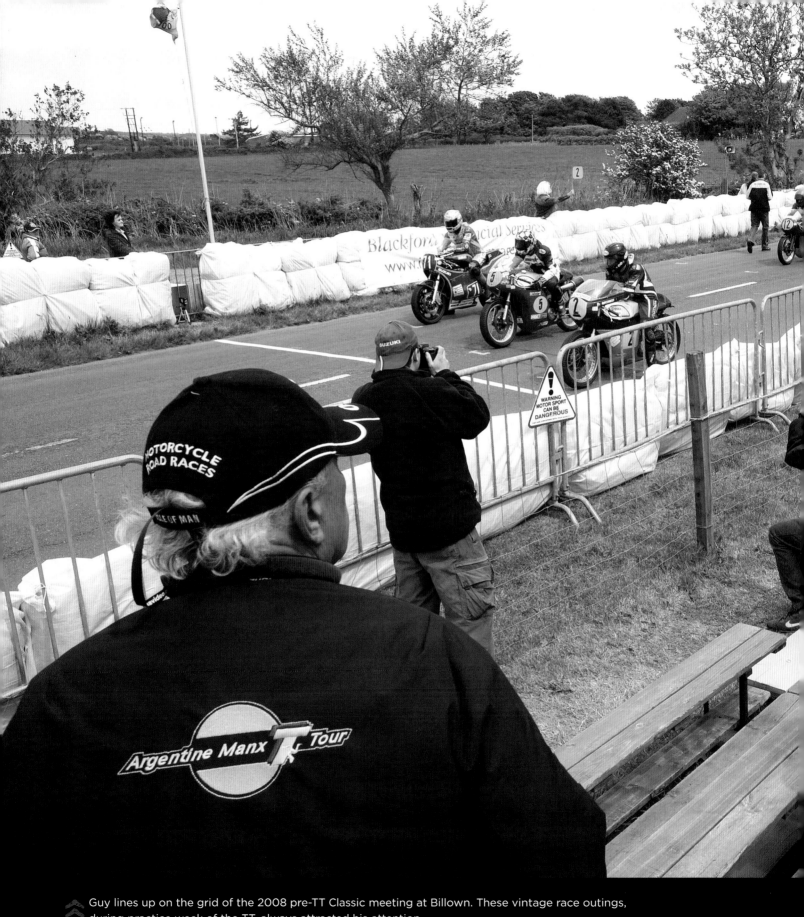

Guy lines up on the grid of the 2008 pre-TT Classic meeting at Billown. These vintage race outings, during practice week of the TT, always attracted his attention.

Guy crashed whilst leading on the final lap of this race – something Hydrex Honda boss Shaun Muir would probably have been worried about, had he even known Guy was competing.

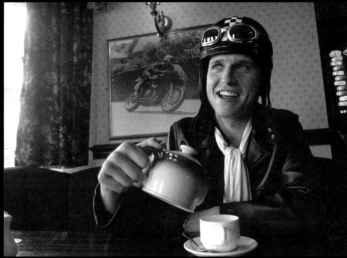

Guy gets into the Rocker vibe during a TT promotional event in 2005. Given his love of racing old motorbikes, it seems strange that Guy has never competed in the Classic TT races that are held on the Mountain course during the Manx Grand Prix each year.

Guy inspects the engine of the XR69 Suzuki replica he raced at the 2012 pre-TT Classic meeting at Billown.

Although he now spends most of his time racing the very latest motorcycles that bristle with electronic aids, Guy is a devotee of all things mechanical and enjoys an encyclopaedic knowledge of a huge range of machinery, from aeroplanes and trucks to motorcycles and pushbikes.

His fascination lies in understanding how everything works, and admiring the engineering and craftsmanship involved.

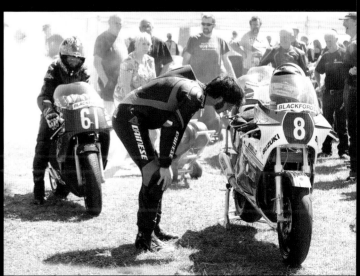

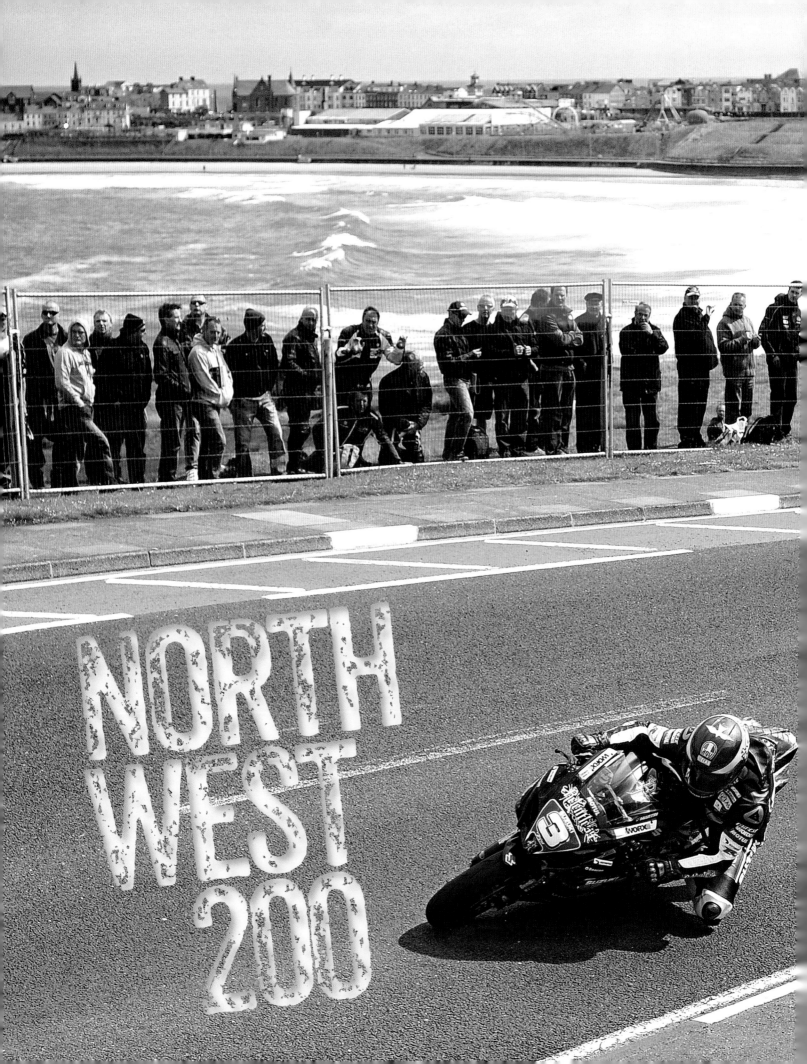

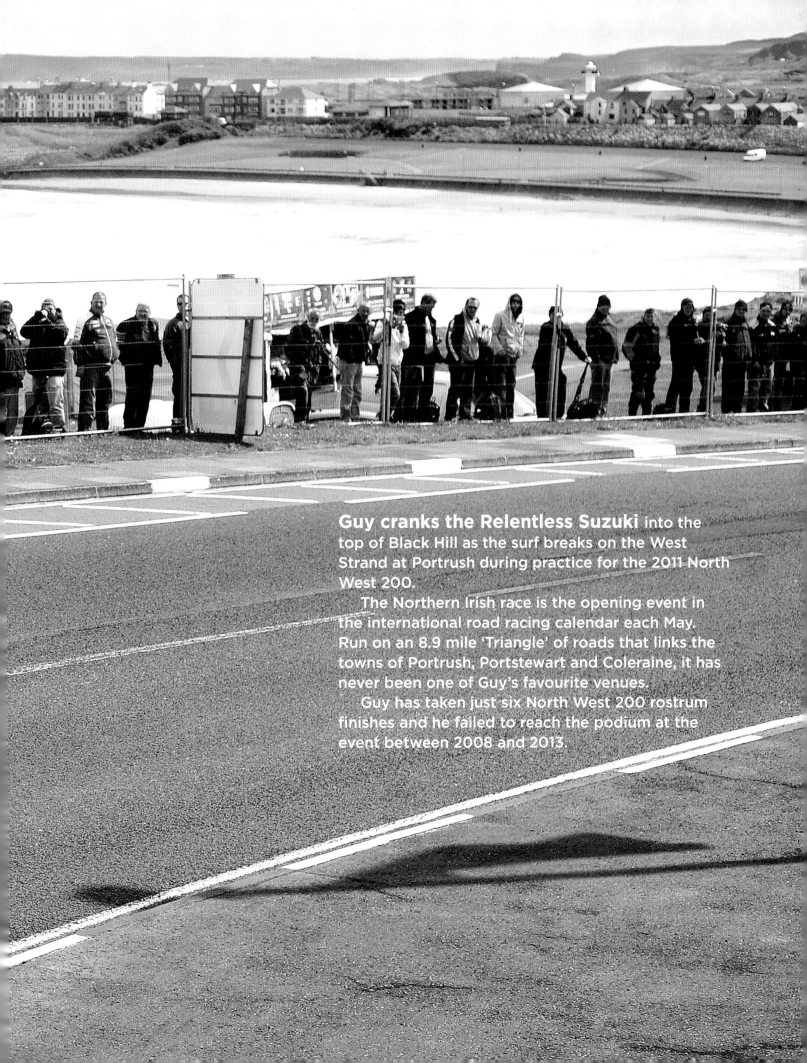

Guy cranks the Relentless Suzuki into the top of Black Hill as the surf breaks on the West Strand at Portrush during practice for the 2011 North West 200.

The Northern Irish race is the opening event in the international road racing calendar each May. Run on an 8.9 mile 'Triangle' of roads that links the towns of Portrush, Portstewart and Coleraine, it has never been one of Guy's favourite venues.

Guy has taken just six North West 200 rostrum finishes and he failed to reach the podium at the event between 2008 and 2013.

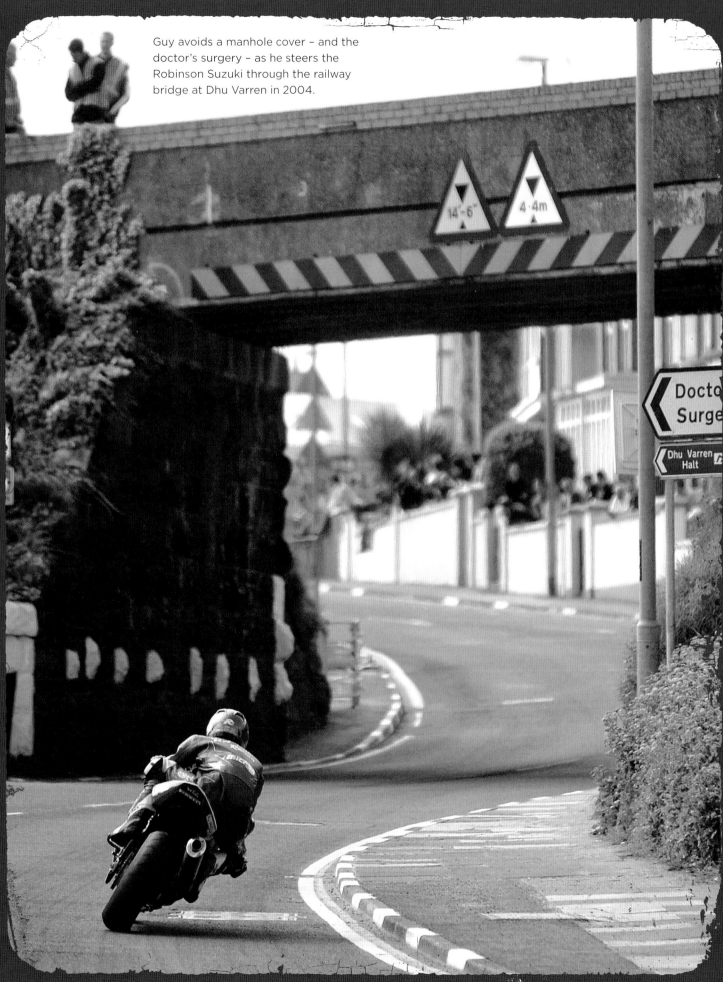

Guy avoids a manhole cover – and the doctor's surgery – as he steers the Robinson Suzuki through the railway bridge at Dhu Varren in 2004.

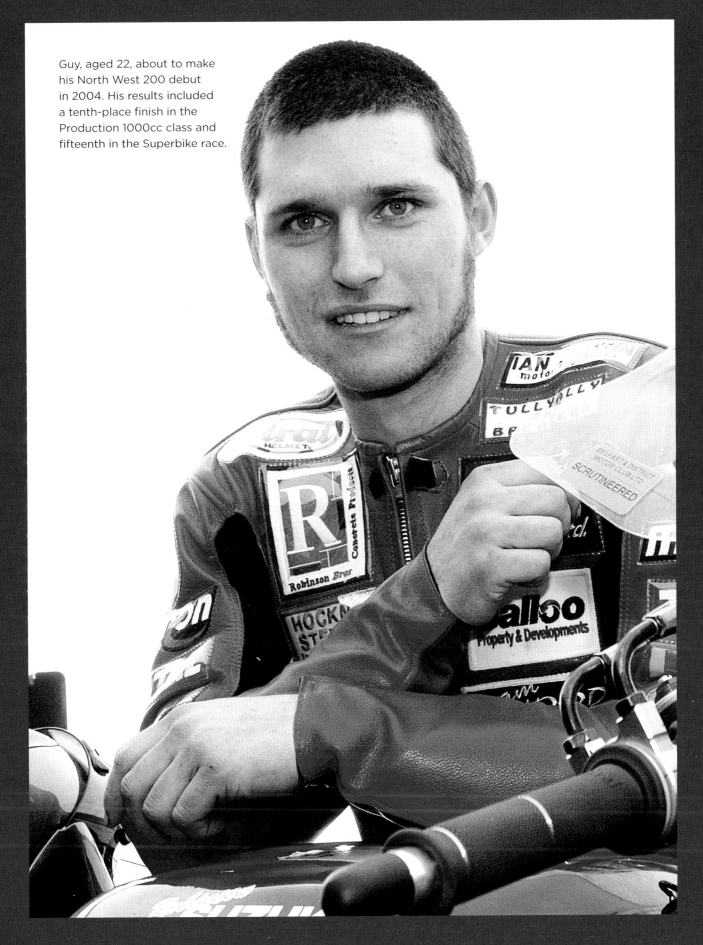

Guy, aged 22, about to make his North West 200 debut in 2004. His results included a tenth-place finish in the Production 1000cc class and fifteenth in the Superbike race.

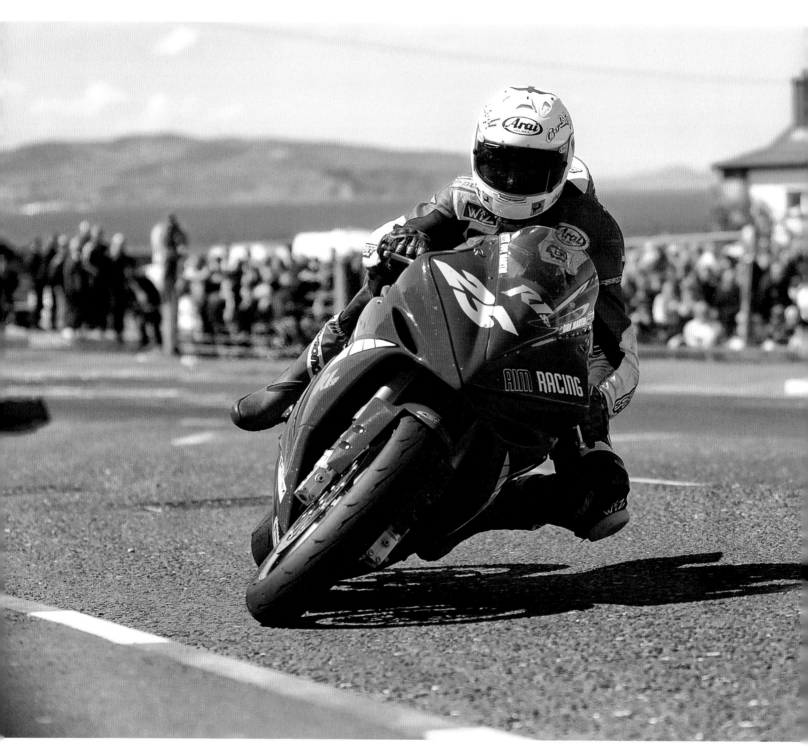

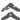 Guy runs the R1 Yamaha to the edge of the kerb on the exit of York hairpin during the 2006 NW200.

His shift from the Irish-based Robinson team to the Scottish AIM Yamaha outfit brought a new approach. Guy would prepare for the international road races at British championship short circuit meetings, rather than at the Irish National events as he had done previously.

But with his bikes slow to arrive in 2006, Guy had just one race outing before the North West and his lack of track time saw him struggle to find a good setup on the Yamahas.

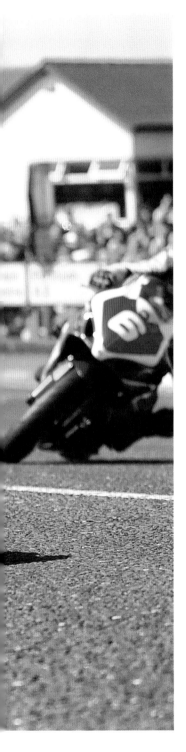

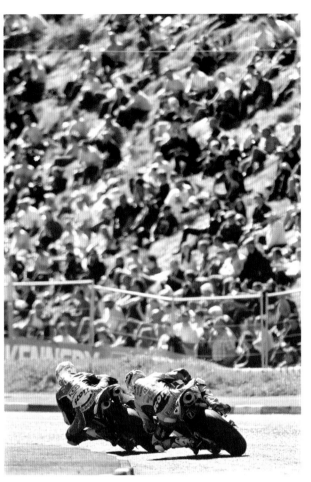

The crowd on the Metropole embankment have a grandstand view of Guy's battle with Cameron Donald during the 2006 North West 200 Superbike race.

Guy leads the pack around York hairpin in the 2006 NW200 Superstock race.

The AIM Yamaha team had won the Superbike and Senior TTs with John McGuinness the previous year. Guy's move to the factory-supported team was regarded as a progression after the promise he had shown in 2004–5.

'Guy was seen as the next big thing at that stage,' according to Paul Phillips, the man who has guided the renaissance of the Isle of Man TT races over the last decade. Phillips was involved in the contract discussions.

'I gave Guy some advice during the early part of his career,' he recalls. 'We were good friends. Guy was a lot more relaxed and easy-going back then. He was quirky and funny to be around.'

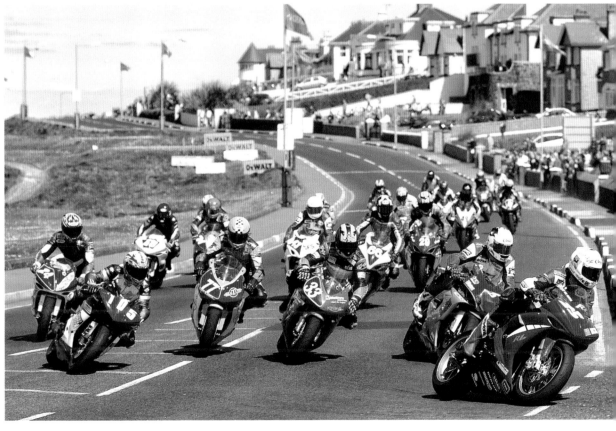

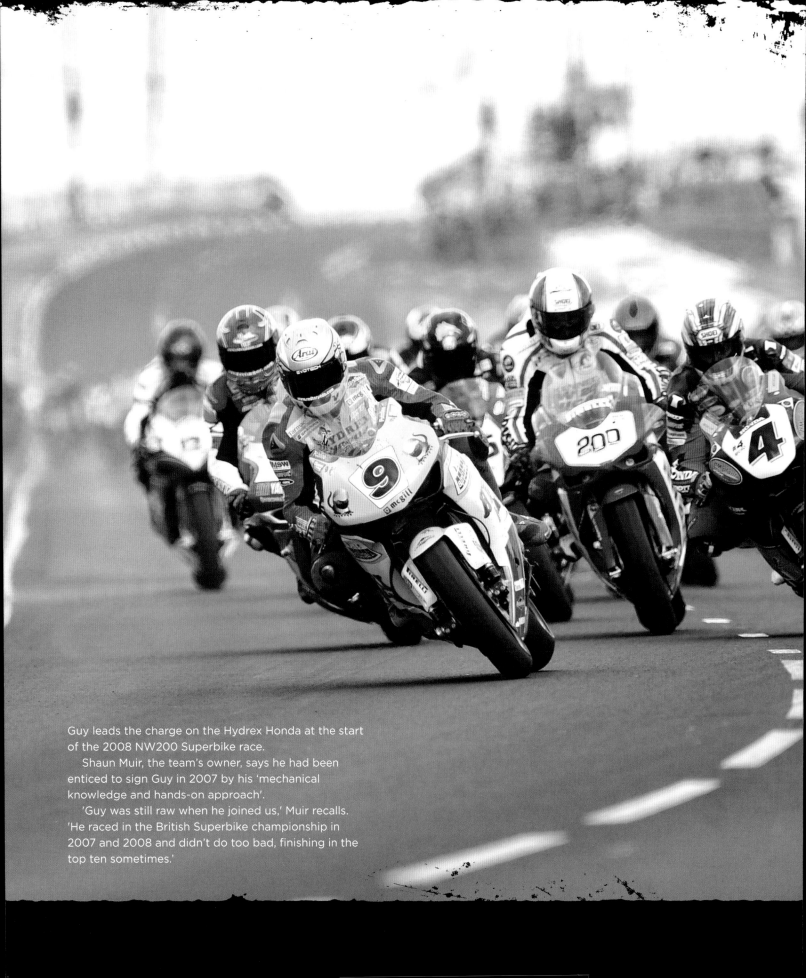

Guy leads the charge on the Hydrex Honda at the start
of the 2008 NW200 Superbike race.

Shaun Muir, the team's owner, says he had been
enticed to sign Guy in 2007 by his 'mechanical
knowledge and hands-on approach'.

'Guy was still raw when he joined us,' Muir recalls.
'He raced in the British Superbike championship in
2007 and 2008 and didn't do too bad, finishing in the
top ten sometimes.'

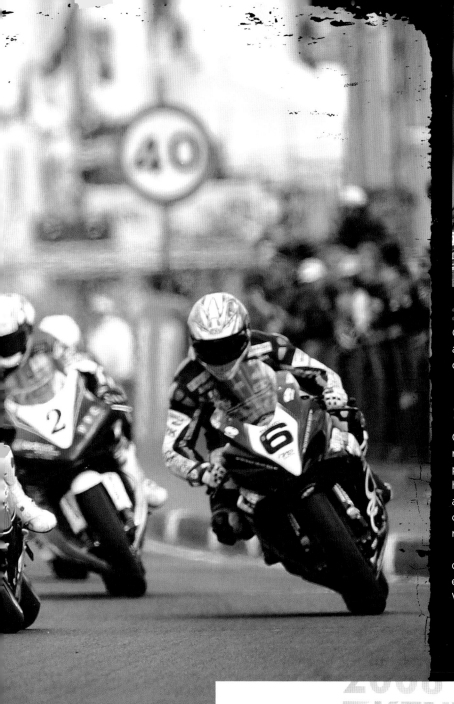

One of Guy's best-known traits is his love of tea and he has always been delighted to offer his opinions on the merits of a 'good brew'.

Guy shares the podium of the first NW200 superbike race in 2008 with winner Michael Rutter and third-placed John McGuinness. Guy had led the race until his Hydrex Honda Fireblade suffered brake fade and he was dominating the second race with a lead of several seconds before a water leak forced his retirement.

Many people feel that 2008 was Guy's finest year on the roads and it would be as close as he would ever come to winning a big bike race at the North West 200.

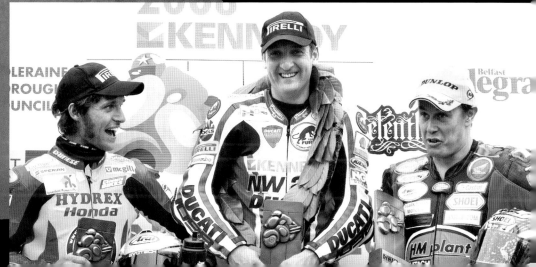

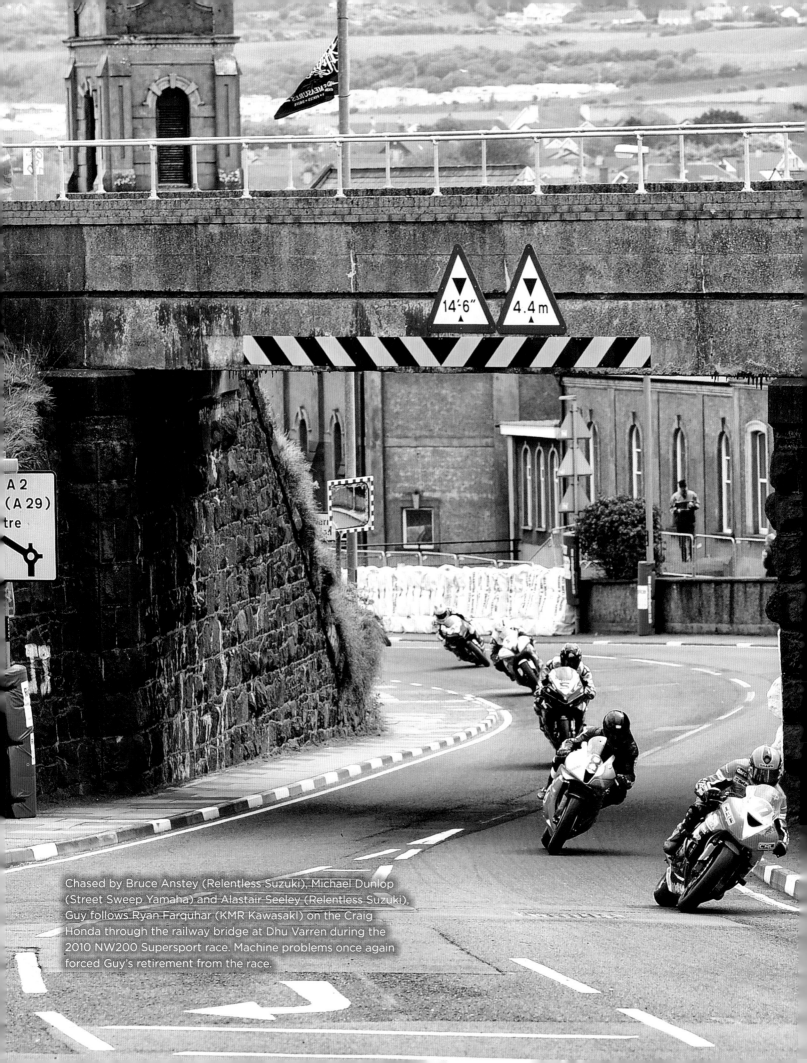

Chased by Bruce Anstey (Relentless Suzuki), Michael Dunlop (Street Sweep Yamaha) and Alastair Seeley (Relentless Suzuki), Guy follows Ryan Farquhar (KMR Kawasaki) on the Craig Honda through the railway bridge at Dhu Varren during the 2010 NW200 Supersport race. Machine problems once again forced Guy's retirement from the race.

Guy wheelies the Relentless Suzuki over Black Hill during practice for the 2011 NW200. His best result was an eighth-place finish in the Supersport race.

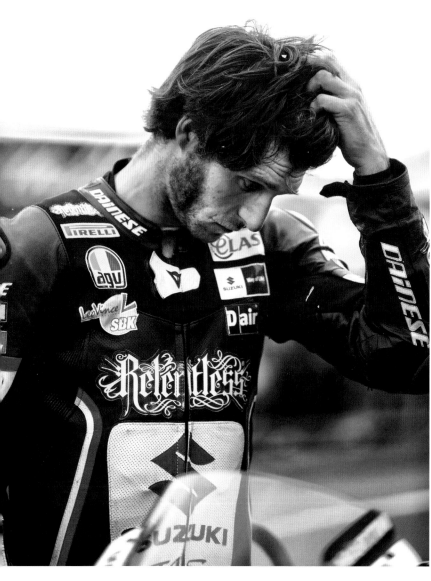

By 2011 Guy was a household name, famous outside the road racing world. His celebrity status and the television work made new demands on him, taking up his time and attention. These pressures distracted him from road racing and would contribute to increasingly disappointing results at the North West 200.

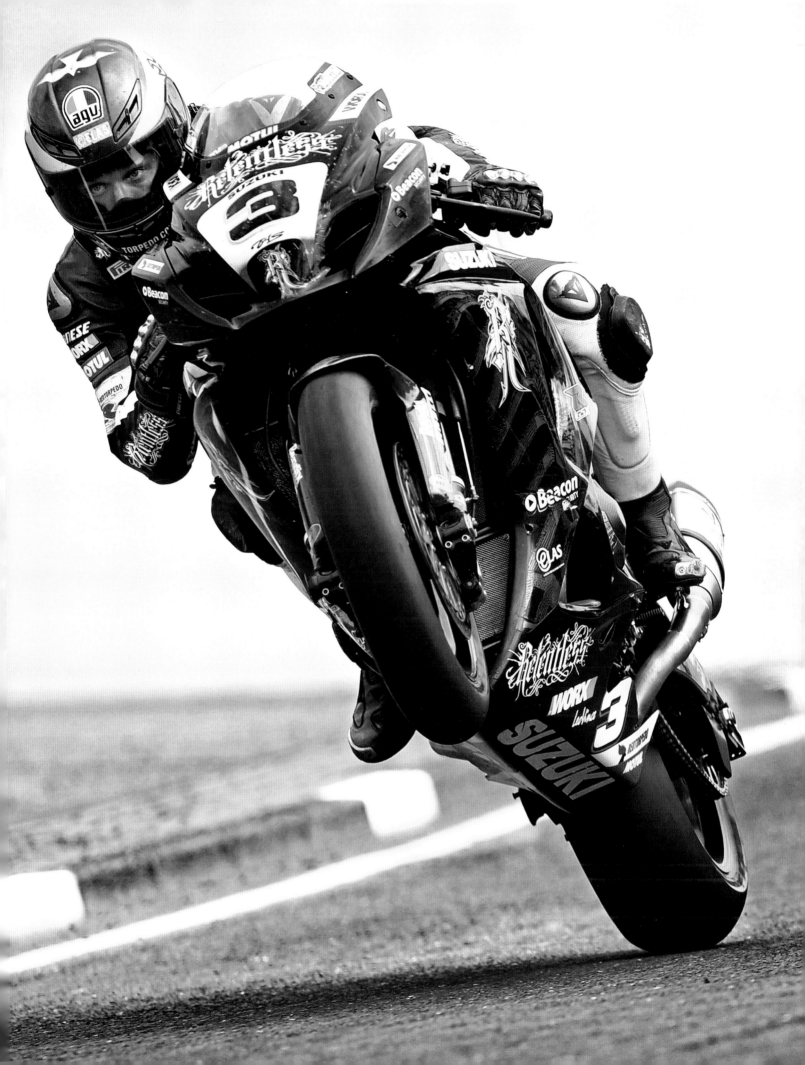

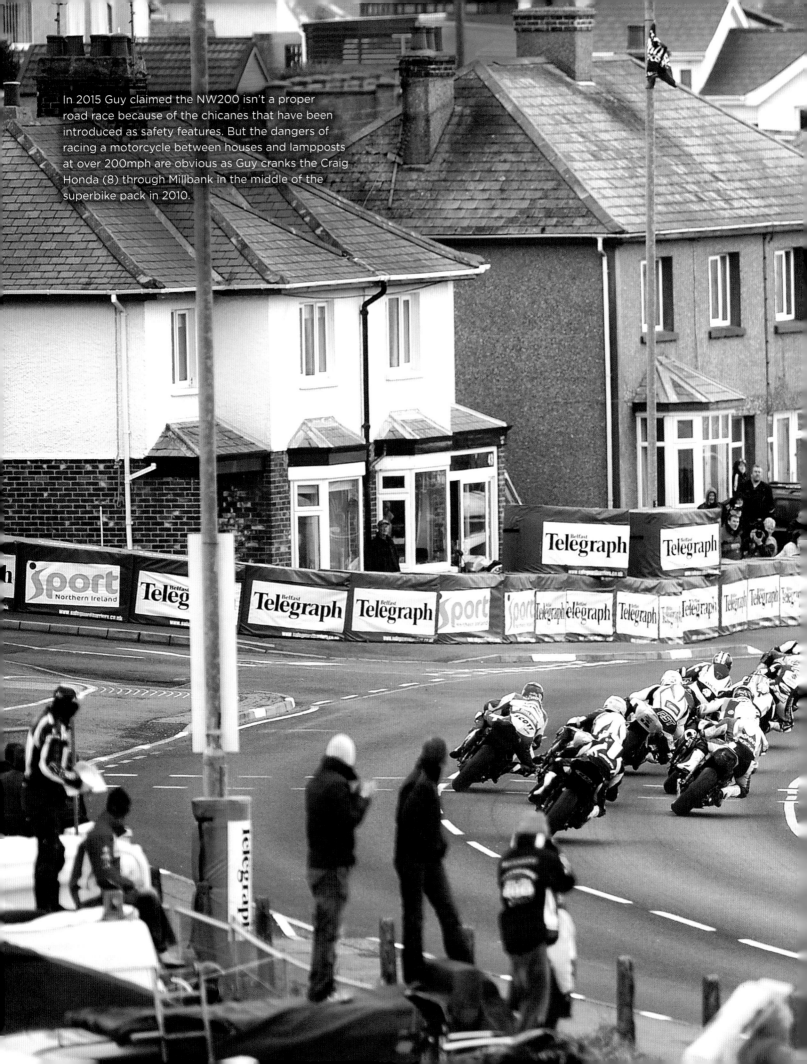

In 2015 Guy claimed the NW200 isn't a proper road race because of the chicanes that have been introduced as safety features. But the dangers of racing a motorcycle between houses and lampposts at over 200mph are obvious as Guy cranks the Craig Honda (8) through Millbank in the middle of the superbike pack in 2010.

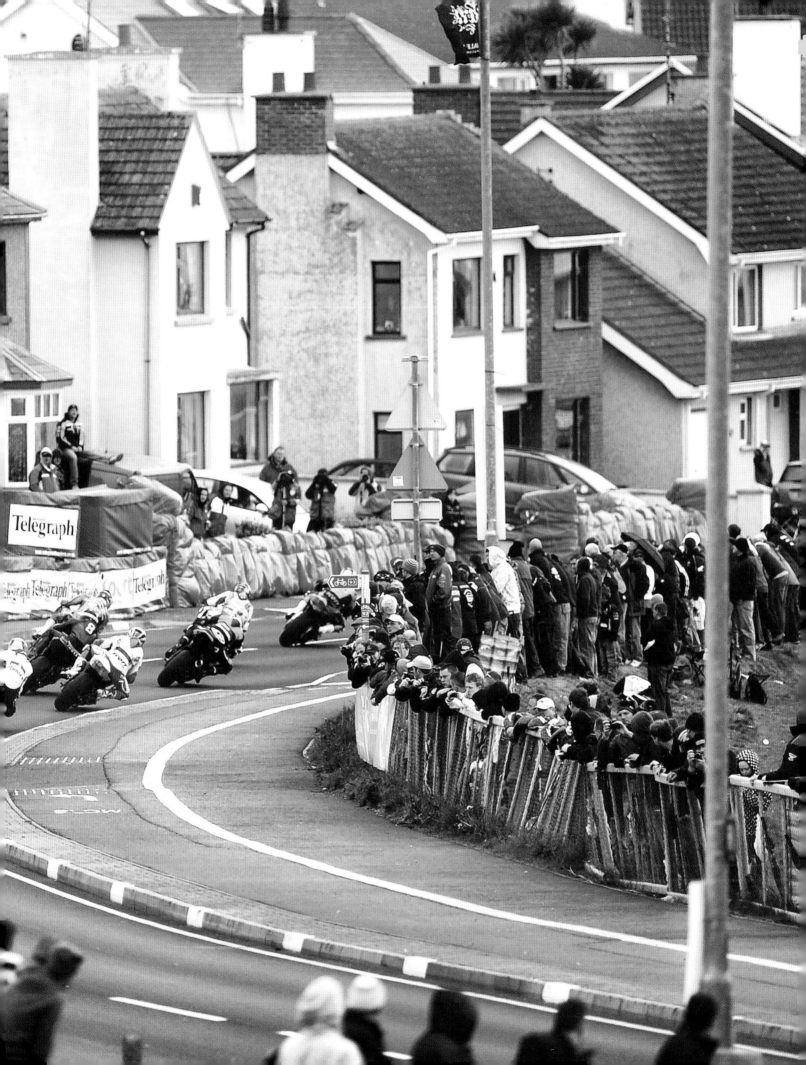

Guy has suffered several big crashes on the North West 200 circuit.

In 2008 he had a huge off at Black Hill after clipping the kerb on his Hydrex Honda during the Supersport race. He had another 600cc smash in this high-speed fall from his Tyco Suzuki at Dhu Varren in 2012. Luckily he escaped serious injury in all of these crashes.

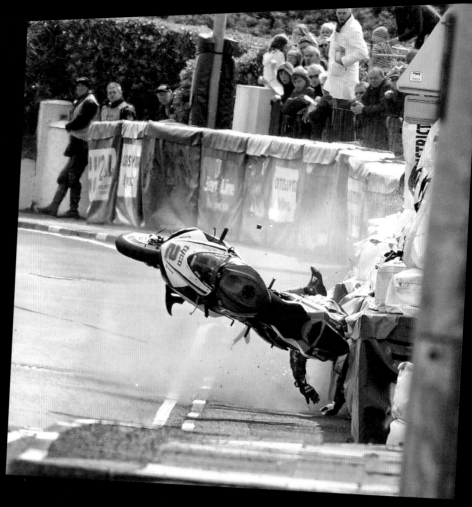

» Guy is saved from hitting the unforgiving wall at 120mph by a protective Recticel bale.

» As Guy bounces back into the road his Tyco Suzuki begins to break up after the impact. Petrol sprays from a split in the fuel tank and the bodywork is ripped off the GSXR.

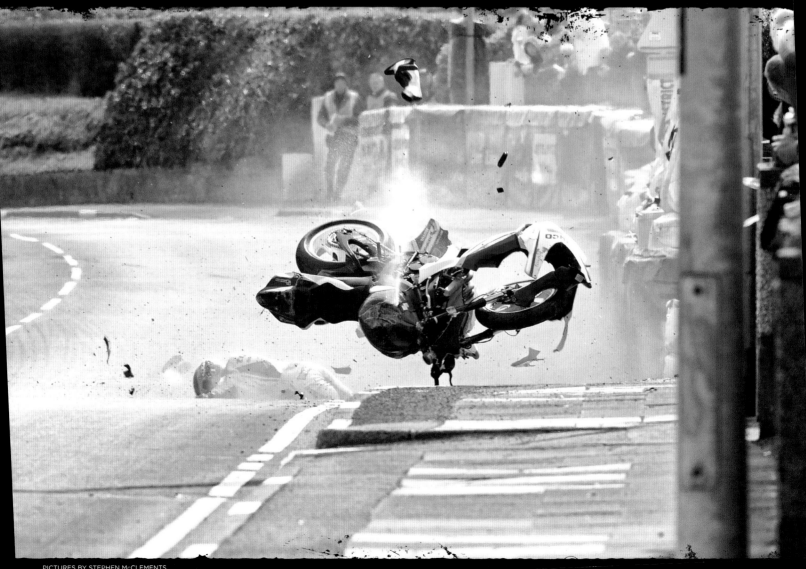

PICTURES BY STEPHEN McCLEMENTS

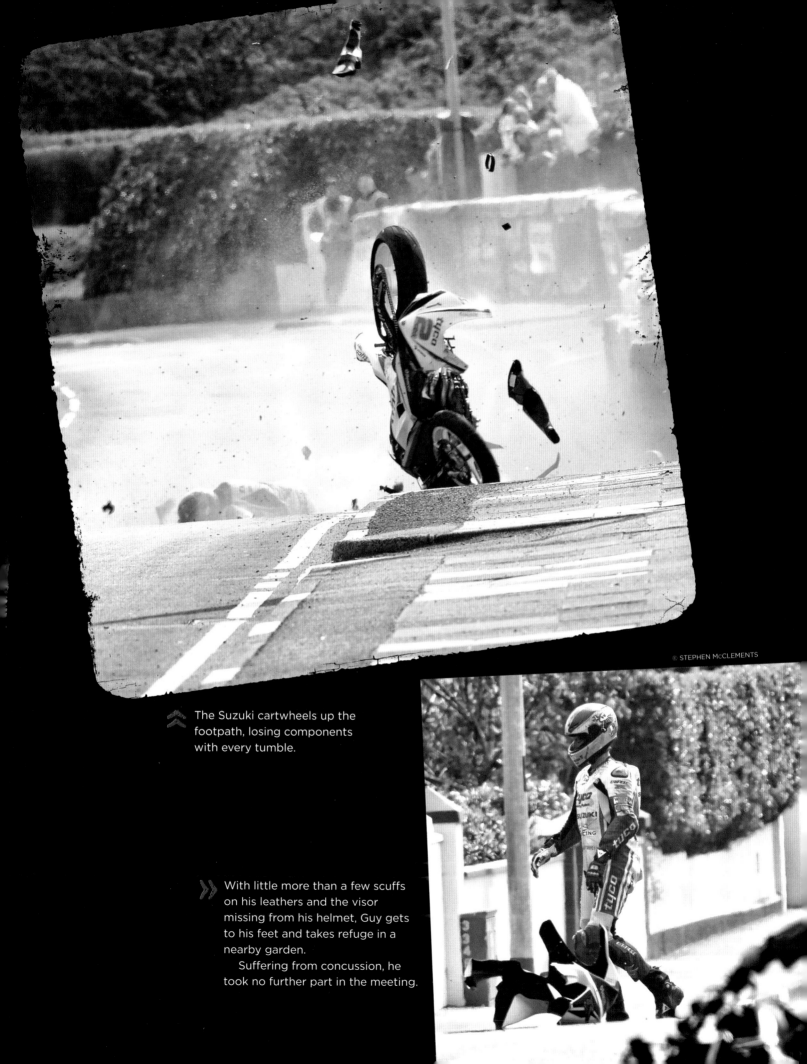

The Suzuki cartwheels up the footpath, losing components with every tumble.

With little more than a few scuffs on his leathers and the visor missing from his helmet, Guy gets to his feet and takes refuge in a nearby garden.

Suffering from concussion, he took no further part in the meeting.

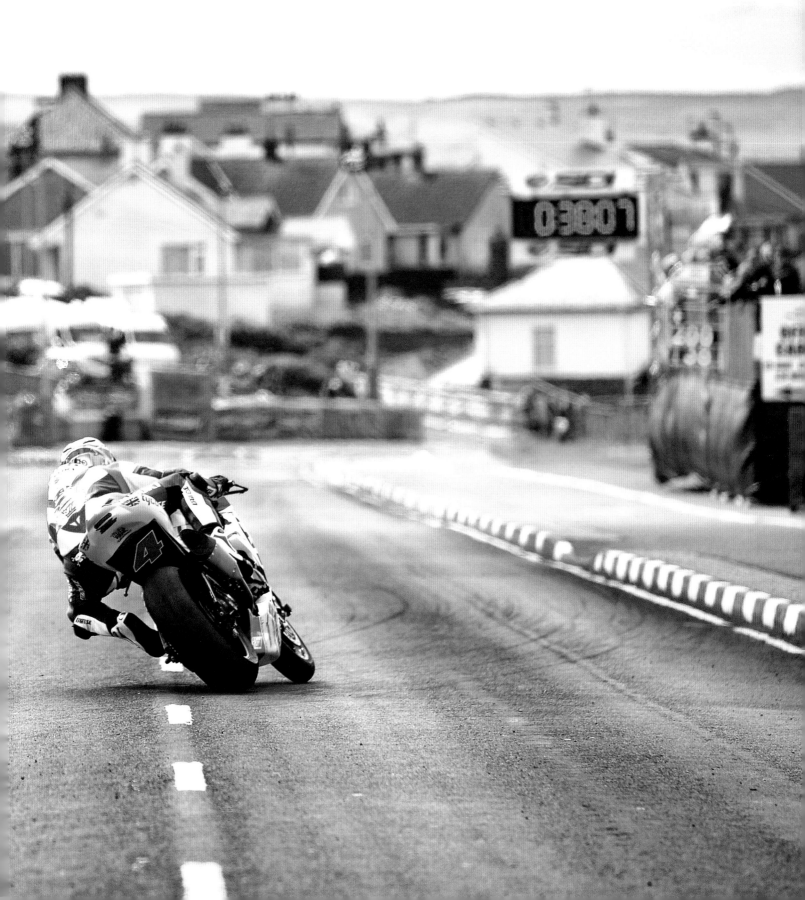

With a clear track in front of his Tyco Suzuki, Guy races on to the coast road to begin another lap at the 2014 North West 200.

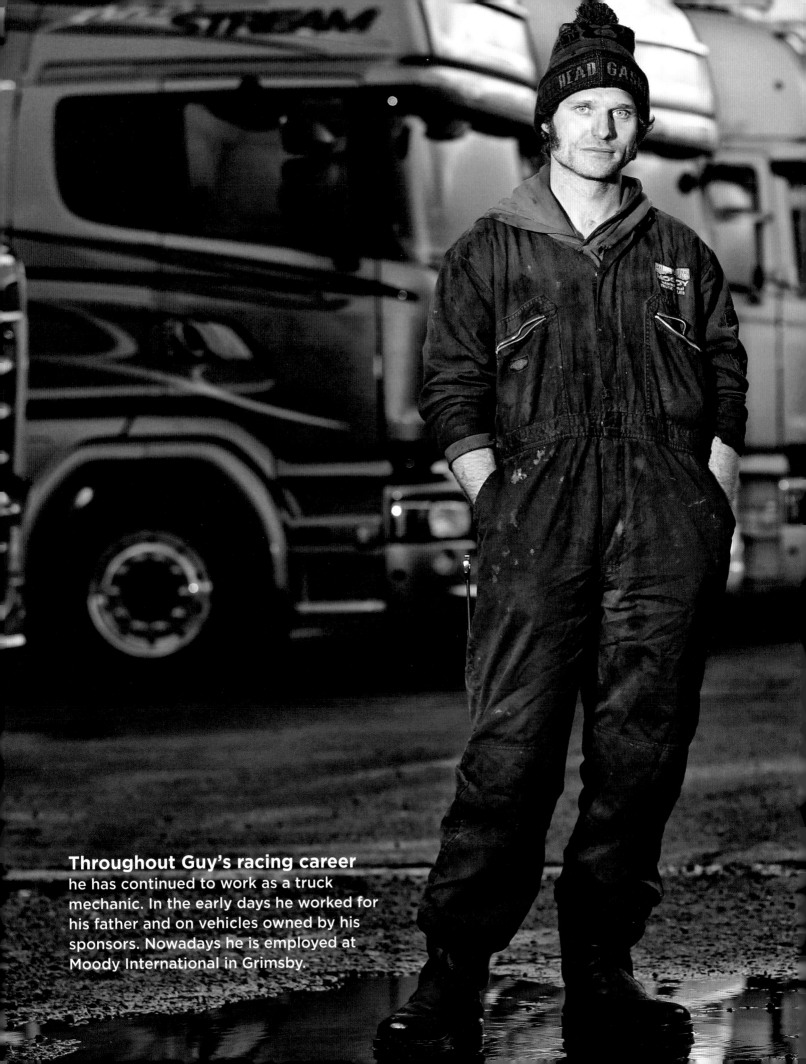

Throughout Guy's racing career he has continued to work as a truck mechanic. In the early days he worked for his father and on vehicles owned by his sponsors. Nowadays he is employed at Moody International in Grimsby.

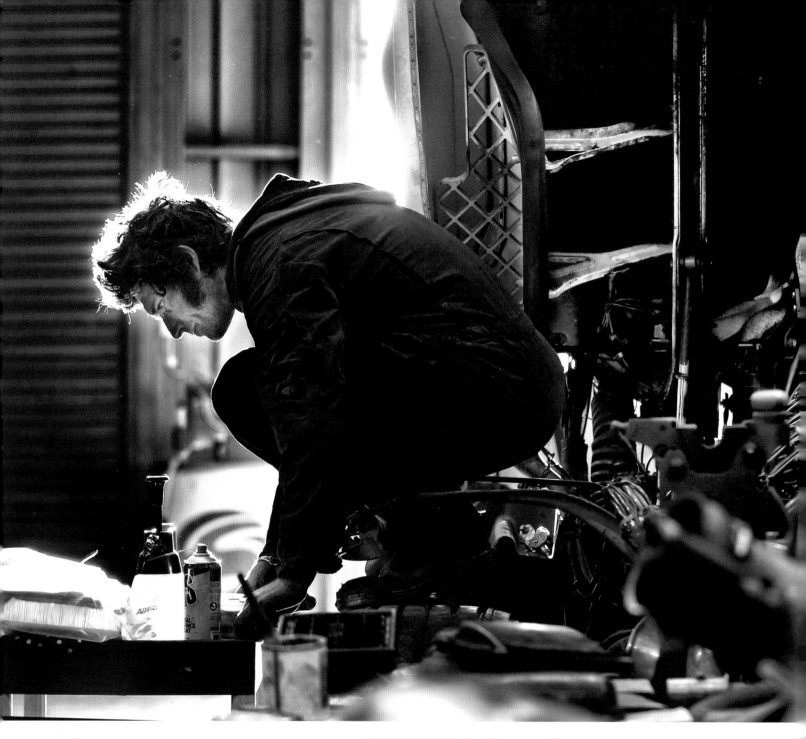

Given his income from racing, and the television contracts Guy enjoys, it is unlikely he needs to work as a truck mechanic to make a living. Guy says it is something he has always done and feels it is important to have a 'proper job' away from motorbikes.

He has an encyclopaedic knowledge of almost every make and model of truck, and can easily quote specifications and part numbers of the vehicles he works on.

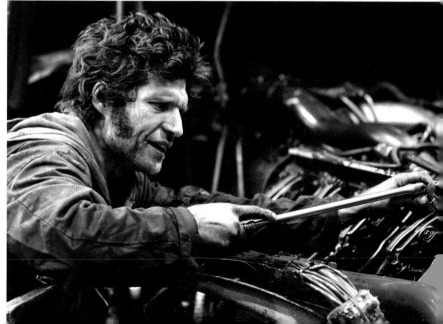

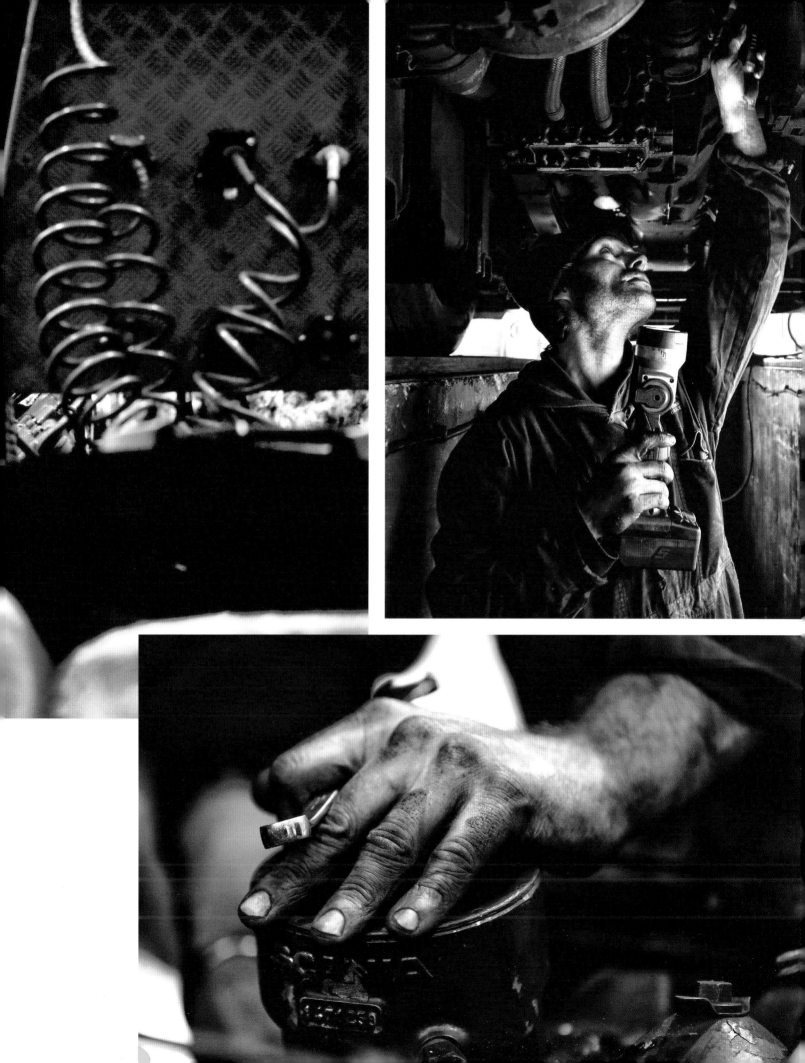

THE COURSE

BALLAU

BUNG

KIRK MICHAEL

Ⓖ
GLEN HELEN

CREG
NA
BAA

BALLIG BRIDGE
LAUREL BANK BALLACRAINE

KEPP
GAT

START

CROSBY

UNION MILLS

GOV. BRIDGE

6TH

QR.BRIDGE

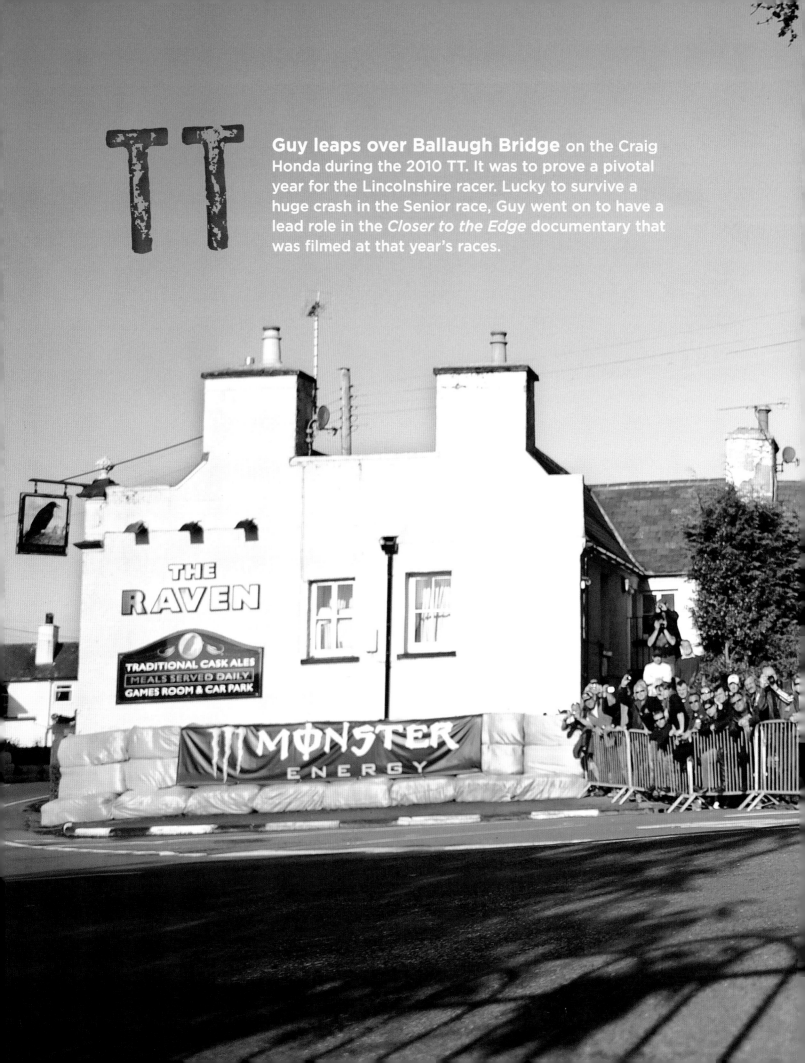

TT

Guy leaps over Ballaugh Bridge on the Craig Honda during the 2010 TT. It was to prove a pivotal year for the Lincolnshire racer. Lucky to survive a huge crash in the Senior race, Guy went on to have a lead role in the *Closer to the Edge* documentary that was filmed at that year's races.

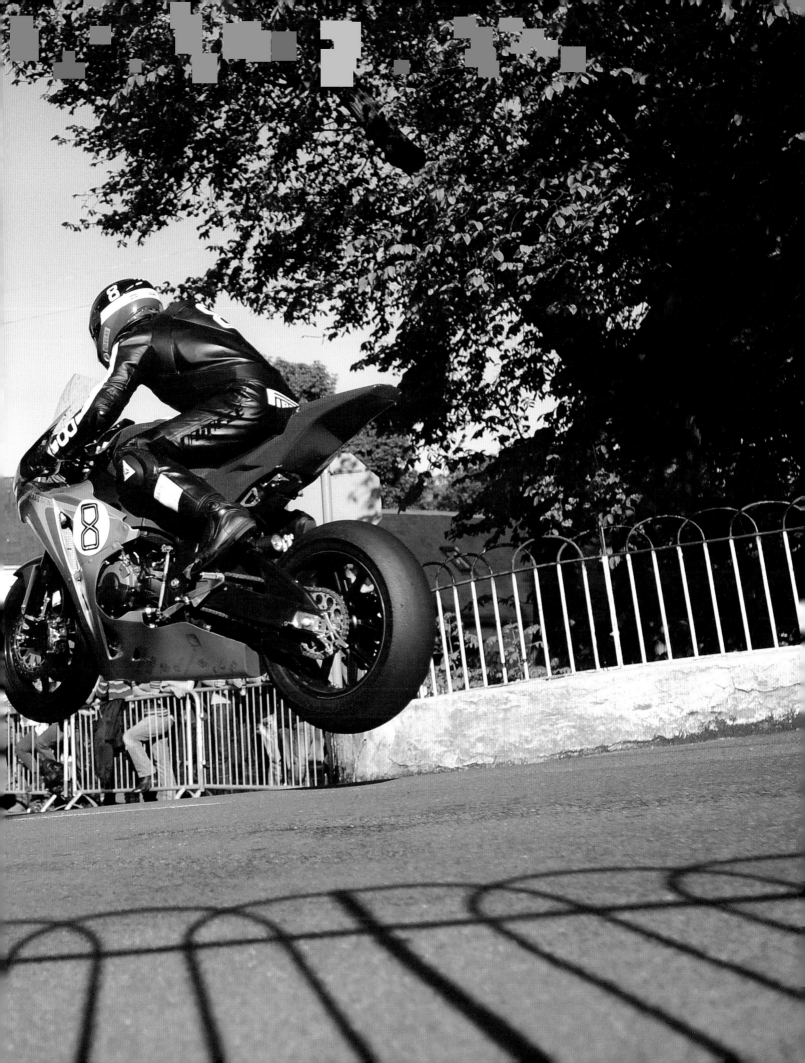

Guy clutches a silver replica after the prize-giving at TT 2004.

'Guy wasn't daunted by the opposition,' Uel Duncan recalls of his young protégé. 'He was good at learning the circuit and was very naturally gifted. I sometimes thought that if he hadn't been such a natural he would've been forced to plan his approach more, which might not have been such a bad thing.'

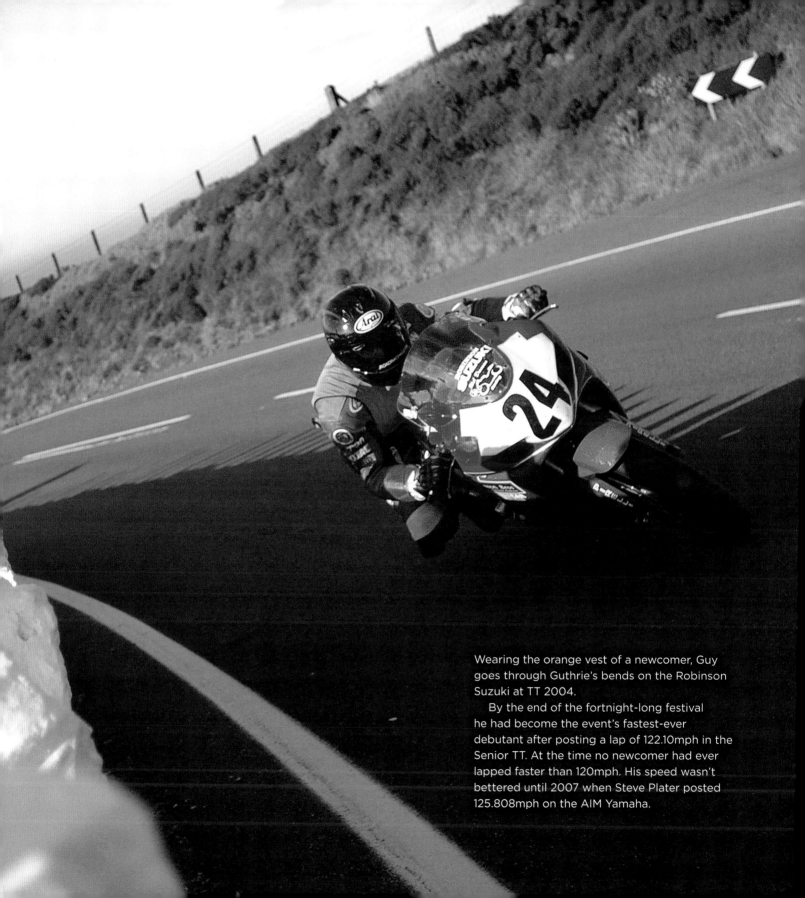

Wearing the orange vest of a newcomer, Guy goes through Guthrie's bends on the Robinson Suzuki at TT 2004.

By the end of the fortnight-long festival he had become the event's fastest-ever debutant after posting a lap of 122.10mph in the Senior TT. At the time no newcomer had ever lapped faster than 120mph. His speed wasn't bettered until 2007 when Steve Plater posted 125.808mph on the AIM Yamaha.

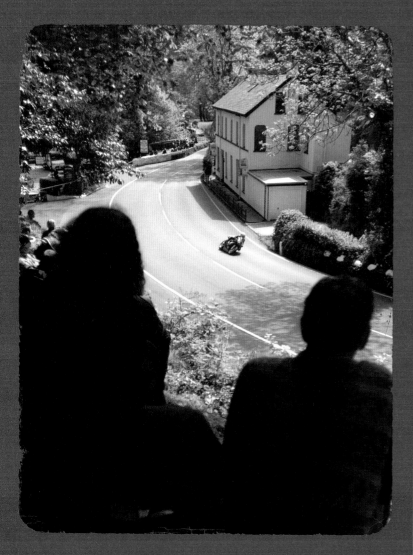

Guy cranks the AIM Yamaha R1 through Glen Helen on his way to a fourth-place finish in the Superstock race, his best performance in 2006.

A lack of track time for both Guy and the AIM machines was blamed for his disappointing performances. It was the beginning of a familiar cycle of post-mortem examinations of TTs that didn't quite live up to expectations.

Climbing the mountain at Tower Bends, 2006. This was supposed to be a breakthrough TT year for Guy after he joined AIM Yamaha but niggling oil leaks made it a frustrating week.

'He was fast but he broke down a lot' is how Paul Phillips remembers Guy's 2006 TT. Guy retired from the Superbike race and finished fifth in the Senior.

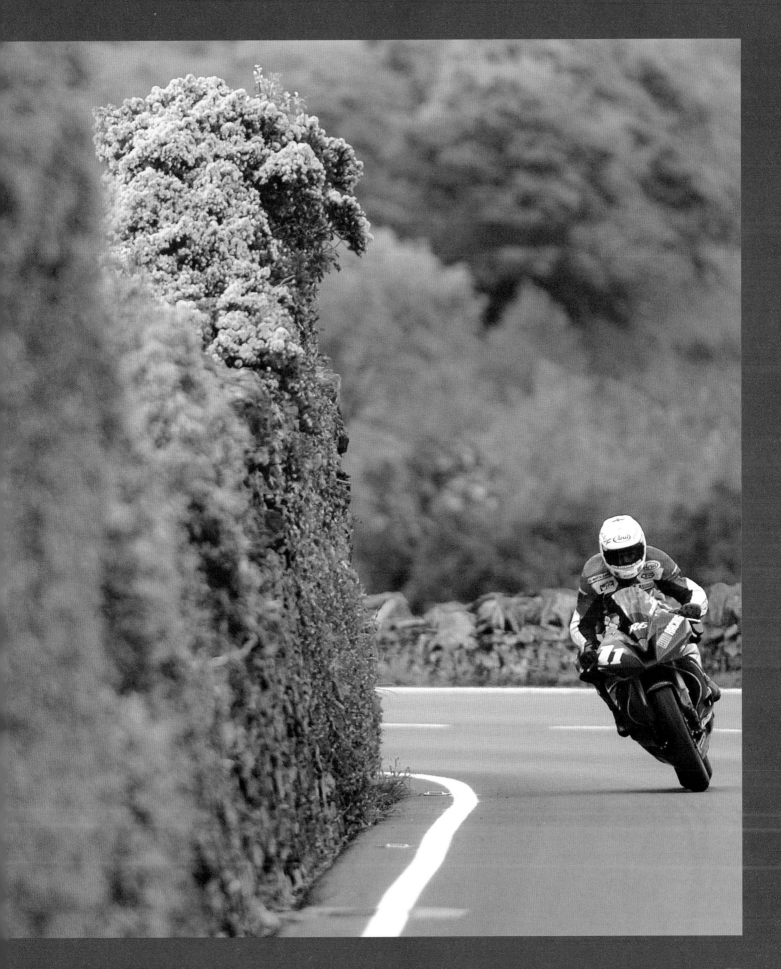

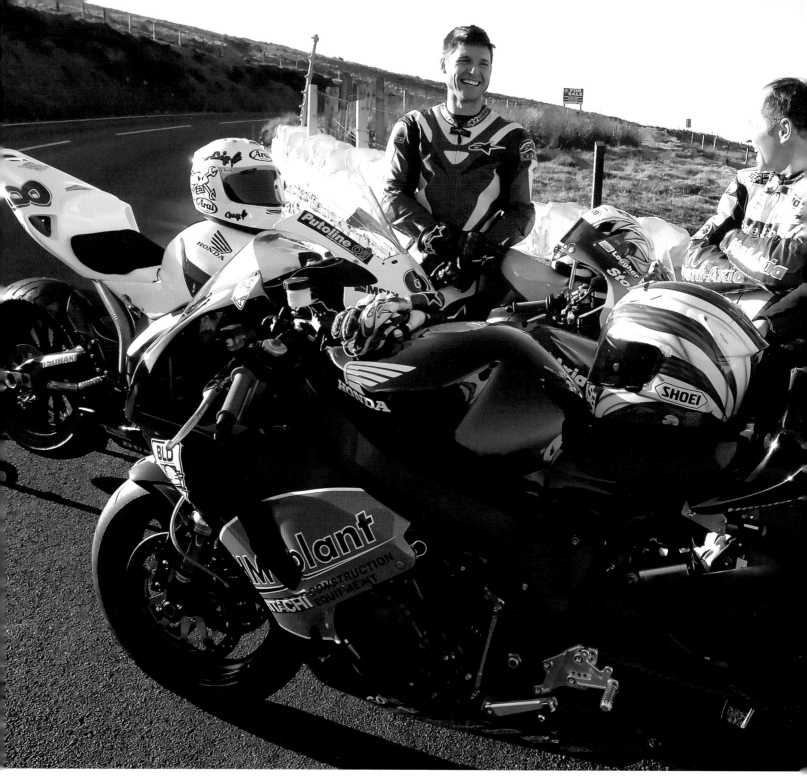

Guy joined Shaun Muir's Hydrex Honda squad for 2007, the TT's centenary year. He was now mounted on similar machinery to that of his principal rivals, Ian Lougher and John McGuinness, whom he is pictured with here during a TT launch event on the Mountain.

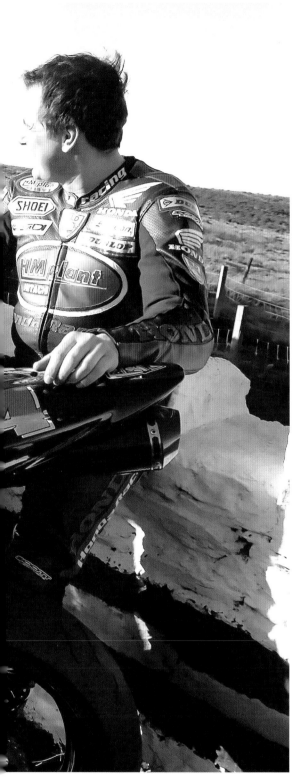

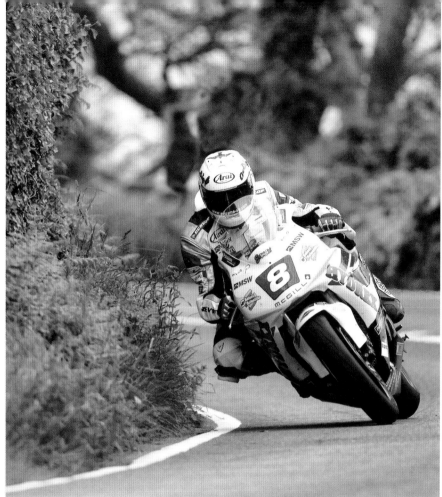

Guy brushes the grass as he climbs up the mountain from Waterworks on the Hydrex Honda during a TT 2007 practice session.

Muir provided Guy with a season of British Superbike championship racing alongside teammate, Karl Harris, to help Guy hone his speed. His TT results showed an immediate improvement with runner-up finishes in both the Superbike and Senior races.

Guy wheelies along the mountain road with McGuinness and Lougher during the Centenary TT launch.

Those seeking an explanation for Guy's inability to win a TT race have pointed to his misfortune at having to face John McGuinness at the height of the Morecambe man's powers.

McGuinness is second only to the late Joey Dunlop in the all-time TT winners' list with 23 victories to the Irishman's 26.

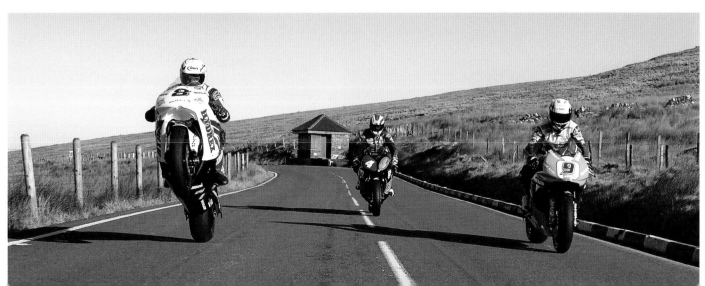

Guy was injured when he arrived at TT 2008 after a huge crash in the Supersport race at Black Hill during the North West 200. He took to the waters of Peel for an early morning swim to help ease the pain of his badly bruised back.

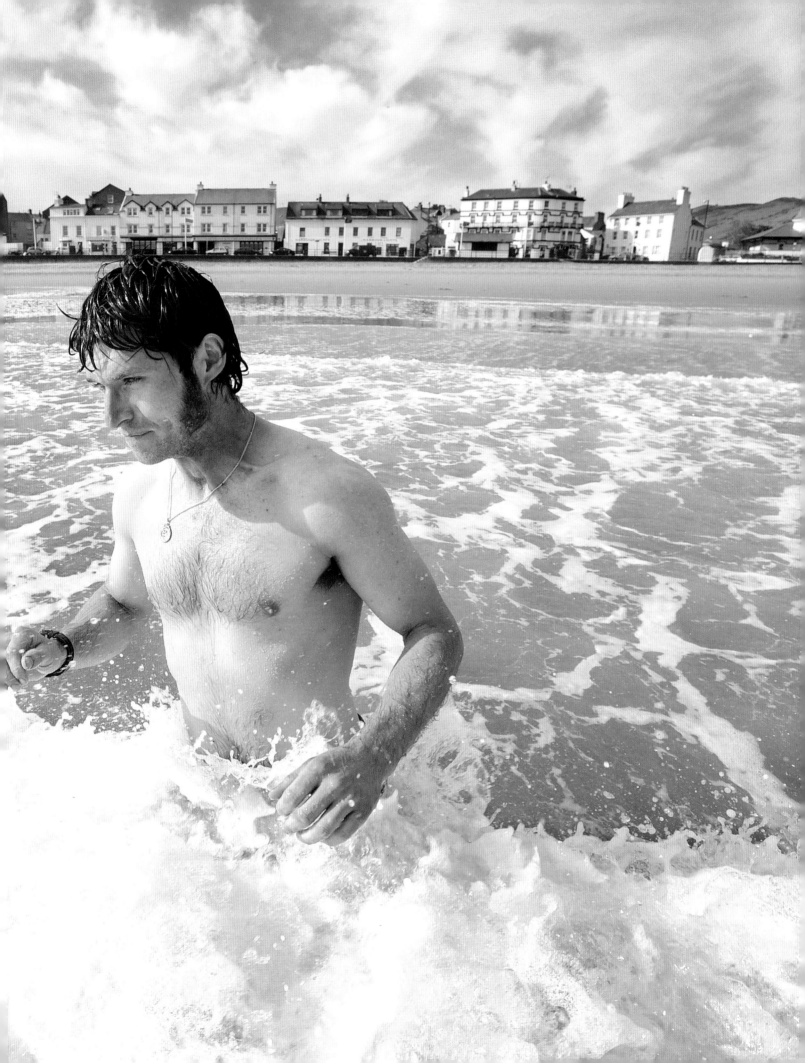

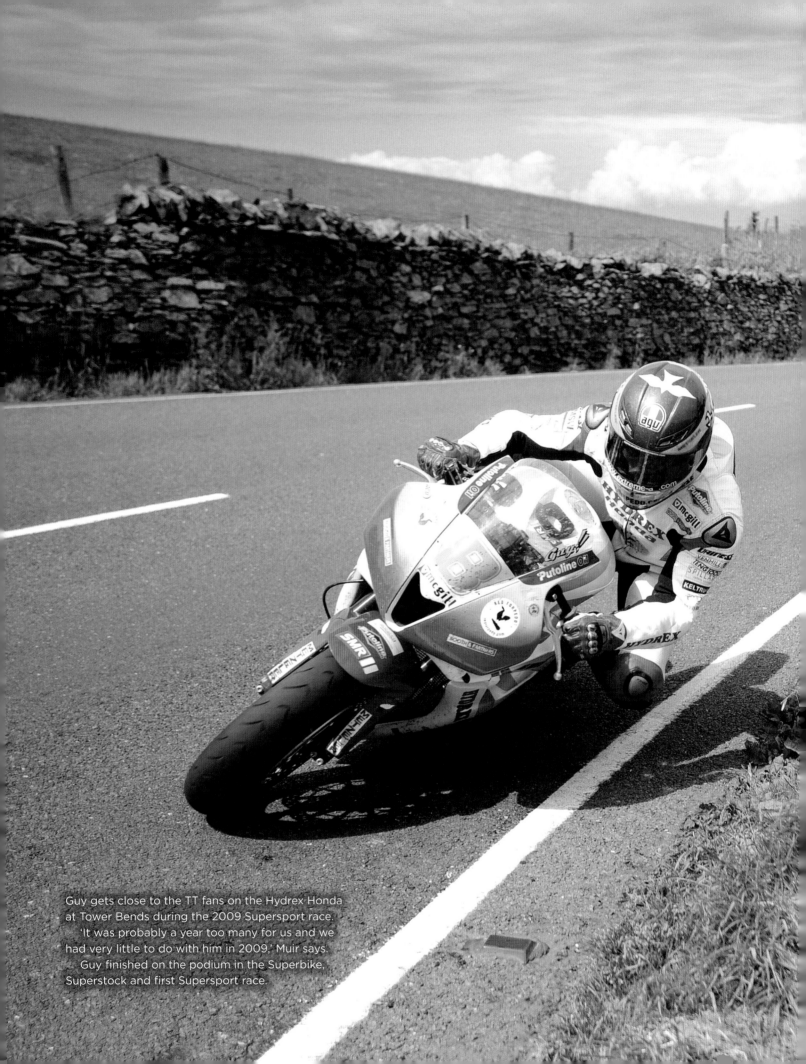

Guy gets close to the TT fans on the Hydrex Honda at Tower Bends during the 2009 Supersport race. 'It was probably a year too many for us and we had very little to do with him in 2009.' Muir says. Guy finished on the podium in the Superbike, Superstock and first Supersport race.

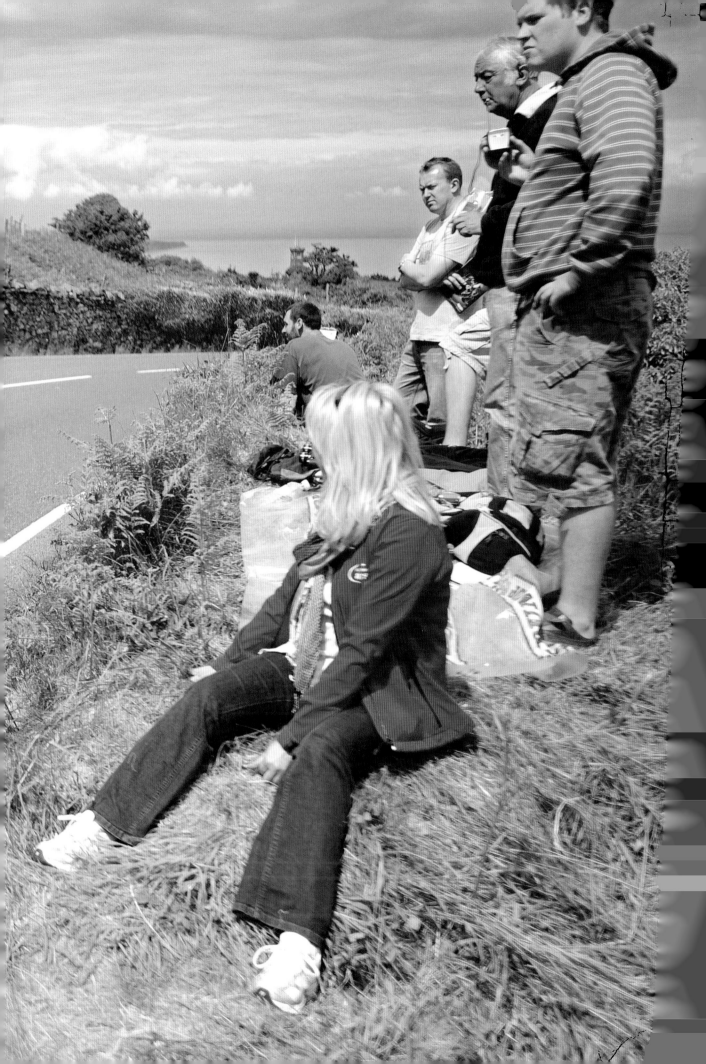

MotoGP star Valentino Rossi visited the TT in 2009 and shared a press conference with Guy. The Lincolnshire man tried to explain his technique of riding the TT course but something appeared to get lost in translation for the Italian. Eventually, though, everything became clear!

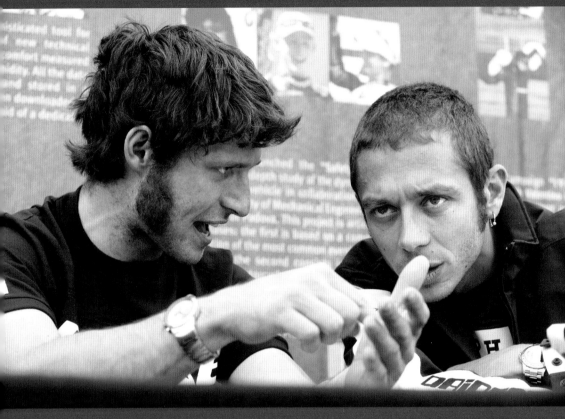

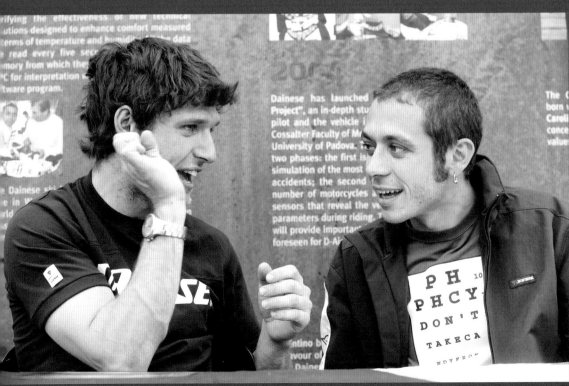

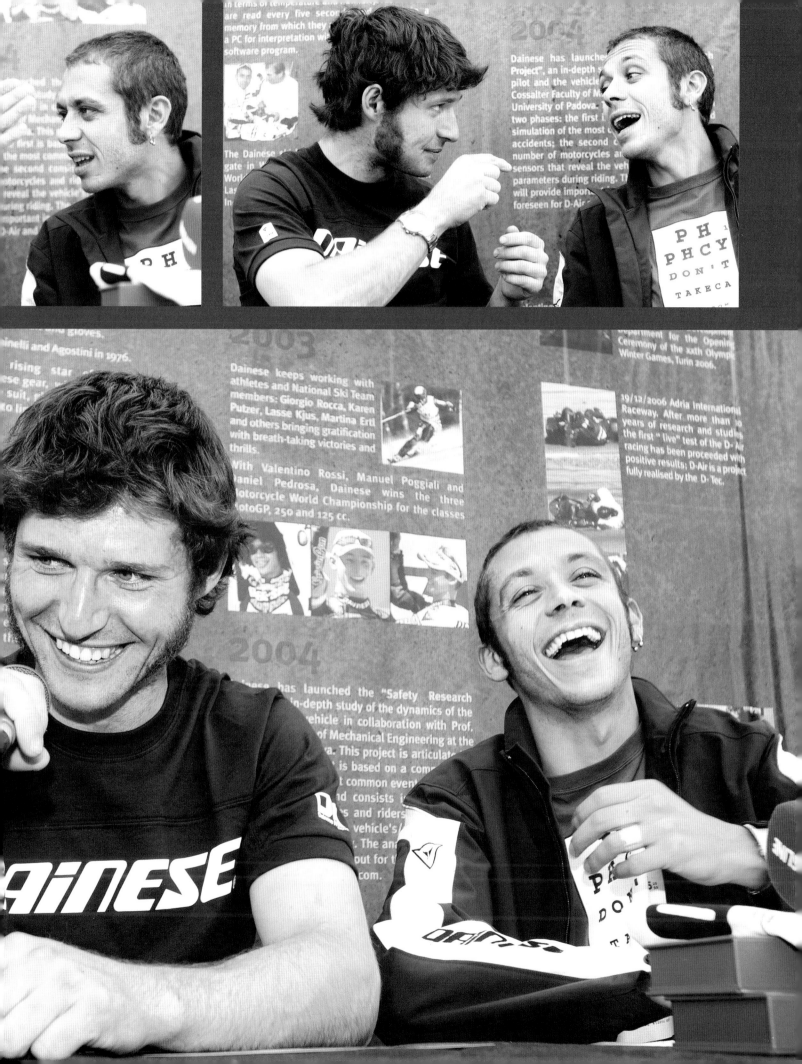

After racing for big professional race teams, Guy established his own approach in 2010. Riding retro-liveried Wilson Craig Hondas, he wore traditional black leathers in a throwback to the sixties.

Guy skims through Creg-Ny-Baa during the 2010 Superbike TT on the Craig Honda. He finished fourth after receiving a time penalty for speeding in the pit lane.

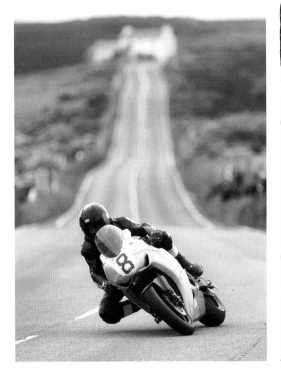

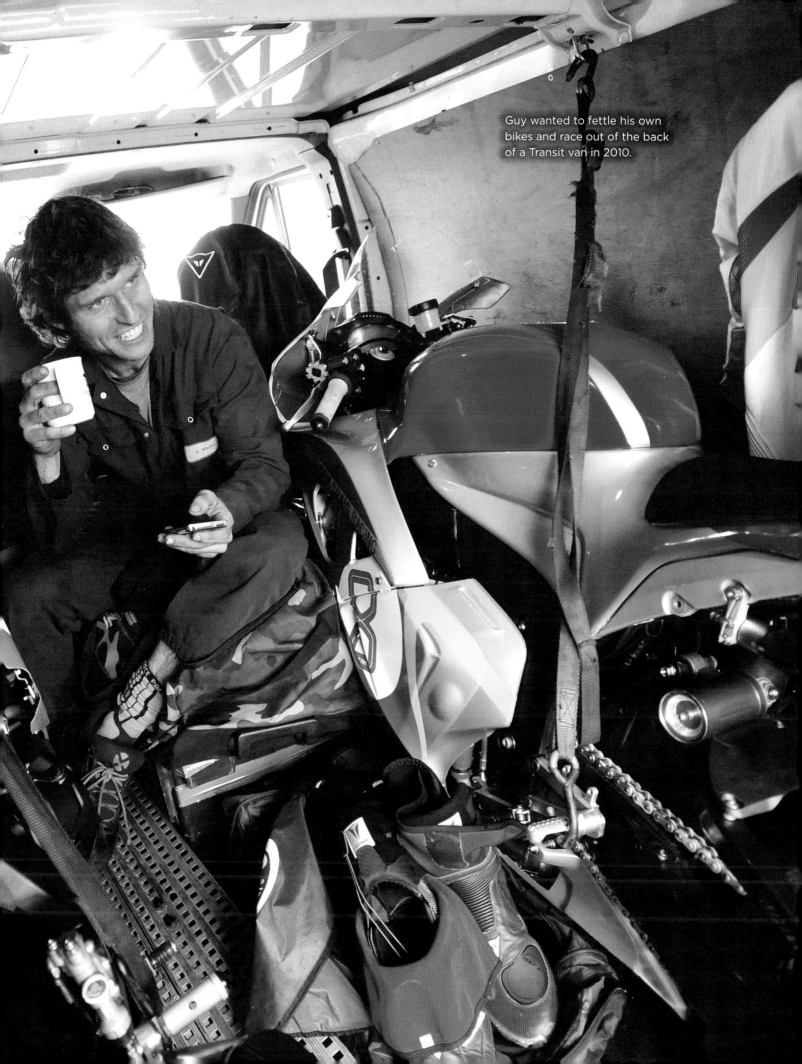

Guy wanted to fettle his own bikes and race out of the back of a Transit van in 2010.

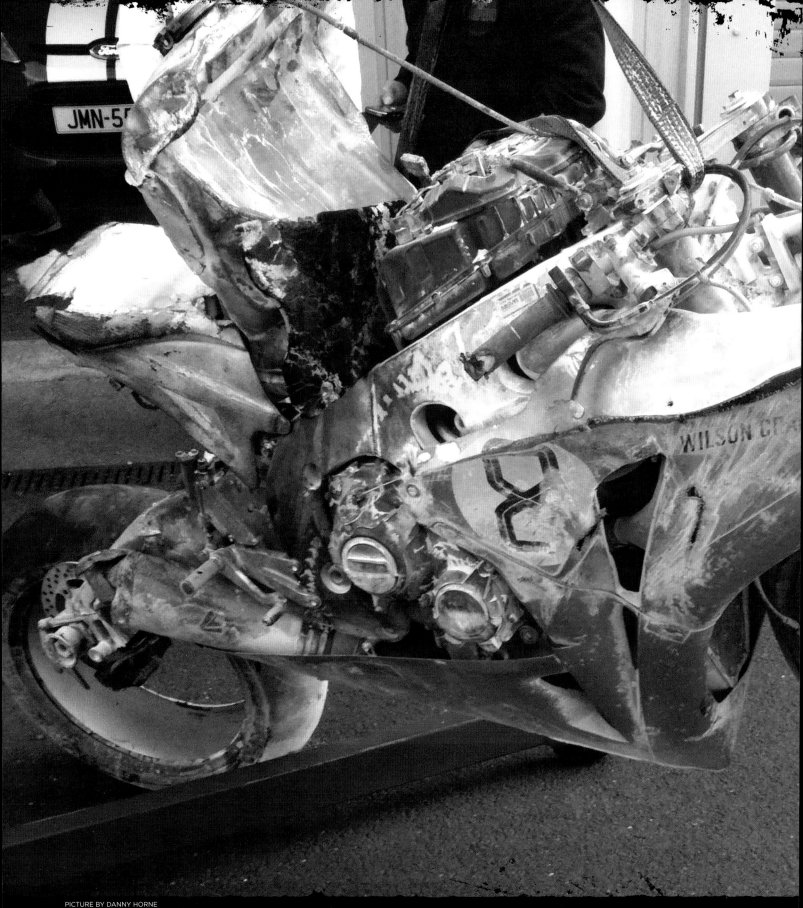

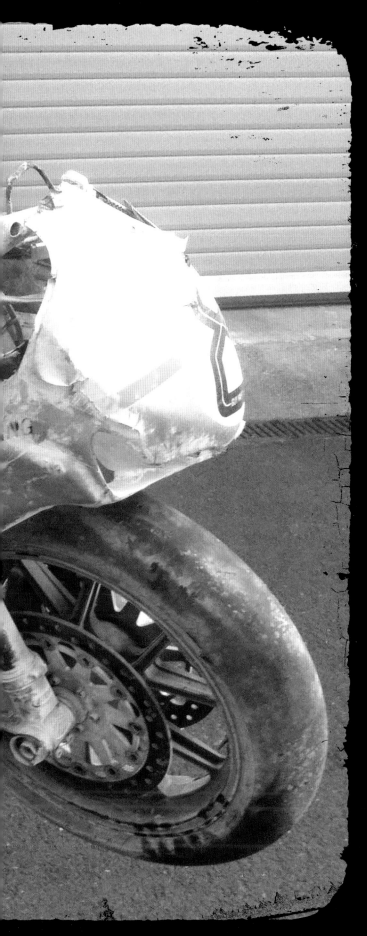

If there is a single defining point in Guy Martin's motorcycle racing career it is his huge crash during the Senior TT in 2010.

Losing the front end of his Craig Honda at over 150mph at Ballagarey on the third lap of the race, Guy miraculously escaped without serious injury. Only twenty-four hours previously, Paul Dobbs had died when he crashed at the same place.

The charred remains of Guy's Craig Honda tell their own tale. For the director of the *Closer to Edge* film, Richard De Aragues, there could have been no better depiction of the risks road racers face. The crash placed Guy at the centre of the film's narrative as a daredevil racer who had cheated death in his pursuit of TT glory.

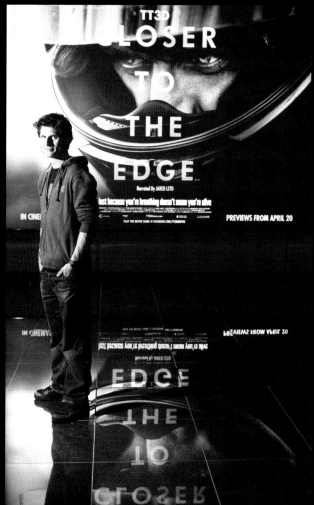

Guy at the premiere of *Closer to the Edge* in London in 2011. His lead role saw Guy become the highest profile British motorcycle racer since Barry Sheene.

Closer to the Edge also launched Guy's parallel career as a television presenter. Over the next few years 'the TV job', as he called it, would see him front a series of popular programmes such as *The Boat That Guy Built*, *Speed* and *Our Guy in China*.

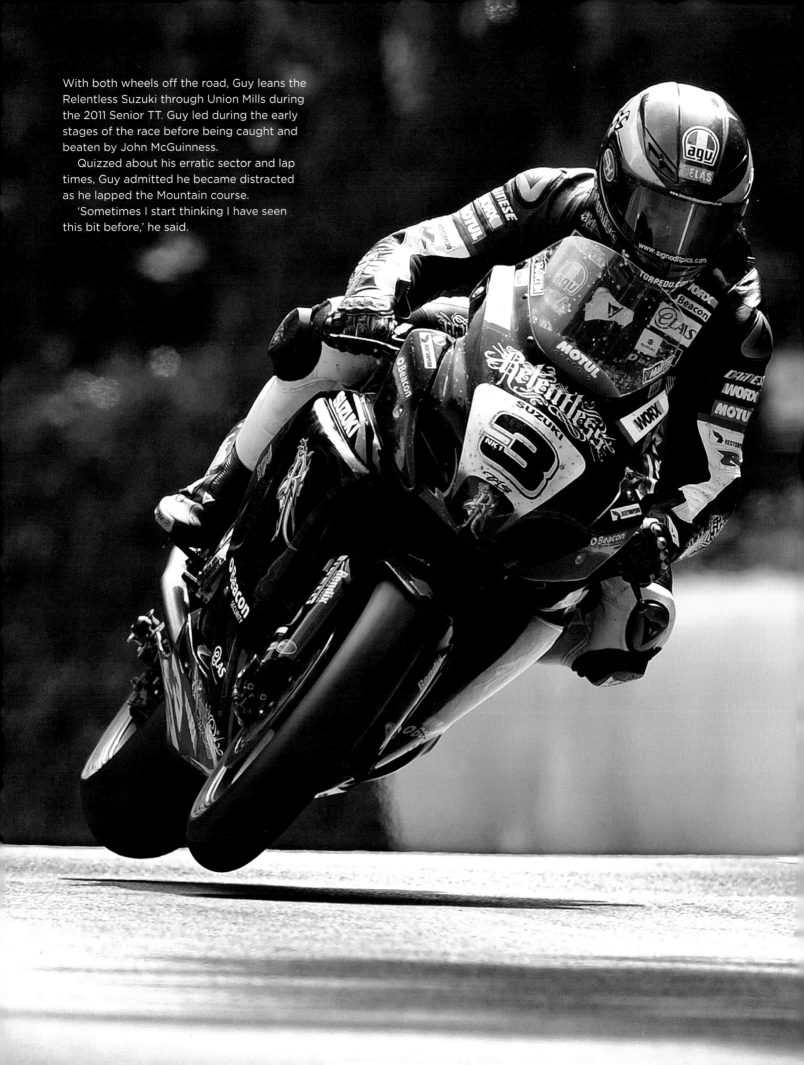

With both wheels off the road, Guy leans the Relentless Suzuki through Union Mills during the 2011 Senior TT. Guy led during the early stages of the race before being caught and beaten by John McGuinness.

Quizzed about his erratic sector and lap times, Guy admitted he became distracted as he lapped the Mountain course.

'Sometimes I start thinking I have seen this bit before,' he said.

After seven barren years without a TT victory, Guy's results improved on the Relentless Suzuki but that elusive maiden win stubbornly refused to come. A mechanical failure in the 2011 Superbike race was followed by four podium finishes. He must have begun to wonder what he would have to do to get his hands on the famous Winged Mercury trophy.

⌃ Guy was delighted with his sixteenth TT podium in 2015 on the Smiths' Triumph and celebrated with team owners Alan and Rebecca Smith.

⌄ As popular as ever with the TT fans that line the course at places like Tower Bends, Guy races to third in the Supersport race on the Smith's Triumph.

PICTURE BY DAVE KNEEN

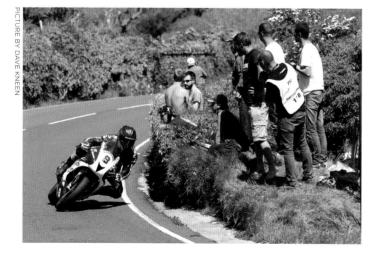

⌃ Guy struggled with the electronics on the BMW, retiring from the 2015 Superbike race and failing to match John McGuinness's lap record pace in the Senior.

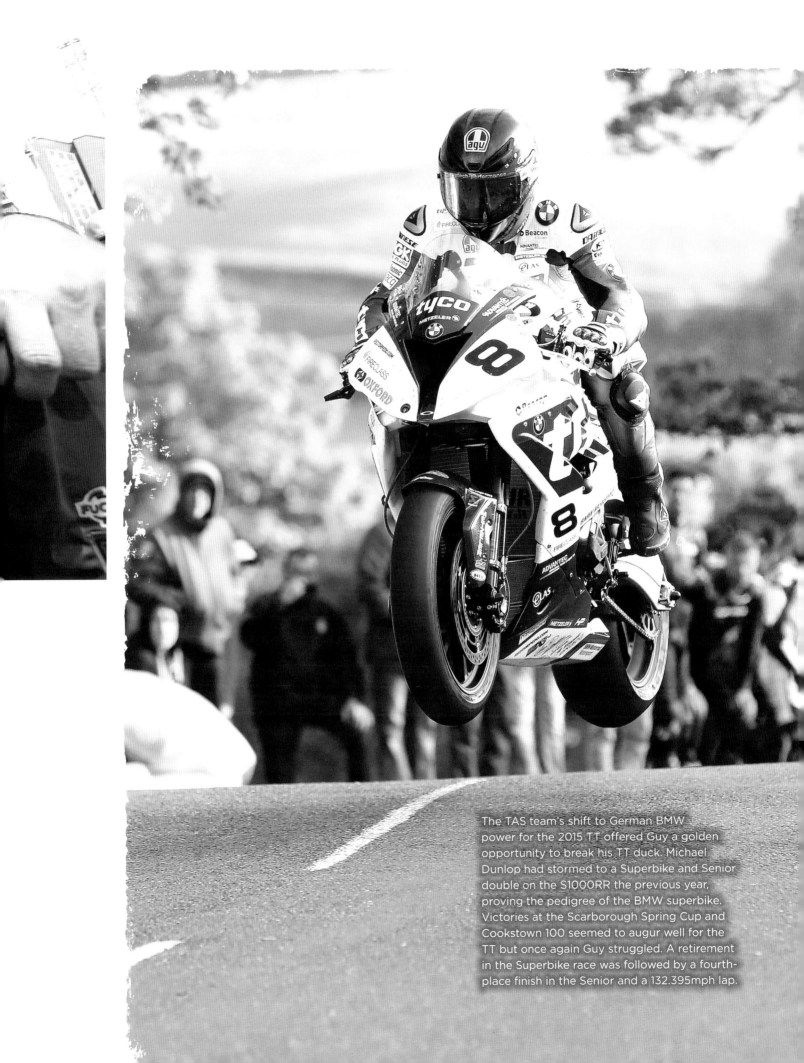

The TAS team's shift to German BMW power for the 2015 TT offered Guy a golden opportunity to break his TT duck. Michael Dunlop had stormed to a Superbike and Senior double on the S1000RR the previous year, proving the pedigree of the BMW superbike. Victories at the Scarborough Spring Cup and Cookstown 100 seemed to augur well for the TT but once again Guy struggled. A retirement in the Superbike race was followed by a fourth-place finish in the Senior and a 132.395mph lap.

All smiles after making his first visit to the winner's enclosure after finishing third behind runner-up, Ian Lougher, and winner, John McGuinness, in the 2005 Senior TT.

Guy entertains Valentino Rossi, Giacomo Agostini, Steve Plater and John McGuinness on the 2009 Superbike TT podium.

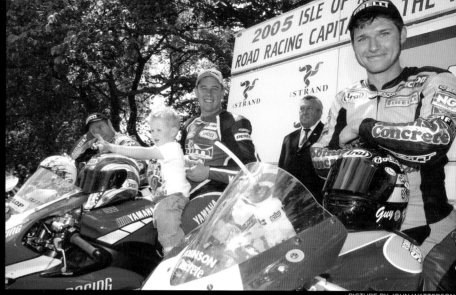

PICTURE BY JOHN WATTERSON

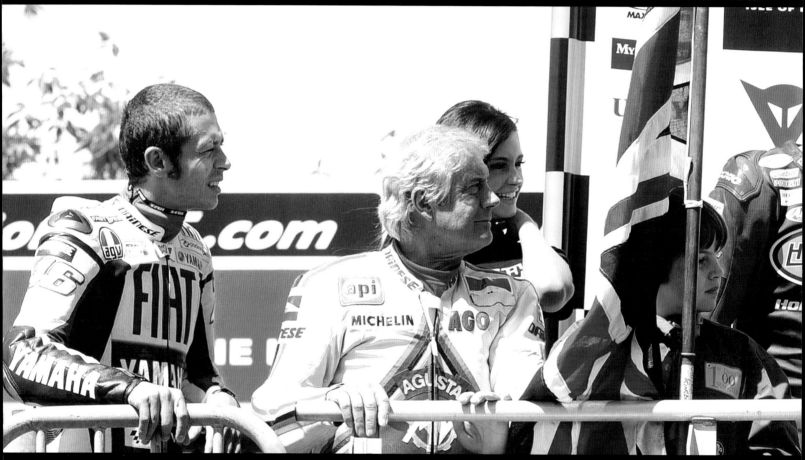

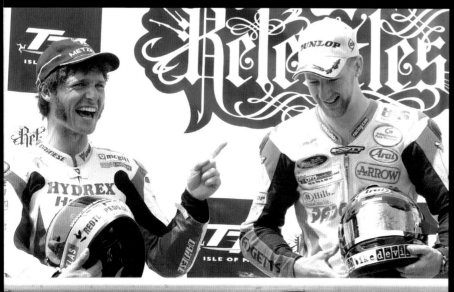

Sharing a joke with winner, Ian Hutchinson, in 2009.

Losing an ice cream fight to John McGuinness in the 2011 Senior TT press conference.

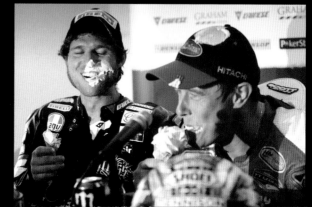

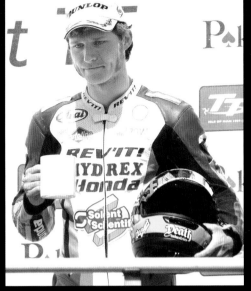

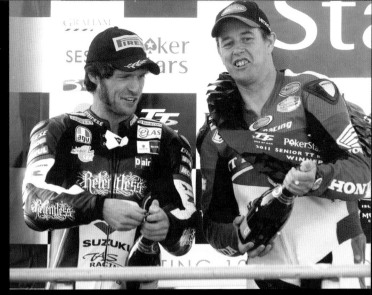

Lost in thought with a cuppa on the podium in 2007.

Getting ready to spray the champagne with John McGuinness after the 2011 Senior.

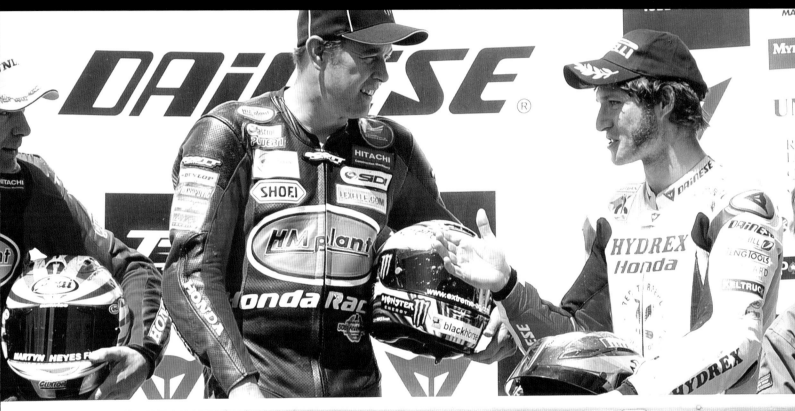

A hair-raising moment after finishing third in the Supersport TT in 2015.

'V' for second in the Zero TT on the Mugen Shinden in 2017.

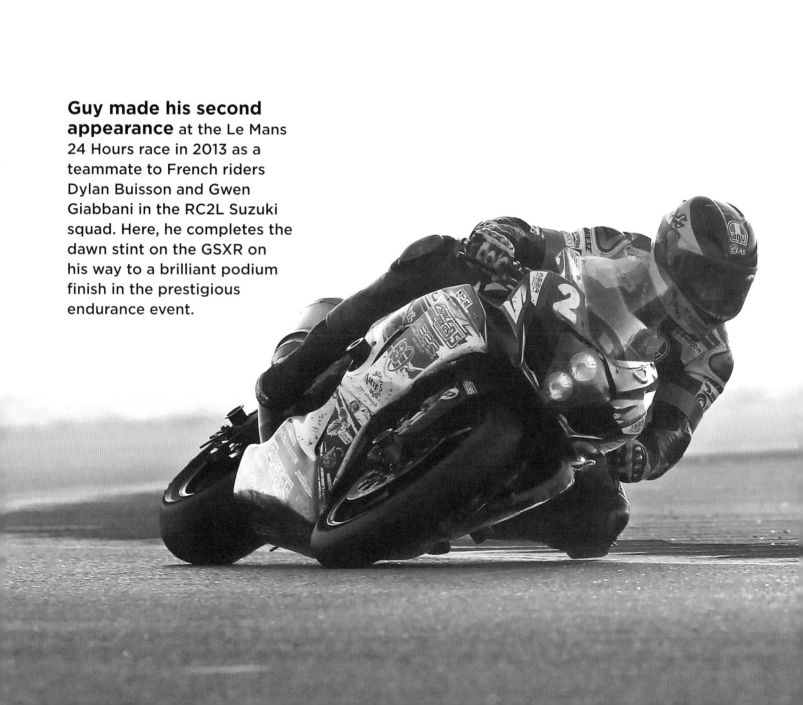

Guy made his second appearance at the Le Mans 24 Hours race in 2013 as a teammate to French riders Dylan Buisson and Gwen Giabbani in the RC2L Suzuki squad. Here, he completes the dawn stint on the GSXR on his way to a brilliant podium finish in the prestigious endurance event.

LE MANS

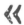

A physiotherapist treats Guy between riding sessions at Le Mans. The racers are given massages and stretches to help them stay supple during the gruelling event.

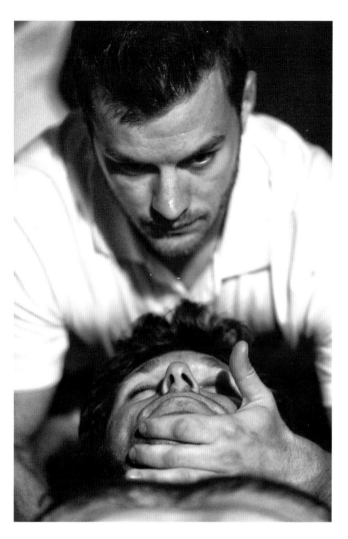

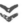

Guy takes over on the Suzuki after a refuelling stop. The team's rider rota meant he was earmarked to ride the final 2013 stint and he felt the pressure.

'This was going to be the best result the team had ever had so I didn't want to make any mistakes,' Guy said. 'If I had fallen off I would never have been allowed back into France!'

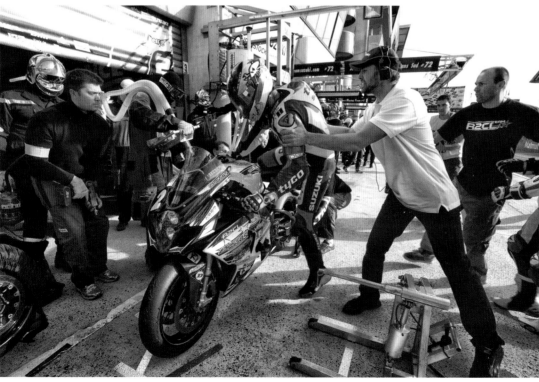

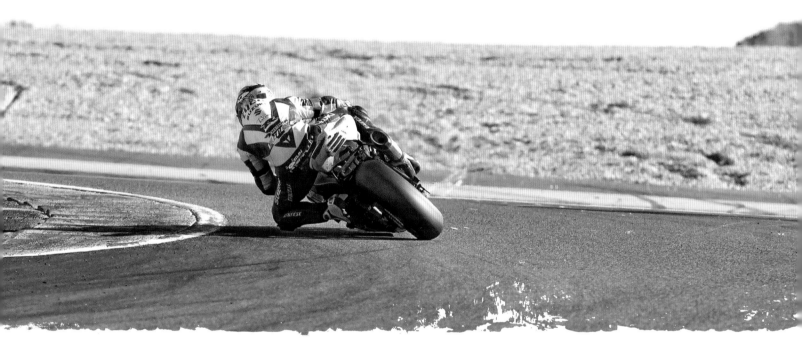

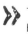 Guy cranks the Suzuki under the famous Dunlop Bridge at Le Mans.

Curious and enthusiastic about attempting all kinds of racing challenges, Guy has ridden his own hand-built turbocharged Suzuki at the famous Pikes Peak hill climb in Colorado and competed on the streets of Whanganui in New Zealand alongside forays into endurance racing at venues like Spa and Le Mans.

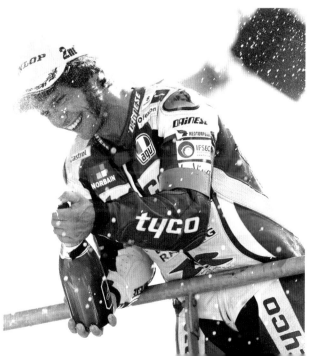

The RC2L Suzuki team is a privately-run affair and Guy and his French teammates were delighted to finish Le Mans as runners-up behind Team SRC Kawasaki trio Gregory Leblanc, Fabien Foret and Nicolas Salchaud. Guy had raced previously at Le Mans in 2007 but the bike failed to finish.

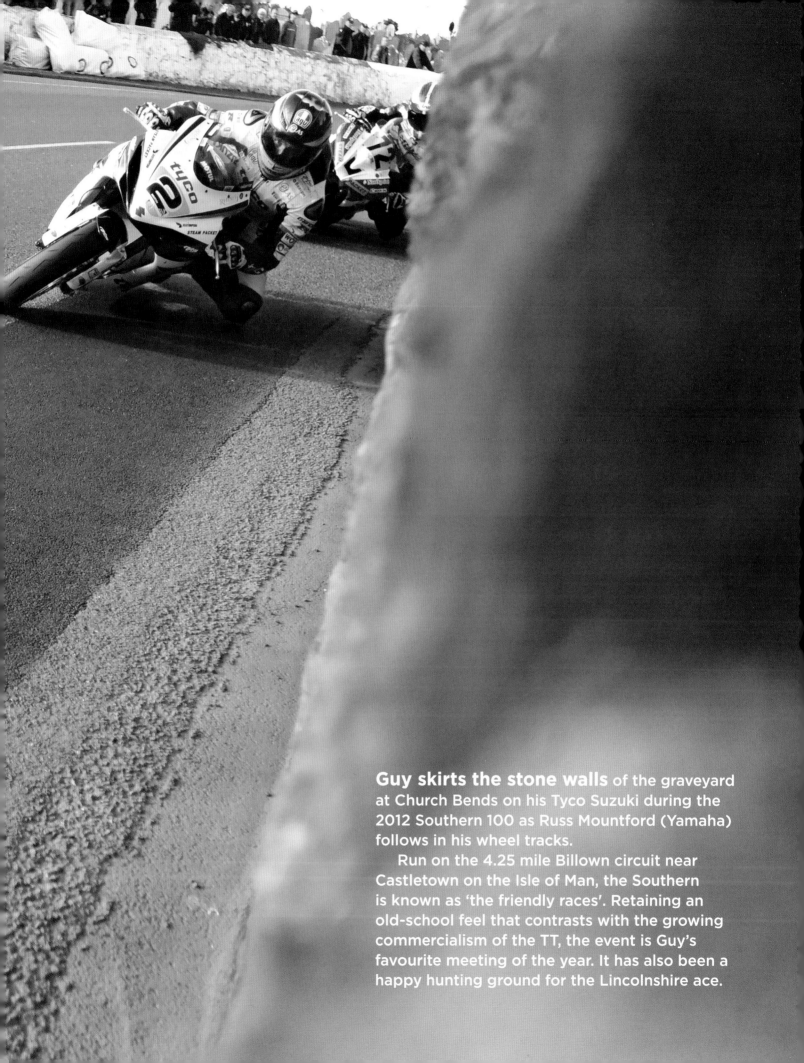

Guy skirts the stone walls of the graveyard at Church Bends on his Tyco Suzuki during the 2012 Southern 100 as Russ Mountford (Yamaha) follows in his wheel tracks.

Run on the 4.25 mile Billown circuit near Castletown on the Isle of Man, the Southern is known as 'the friendly races'. Retaining an old-school feel that contrasts with the growing commercialism of the TT, the event is Guy's favourite meeting of the year. It has also been a happy hunting ground for the Lincolnshire ace.

Approaching Ballanorris during a wet and misty practice session, Guy makes his Billown debut on the TEAM Racing Suzuki in 2003. Battling with Ryan Farquhar on the opening lap of the Solo championship race, Guy crashed and broke his ankle at Iron Gate.

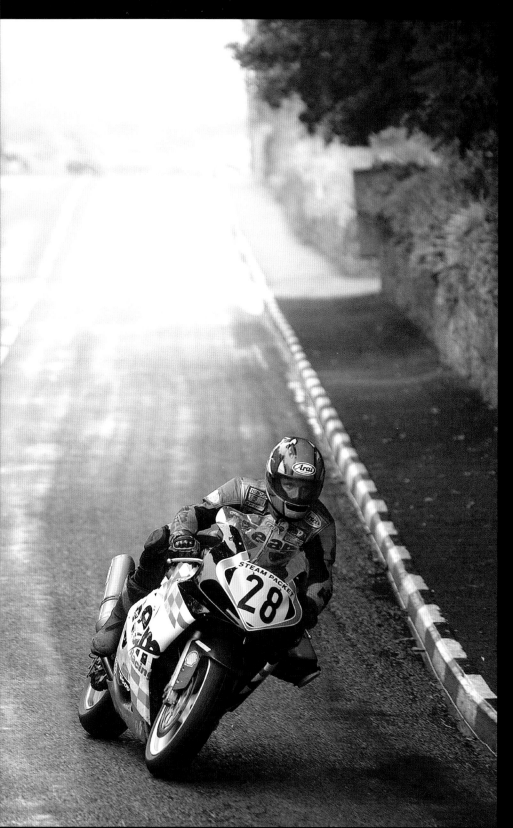

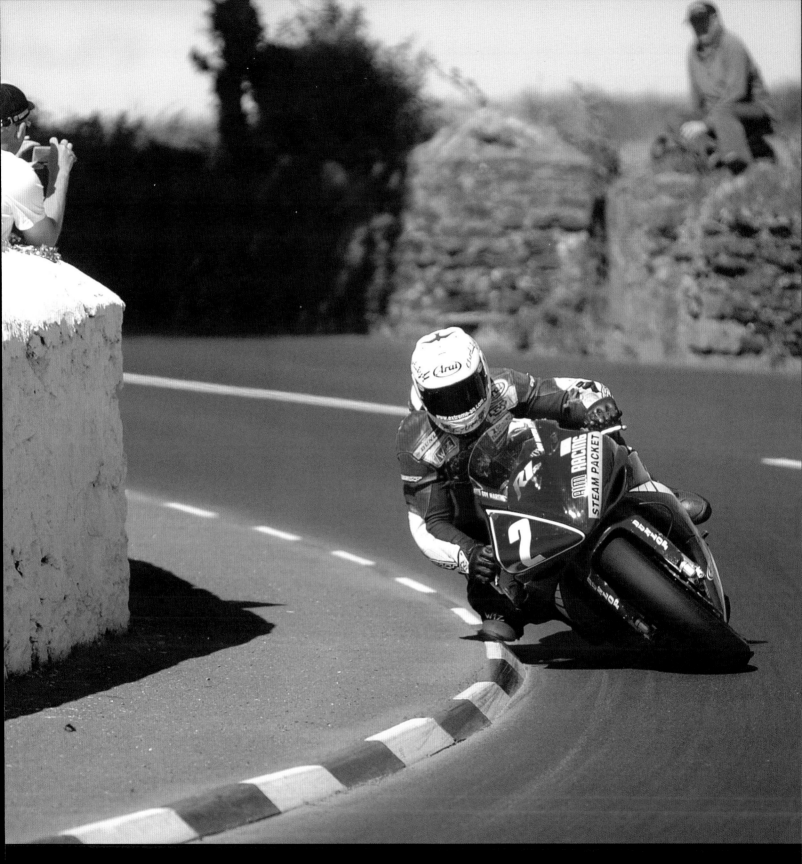

With his knee firmly planted on the kerb, Guy rounds Church Bends
on the AIM Yamaha at the 2006 Southern. Guy won his first race at

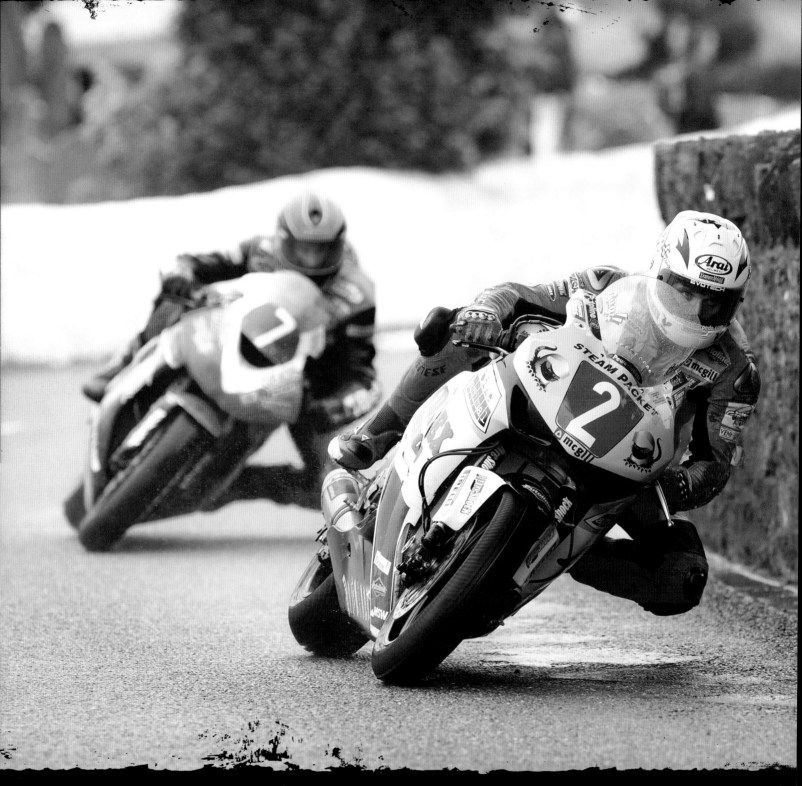

Riding the Hydrex Honda in 2008, Guy leads Ryan Farquhar (KMR Kawasaki) through a damp Church Bends in 2008.

With leading riders like John McGuinness, Bruce Anstey and Ian Hutchinson choosing not to race at the Southern 100, the event doesn't enjoy the same status as the North West 200 or the TT. Nevertheless, Guy has provocatively claimed the TT is 'only a warm-up for the Southern'.

During the 2008 season Guy's sister Kate worked as his mechanic.

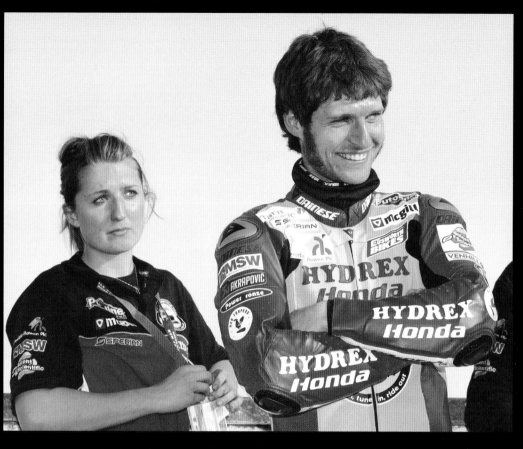

Part of what Guy enjoys about the Southern is the more laid-back feel of the four-day-long event.

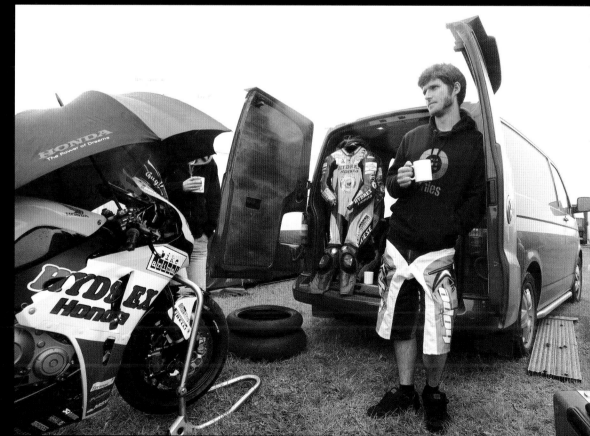

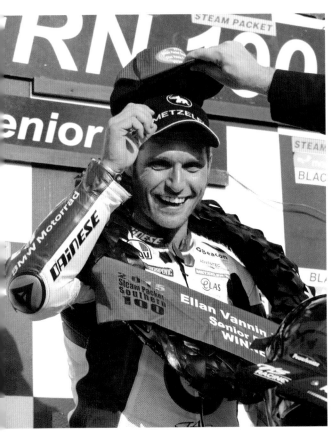

Guy celebrates his 2015 Southern 100 Solo championship success. Throughout Guy's career, disappointing results at the North West 200 and TT have often been followed by brilliant performances at the Southern.

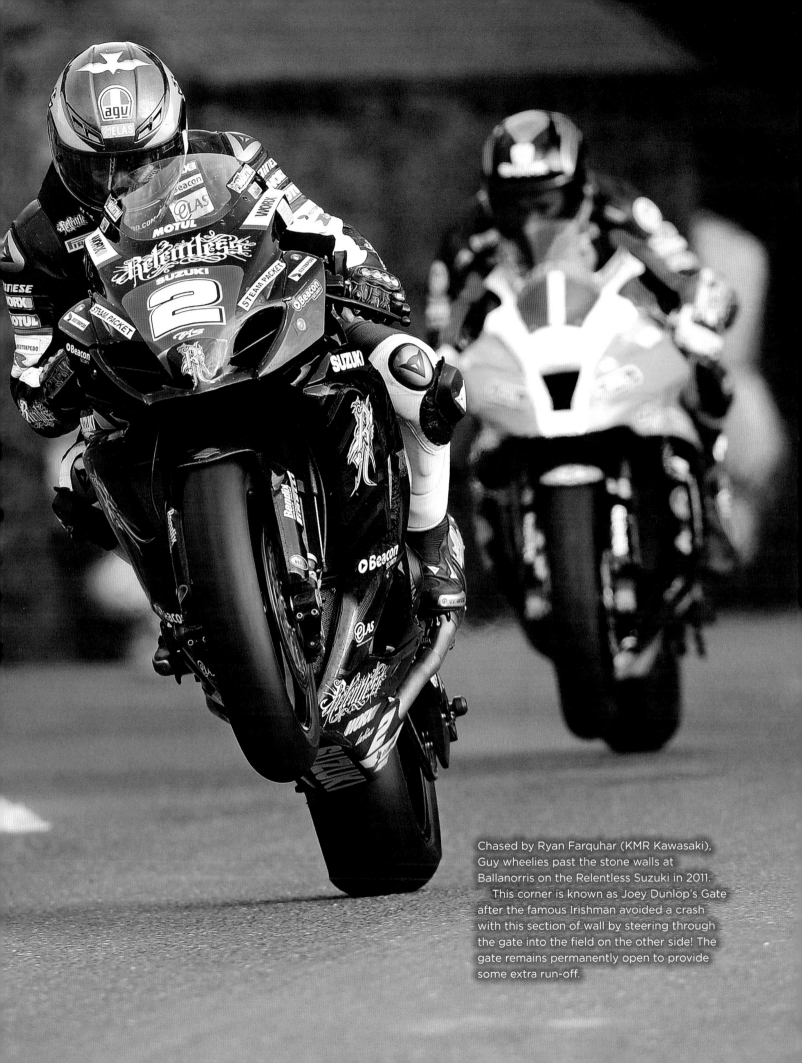

Chased by Ryan Farquhar (KMR Kawasaki), Guy wheelies past the stone walls at Ballanorris on the Relentless Suzuki in 2011.

This corner is known as Joey Dunlop's Gate after the famous Irishman avoided a crash with this section of wall by steering through the gate into the field on the other side! The gate remains permanently open to provide some extra run-off.

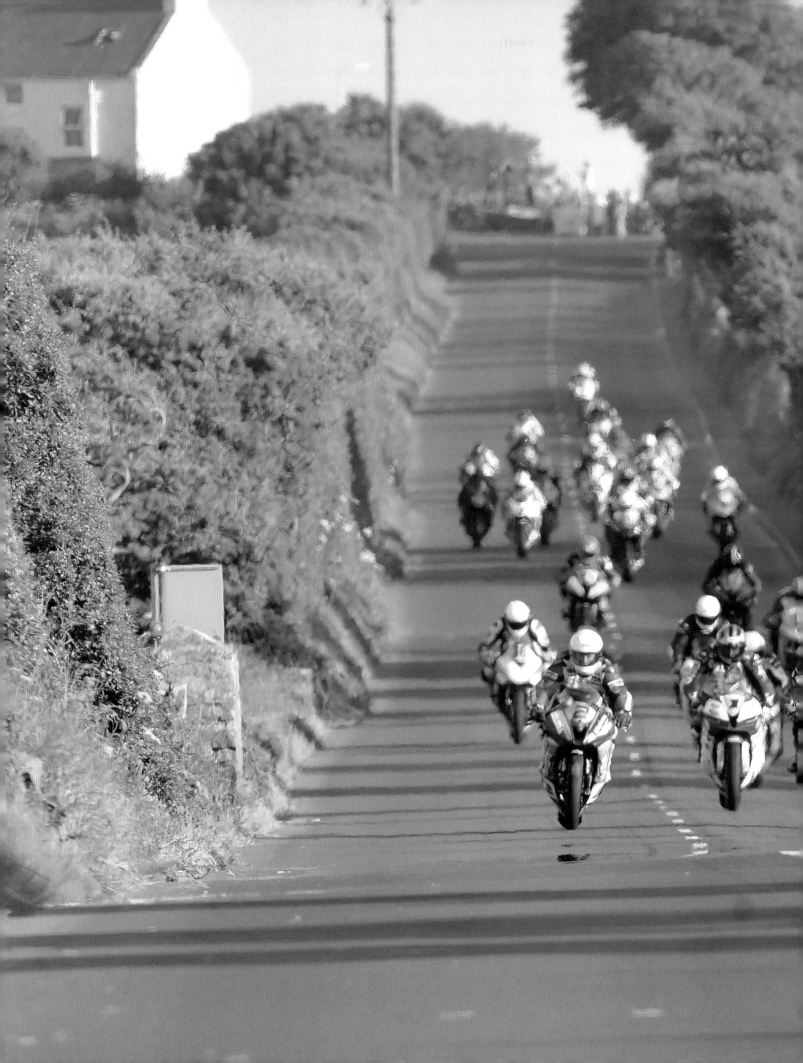

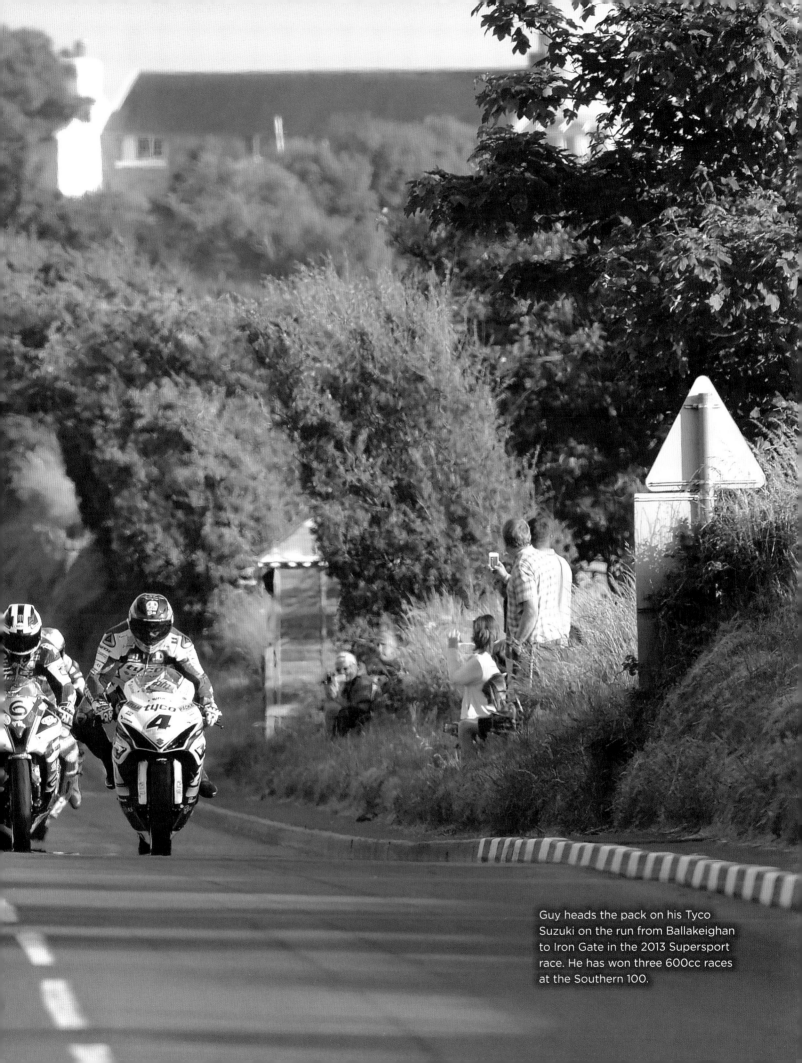

Guy heads the pack on his Tyco Suzuki on the run from Ballakeighan to Iron Gate in the 2013 Supersport race. He has won three 600cc races at the Southern 100.

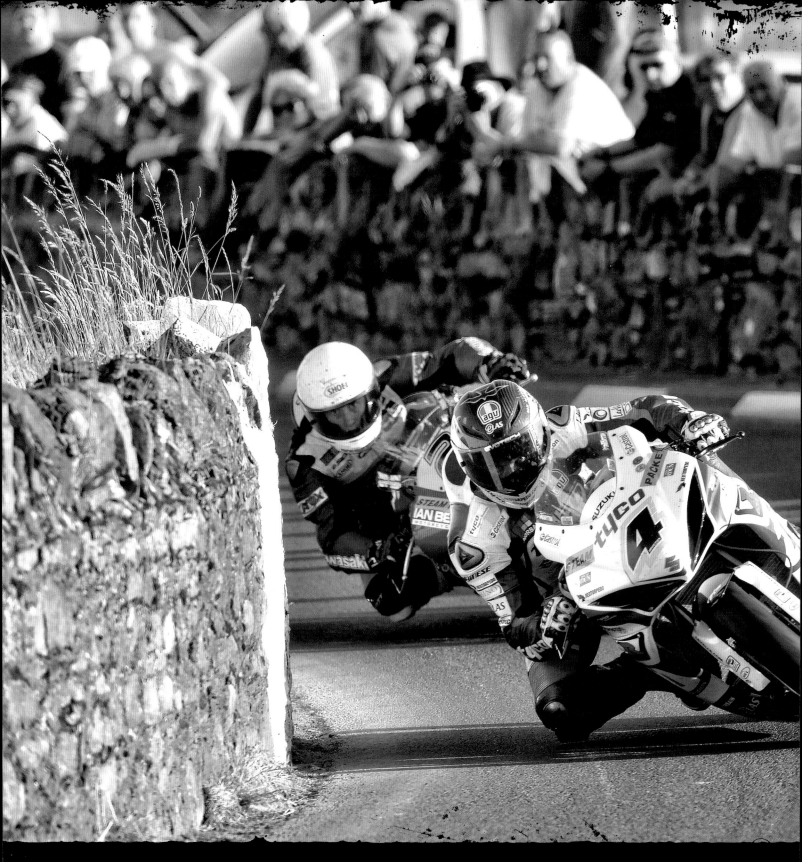

Guy (Tyco Suzuki) and Dean Harrison (Bell Yamaha) are locked in
battle at Iron Gate during the 2013 Supersport race at the Southern.

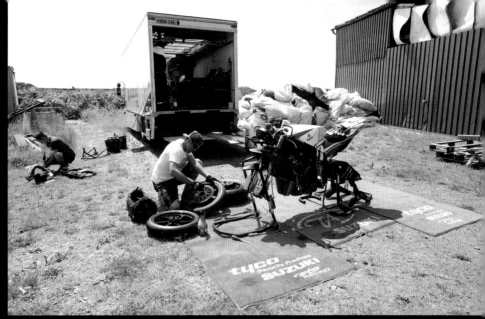

Guy's Tyco Suzuki is prepared in a farmyard at Billown by mechanics Mark McCarville and Danny Horne in 2013.

After finishing second and third in both Superbike races, taking runner-up spot in the Supersport event and winning the Solo championship race at the 2013 Southern 100, Guy had plenty of silverware to collect during the traditional prize-giving in Castletown Square.

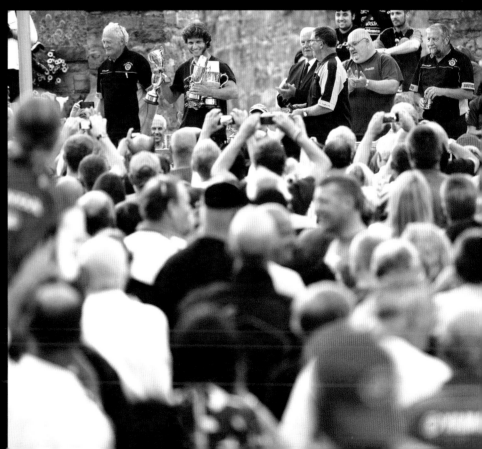

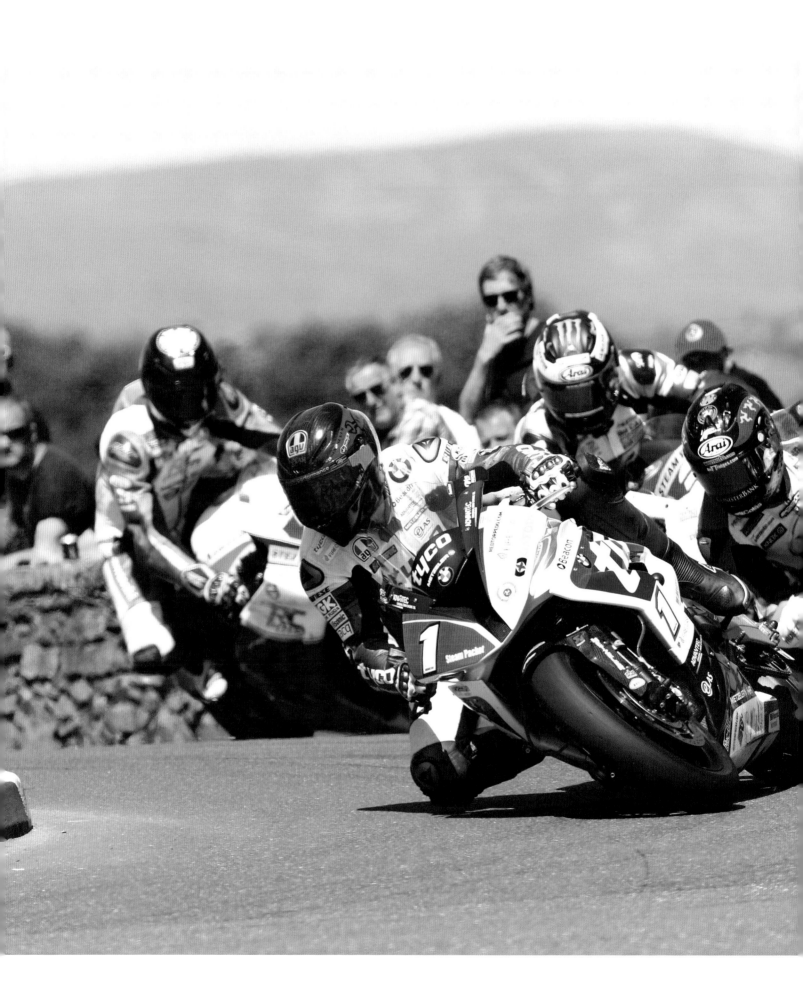

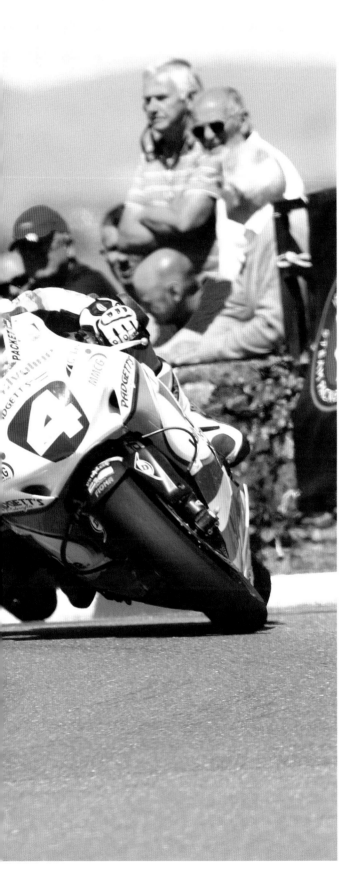

Riding the Tyco BMW, Guy leads Dan Kneen (Padgett's Honda), Michael Dunlop (Hawk BMW) and Ivan Lintin (RC Express Kawasaki) around Castletown Corner in the 2015 Solo championship race. Guy's victory in the feature event would be his third in row, a feat only equalled by Joey Dunlop.

Nigel the Labrador was a new addition to Guy's team for the 2015 season.

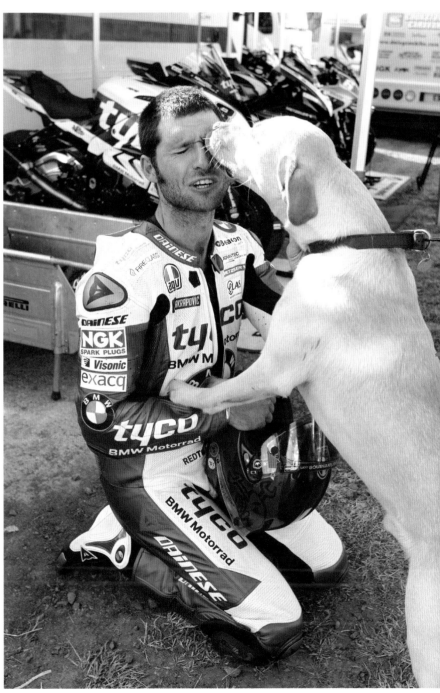

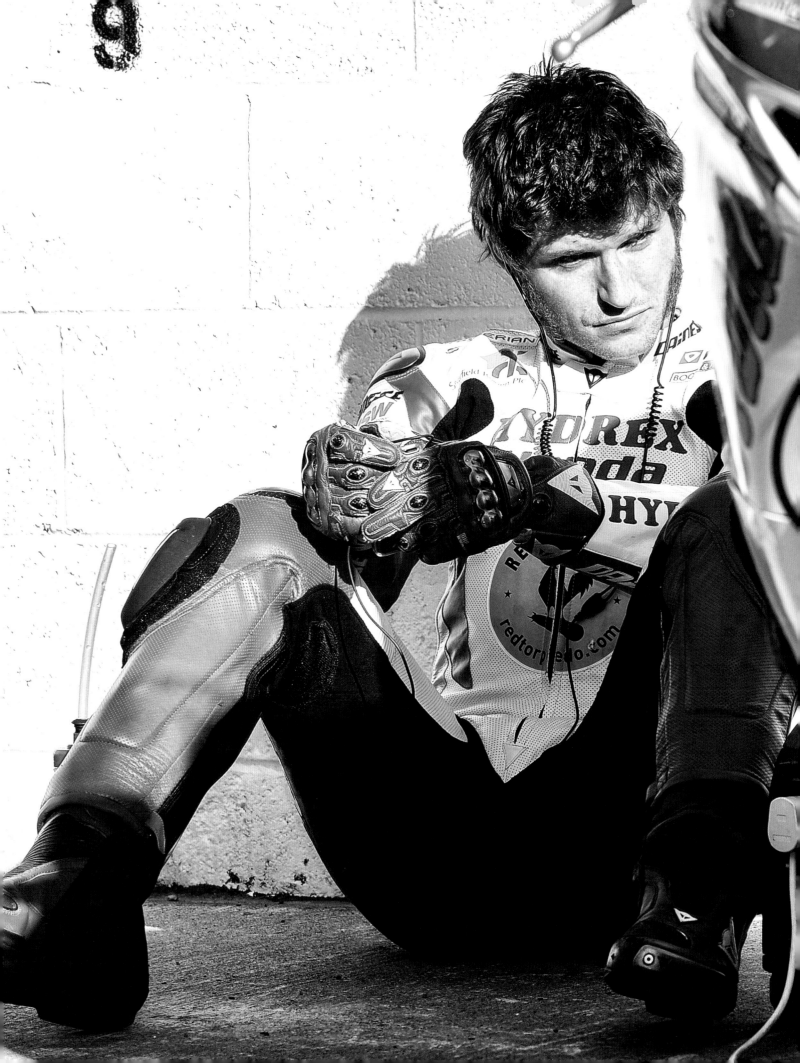

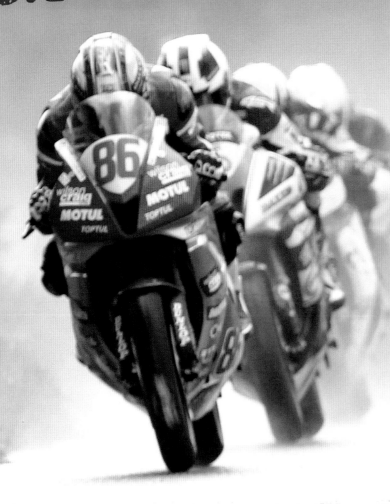

ULSTER GRAND PRIX

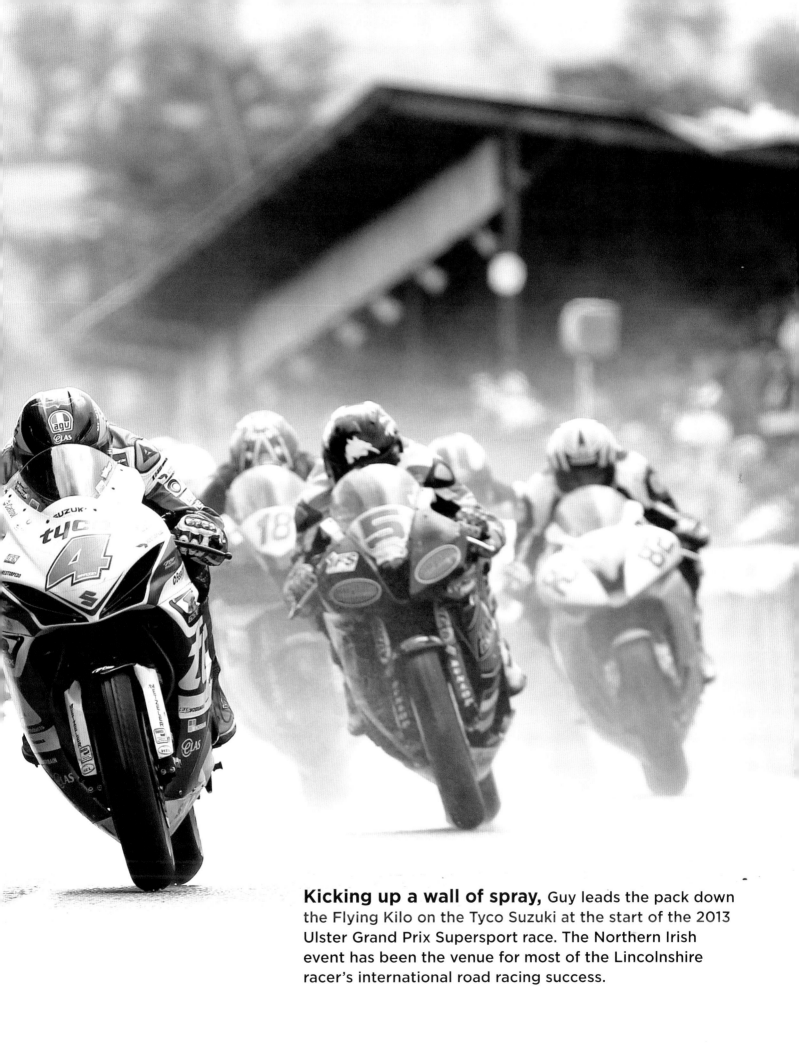

Kicking up a wall of spray, Guy leads the pack down the Flying Kilo on the Tyco Suzuki at the start of the 2013 Ulster Grand Prix Supersport race. The Northern Irish event has been the venue for most of the Lincolnshire racer's international road racing success.

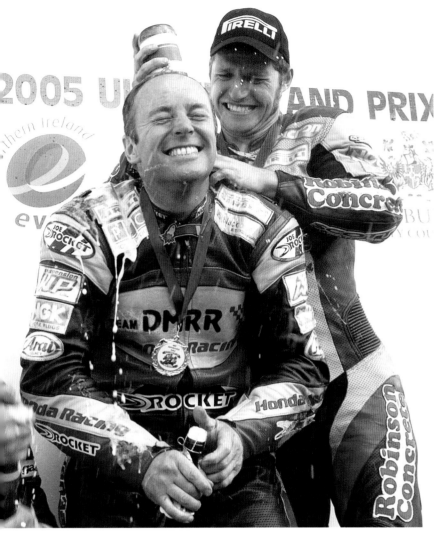

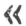
Guy pours champagne down the leathers of race winner Ian Lougher after finishing runner-up to the veteran Welshman in the 2005 Ulster GP Superbike race. In just his second Ulster, Guy stood on the podium three times.

» Steering his way around Lougher's Bend under the watchful eye of the spectators, Guy made his Ulster Grand Prix debut in 2004 on the Robinson Suzuki.

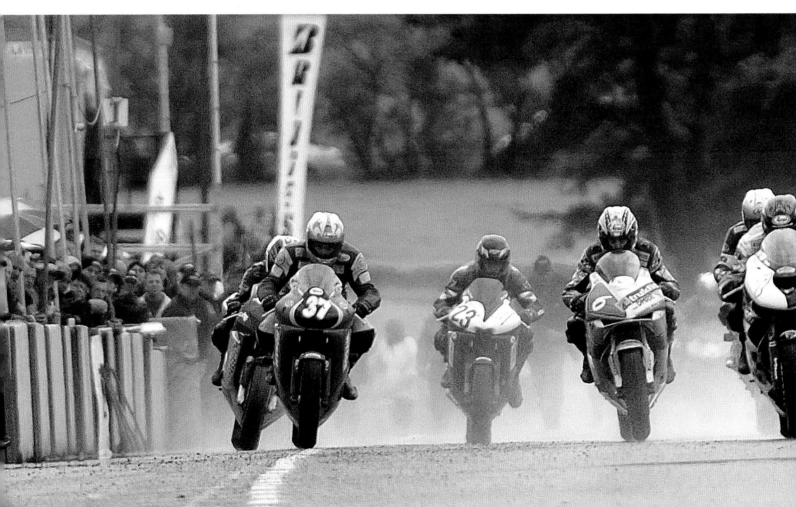

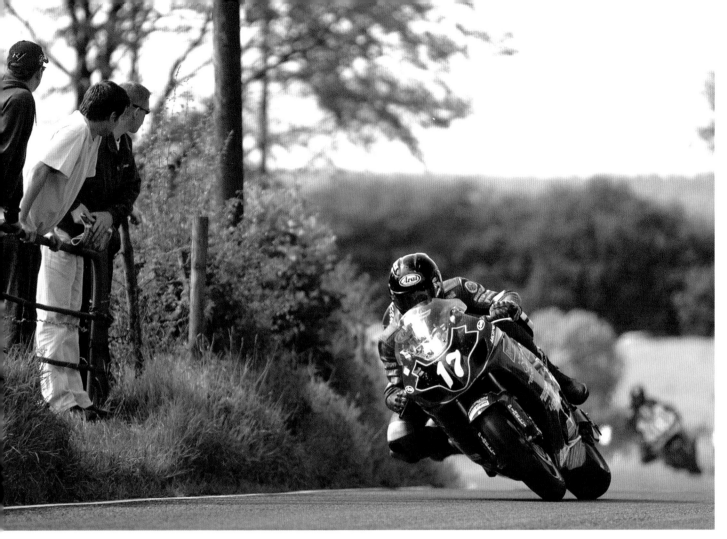

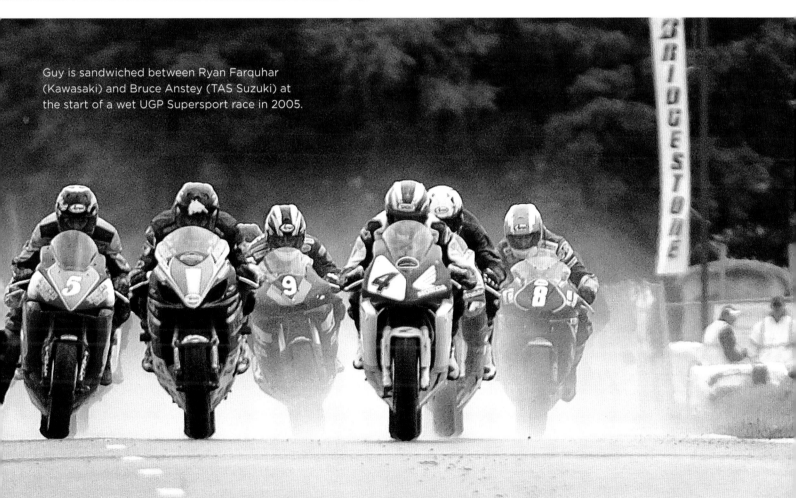

Guy is sandwiched between Ryan Farquhar
(Kawasaki) and Bruce Anstey (TAS Suzuki) at
the start of a wet UGP Supersport race in 2005.

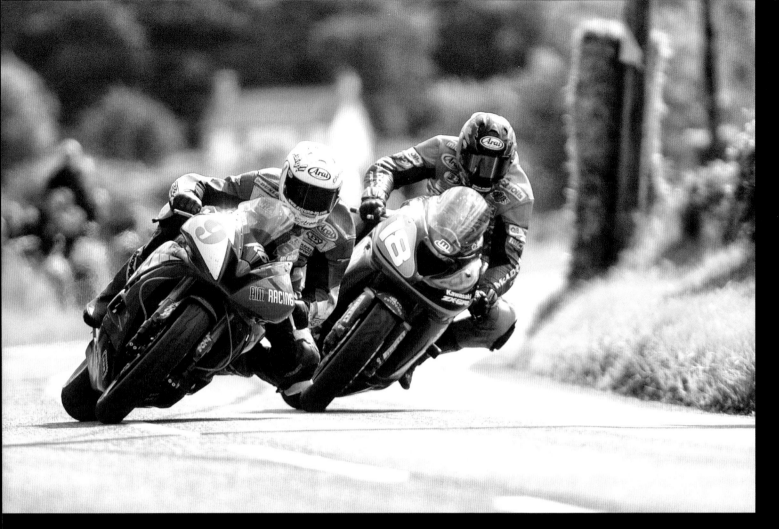

Guy and Ian Hutchinson (McAdoo Kawasaki) battle for the lead at Rock Bends during the 2006 UGP Supersport race. Guy got the better of the exchange and was also the winner of the second 600cc race on the day.

During the 2006 season Guy rode in the British Supersport short circuit championship in between his road race outings. Exposure to this level of competition appeared to pay off at Dundrod and highlighted the benefits extra track time could bring.

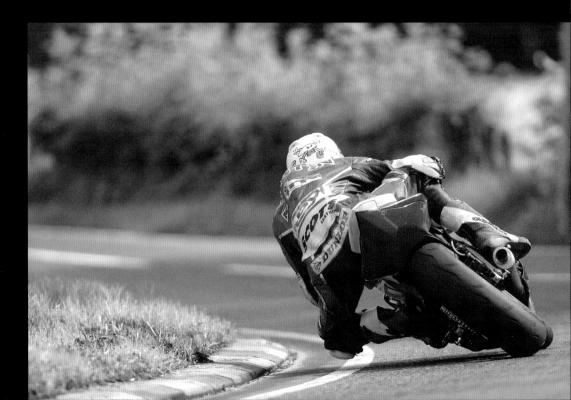

The only view most of the opposition had of Guy at the 2006 Ulster as he rounds Ireland's Bend on the AIM Yamaha.

GRAND PRIX

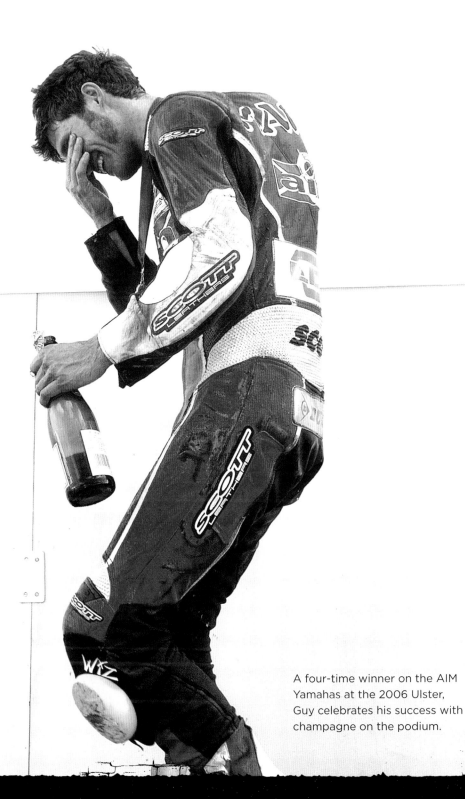

A four-time winner on the AIM Yamahas at the 2006 Ulster, Guy celebrates his success with champagne on the podium.

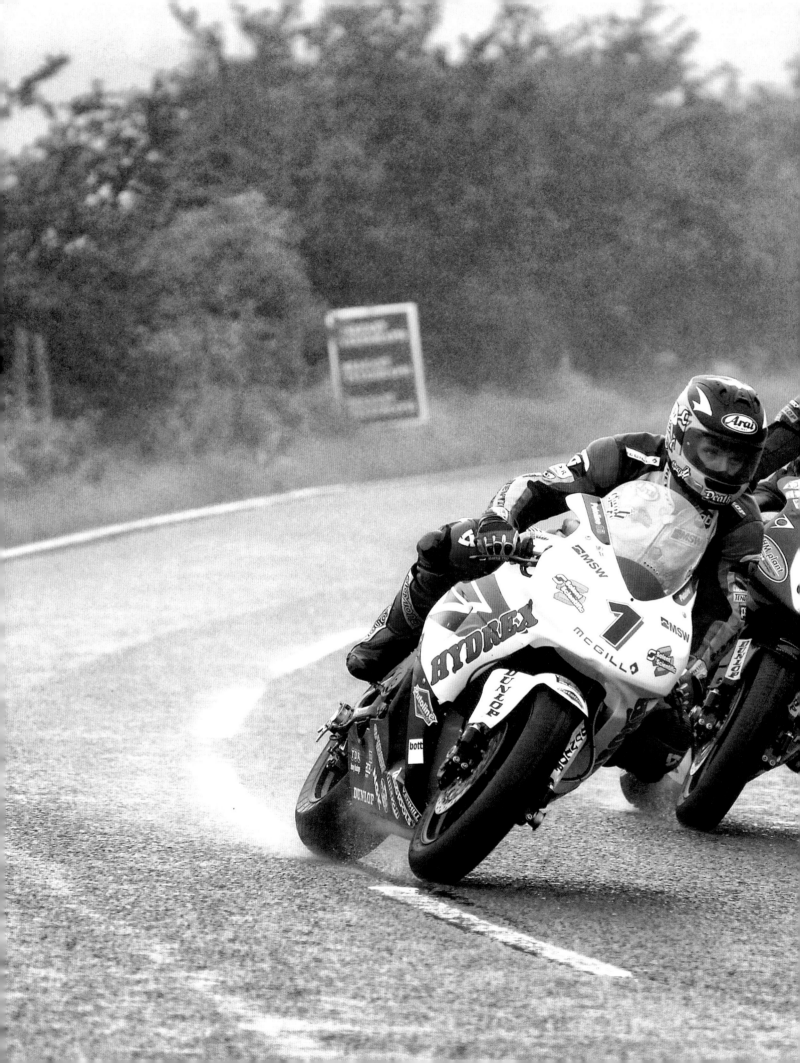

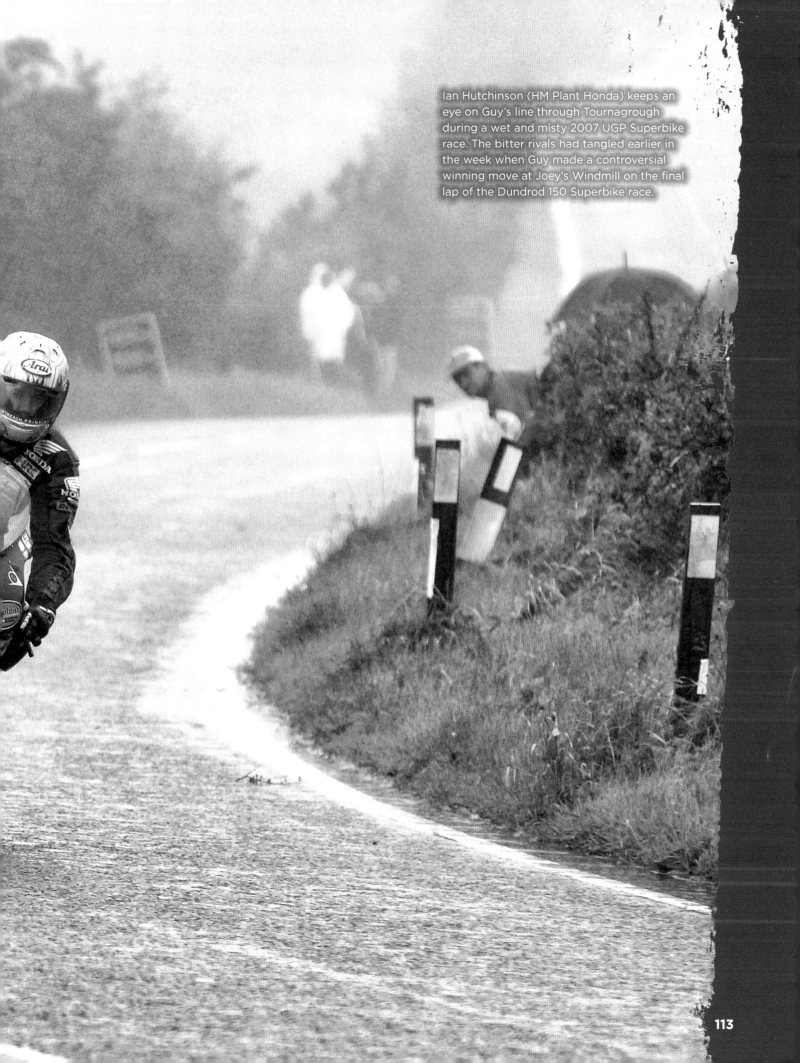

Ian Hutchinson (HM Plant Honda) keeps an eye on Guy's line through Tournagrough during a wet and misty 2007 UGP Superbike race. The bitter rivals had tangled earlier in the week when Guy made a controversial winning move at Joey's Windmill on the final lap of the Dundrod 150 Superbike race.

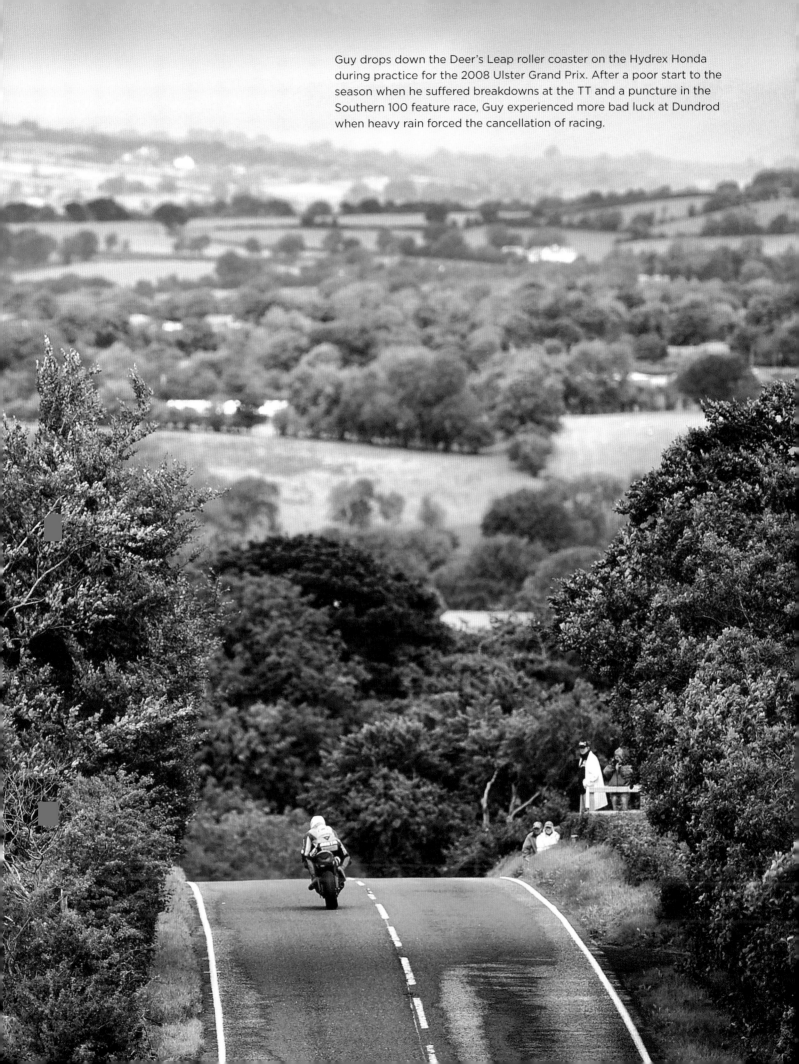

Guy drops down the Deer's Leap roller coaster on the Hydrex Honda during practice for the 2008 Ulster Grand Prix. After a poor start to the season when he suffered breakdowns at the TT and a puncture in the Southern 100 feature race, Guy experienced more bad luck at Dundrod when heavy rain forced the cancellation of racing.

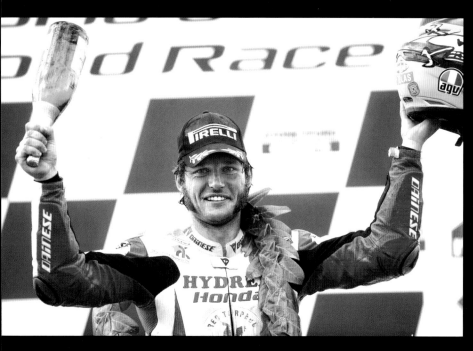

Guy celebrates at the 2009 Ulster after winning
the Superbike race on the Hydrex Honda following
a titanic battle with Ian Hutchinson (Padgett's
Honda), Gary Johnson (Robinson Honda) and
Conor Cummins (McAdoo Kawasaki).
 Less than 0.5 seconds covered the first four
riders in the race.

Guy is doused in champagne by runner-up Ian
Hutchinson and third-placed Gary Johnson on
the podium.

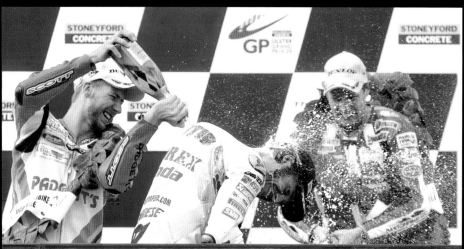

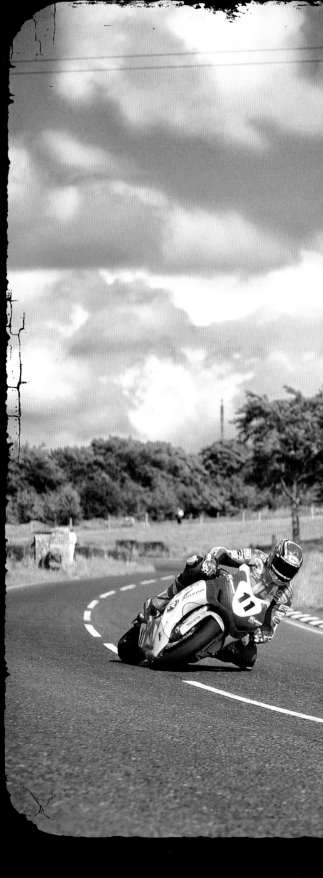

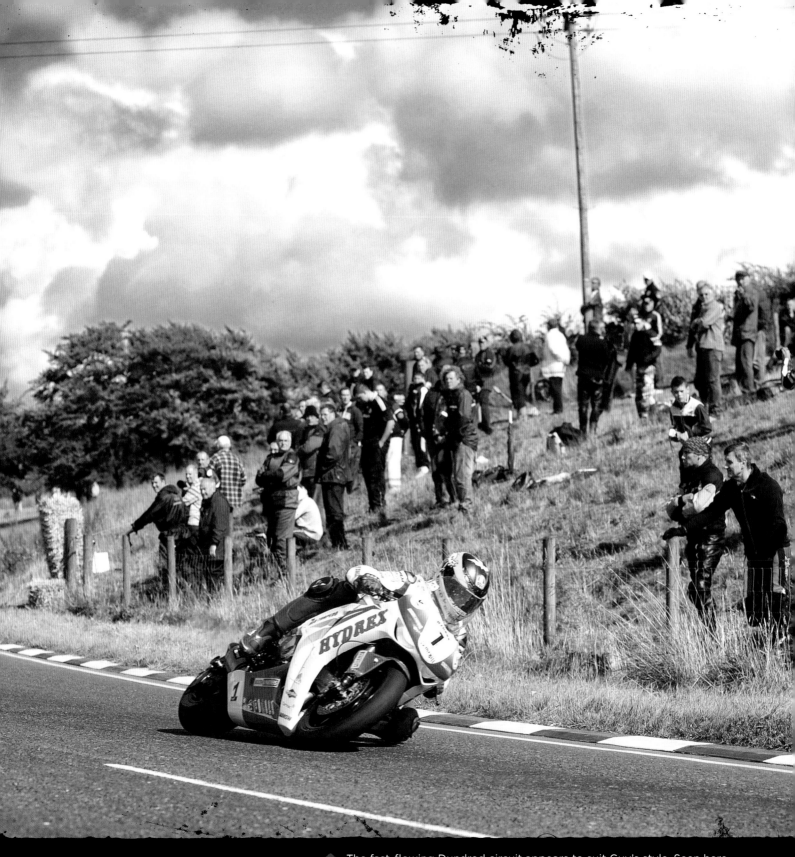

The fast-flowing Dundrod circuit appears to suit Guy's style. Seen here leading Gary Johnson on the Robinson Honda through Quarry Bends, Guy has enjoyed almost continuous success at the Ulster since 2006.

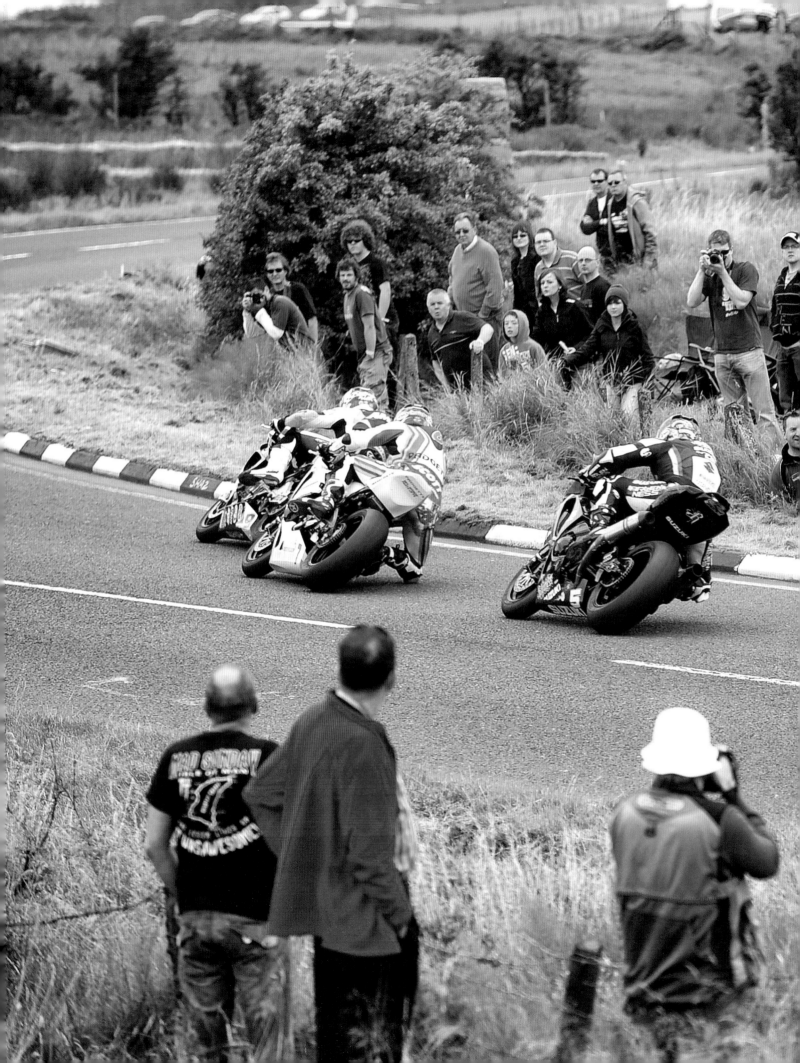

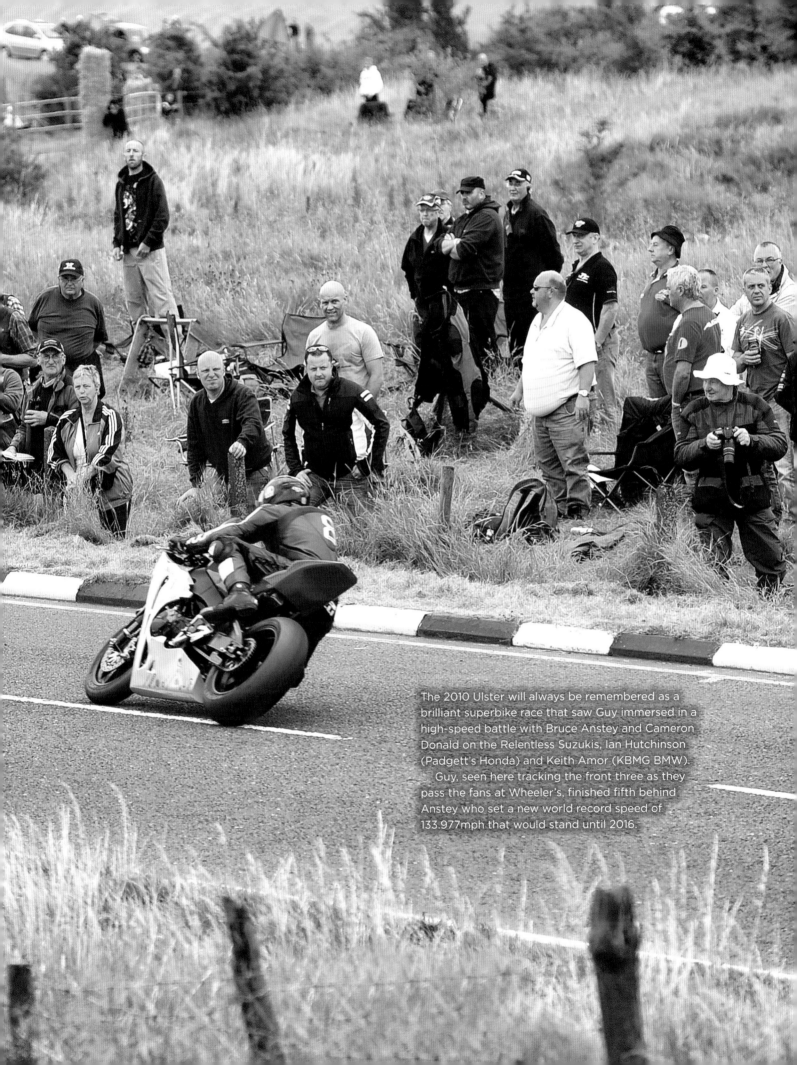

The 2010 Ulster will always be remembered as a brilliant superbike race that saw Guy immersed in a high-speed battle with Bruce Anstey and Cameron Donald on the Relentless Suzukis, Ian Hutchinson (Padgett's Honda) and Keith Amor (KBMG BMW).

Guy, seen here tracking the front three as they pass the fans at Wheeler's, finished fifth behind Anstey who set a new world record speed of 133.977mph that would stand until 2016.

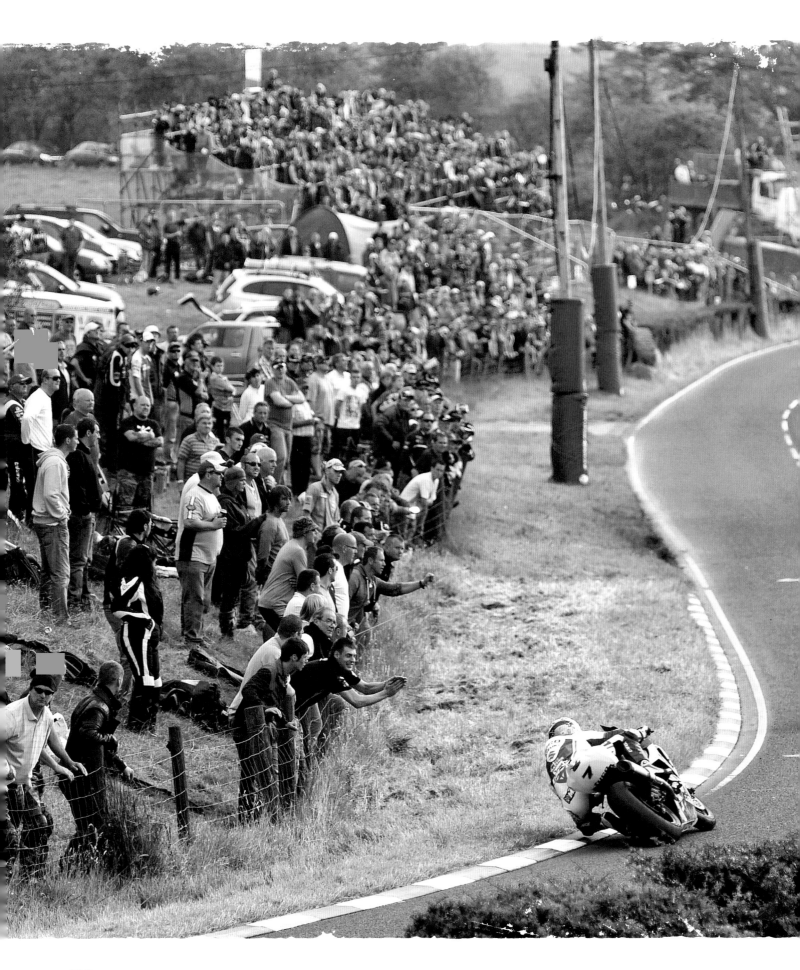

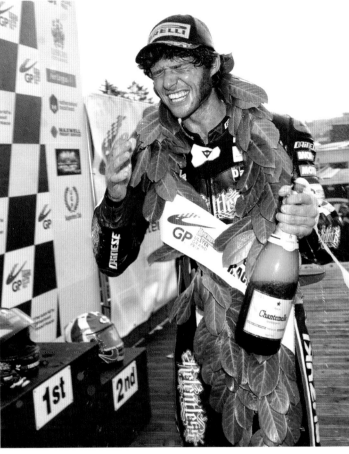

Guy replaced the hero of the 2010 Ulster, Bruce Anstey, in the Relentless Suzuki team the following season. The pair enjoyed a Superbike race win each at Dundrod. Guy also enjoyed runner-up finishes in the Superbike and Superstock races plus a fourth and fifth in both Supersport events.

Coming hard on the heels of his four TT rostrums, which included a runner-up finish in the Senior race, Guy's impressive 2011 Ulster performances marked a significant return to form.

Guy chases Michael Dunlop (McAdoo/Hunts Honda) through Quarry Bends during the 2012 Ulster Grand Prix superbike race. The pair went on to share a big bike win apiece on the day.

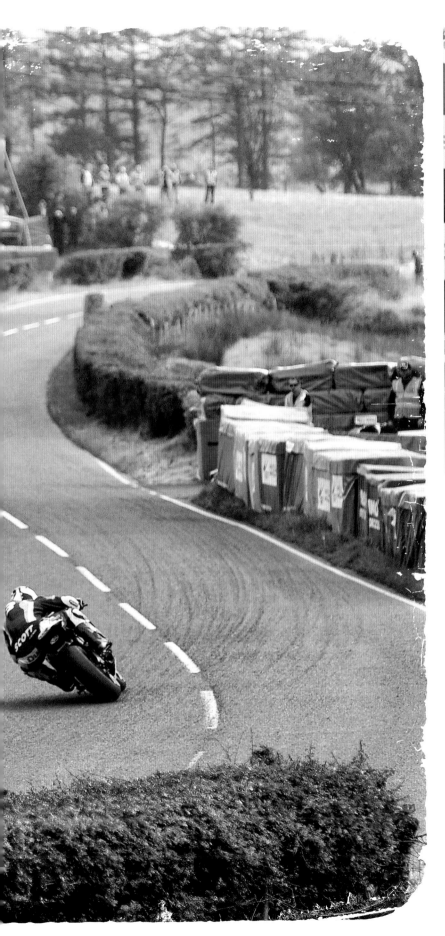

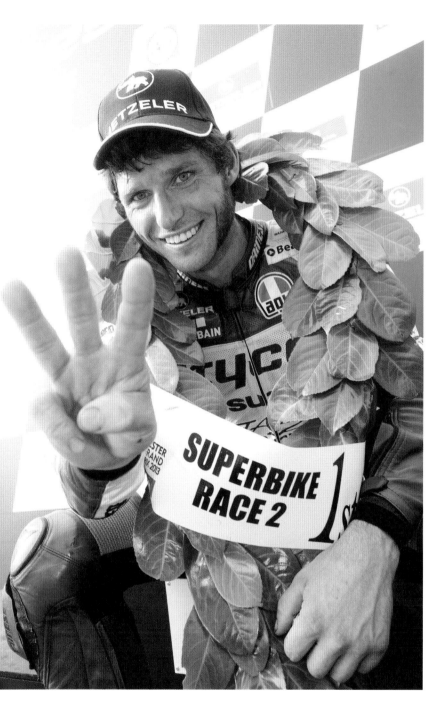

 2013 saw Guy win a treble at the Ulster Grand Prix, with victories in both Superbike races and a Supersport race win on the Tyco Suzukis. It was yet another dominant display, achieved against TT rivals Michael and William Dunlop, Bruce Anstey and Conor Cummins.

With his right knee skimming the tarmac and his eyes focused on the road ahead, Guy leans the Tyco Suzuki through Lougher's Bend at over 150mph during the 2012 Ulster Grand Prix.

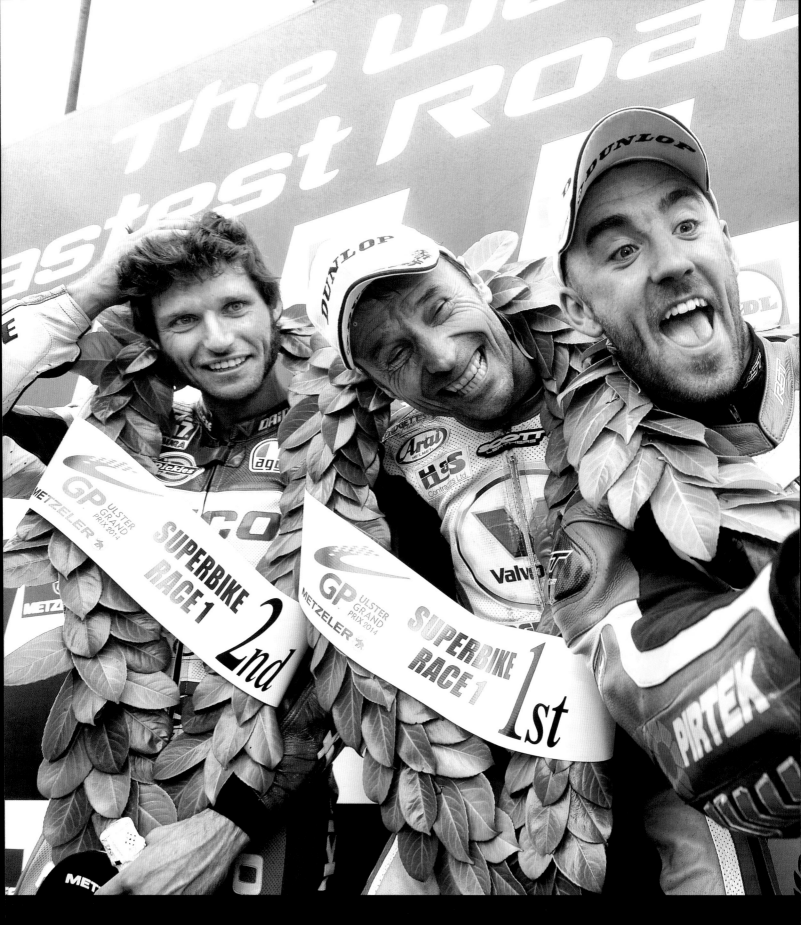

Guy joins Bruce Anstey and Lee Johnston for a selfie on the podium of the Superbike race at the 2014 Ulster Grand Prix. His runner-up finish behind Anstey's Padgett's Honda was to be his last outing on the Suzukis he had ridden for four years as the TAS team shifted to BMW power for the 2015 season.

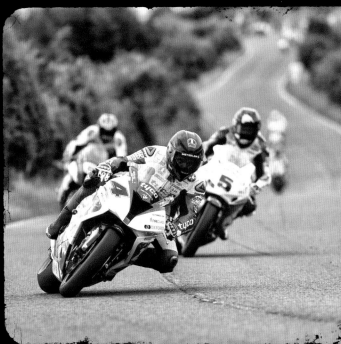

Sadly, Guy Martin's brilliant Ulster Grand Prix career ended in serious injury when he crashed his Tyco BMW whilst leading the Dundrod 150 Superbike race at the 2015 meeting.

Pushed hard by Bruce Anstey (Padgett's Honda) and Ian Hutchinson (PBM Kawasaki), Guy highsided at Ireland's Bend on the final lap. His injuries included broken vertebrae, a cracked sternum and a broken hand.

The crash brought to an end Guy's twelve seasons of racing at the Ulster where he has won eleven Grand Prix races and three Dundrod 150 Superbike events on the famous 7.4 mile circuit.

Guy's record places him fifth in the all-time winners' list for the Dundrod event. Only Joey Dunlop (24), Ian Lougher (18), Phillip McCallen (14) and Bruce Anstey (12) have been more successful.

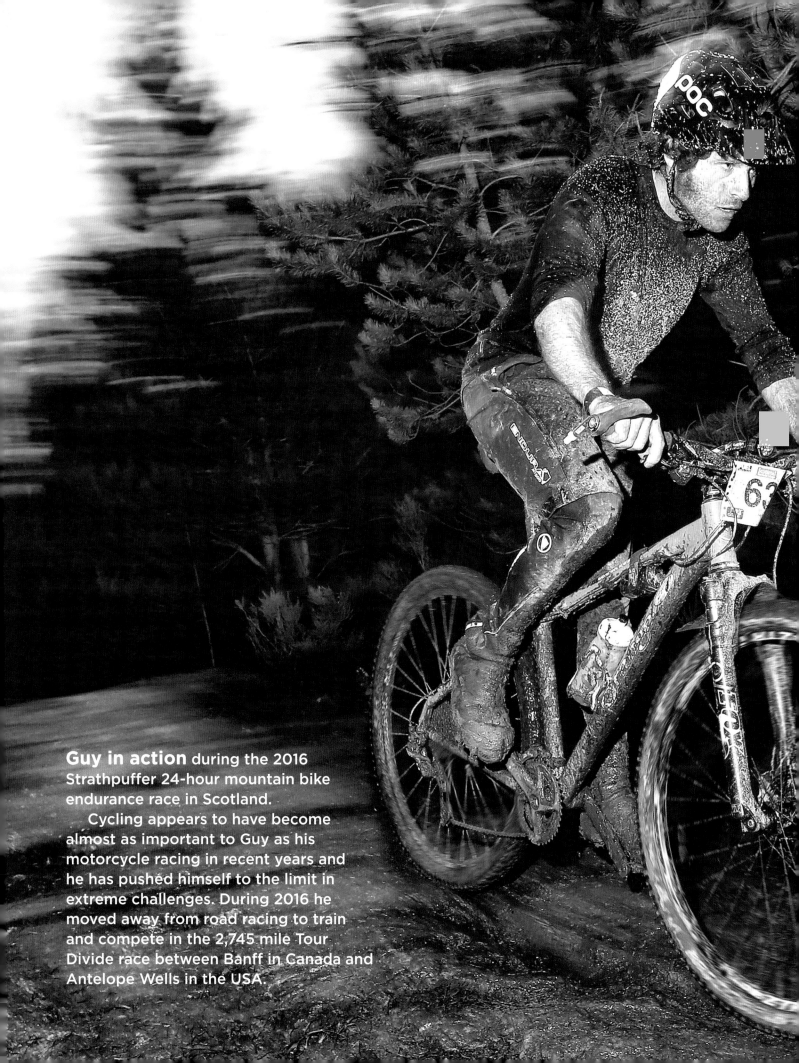

Guy in action during the 2016 Strathpuffer 24-hour mountain bike endurance race in Scotland.

Cycling appears to have become almost as important to Guy as his motorcycle racing in recent years and he has pushed himself to the limit in extreme challenges. During 2016 he moved away from road racing to train and compete in the 2,745 mile Tour Divide race between Banff in Canada and Antelope Wells in the USA.

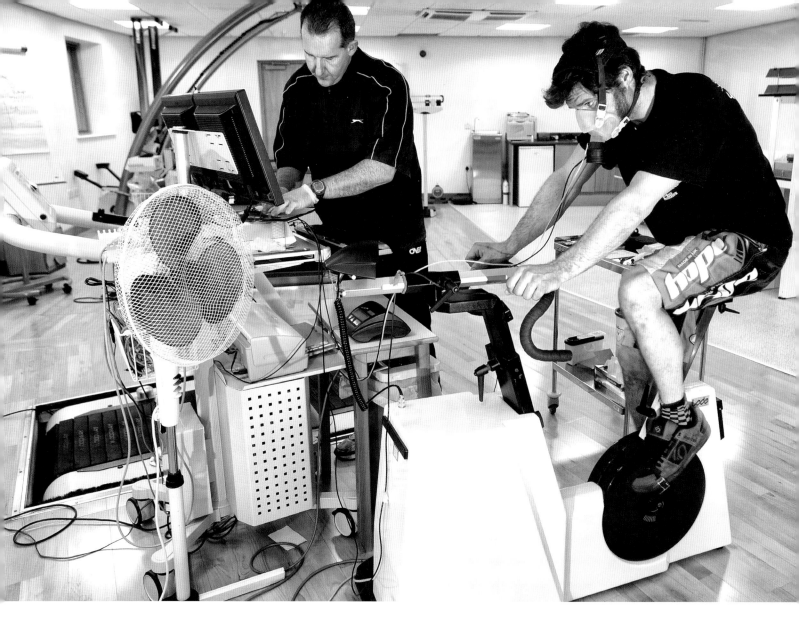

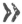 When Guy joined Relentless Suzuki in 2011, team boss Philip Neill arranged for him to have a VO_2 test at a university's high performance centre in Belfast. The test measured the volume of oxygen Guy consumed while exercising at maximum capacity on a cycling treadmill. The results highlighted his fitness and ability to compete in endurance sports.

»

Guy concentrates during the VO_2 test in 2011.

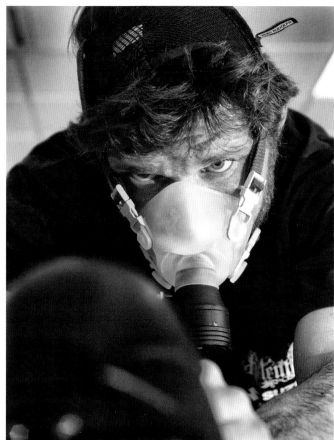

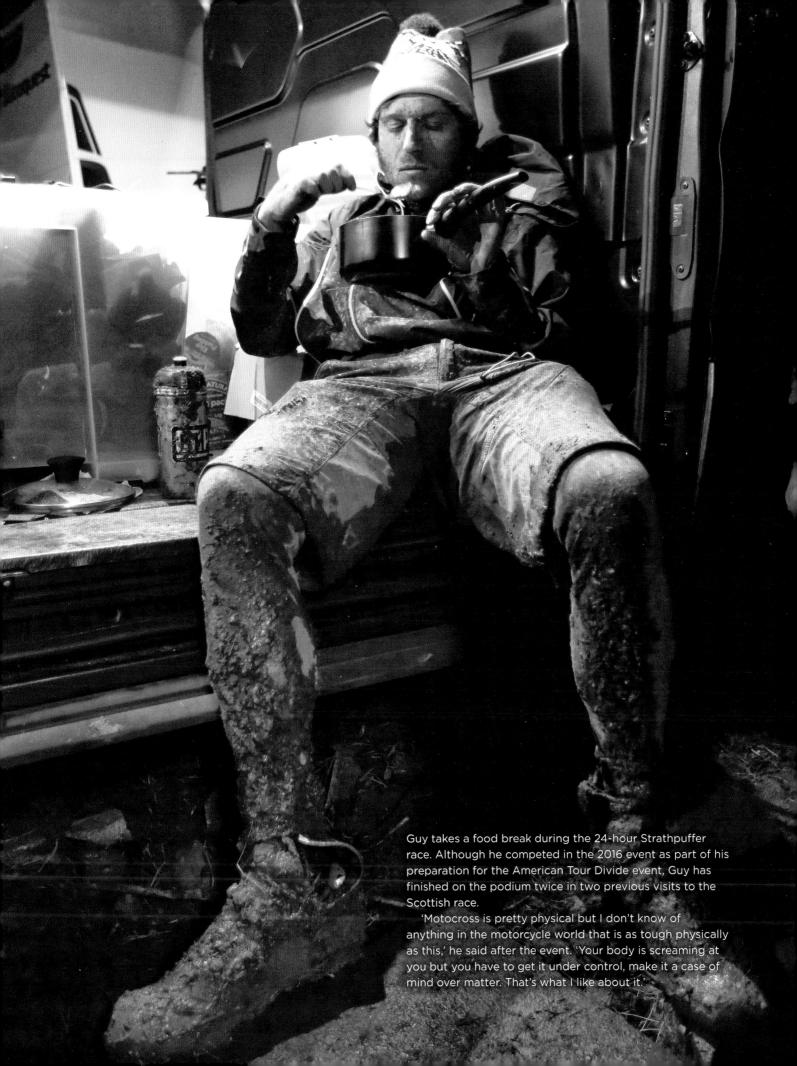

Guy takes a food break during the 24-hour Strathpuffer race. Although he competed in the 2016 event as part of his preparation for the American Tour Divide event, Guy has finished on the podium twice in two previous visits to the Scottish race.

'Motocross is pretty physical but I don't know of anything in the motorcycle world that is as tough physically as this,' he said after the event. 'Your body is screaming at you but you have to get it under control, make it a case of mind over matter. That's what I like about it.'

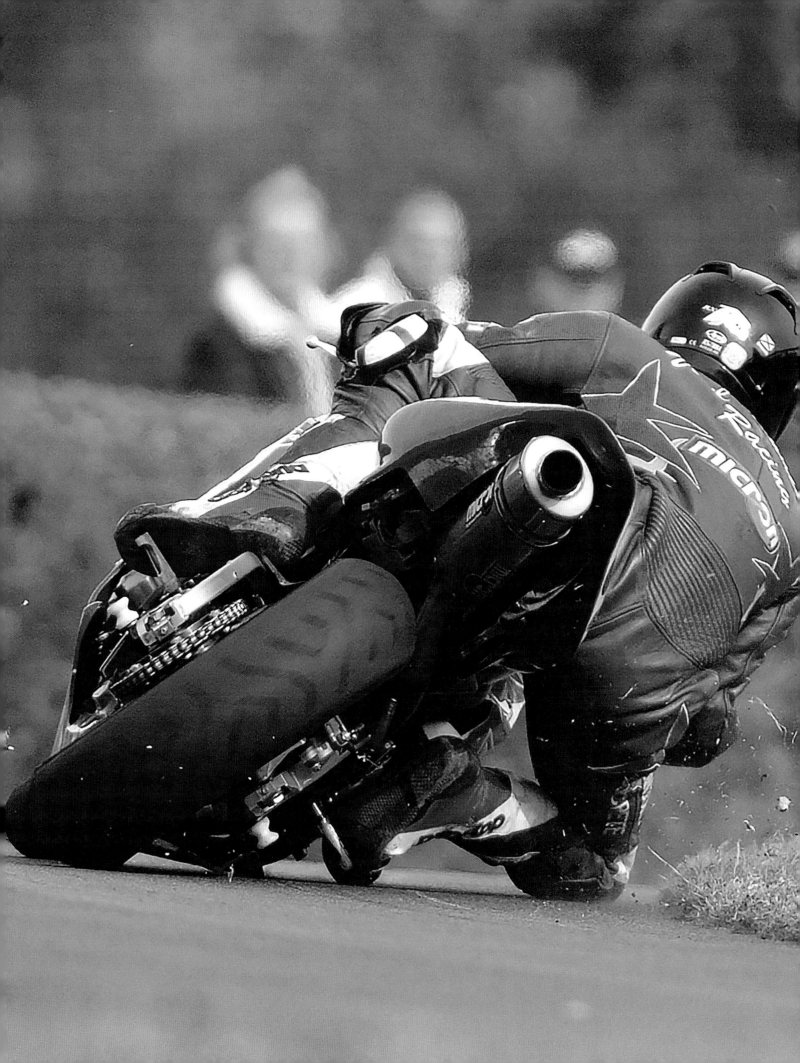

Guy kicks up grass and dust at the Esses on the Robinson Honda during the 2004 Scarborough Gold Cup meeting. The Oliver's Mount circuit on the edge of the seaside town was the venue for Guy's first road race outing in 2002 and has become the scene of some of his finest performances.

SCARBOROUGH

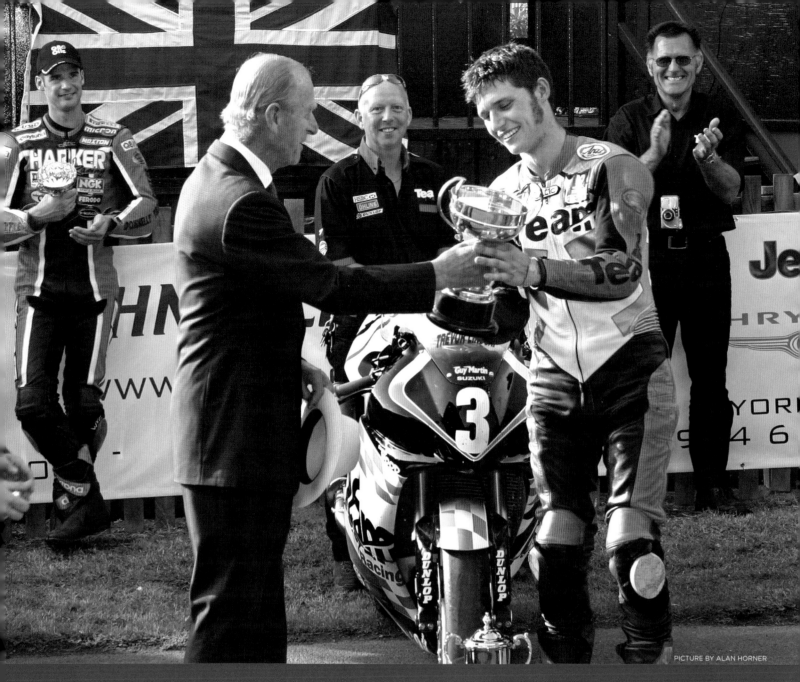

PICTURE BY ALAN HORNER

Guy's first Gold Cup victory came in 2003 on the Team Suzuki in just his second year of racing at Scarborough.

The British motorcycle racing governing body, the Auto-Cycle Union, was celebrating its centenary year and to mark the occasion the Duke of Edinburgh presented the trophy. Looking on are Ryan Farquhar, Sam Finlay, the owner of TEAM Racing, and Guy's father, Ian.

On his way to victory in the 2004 Gold Cup race, Guy leans on to the bank at the exit of the Esses on the Robinson Suzuki.

Although he has admitted that the tight layout of the 2.5 mile venue isn't his favourite type of circuit, Guy was virtually unbeatable at Oliver's Mount during the middle years of his career, enjoying an unbroken victory run in the Gold Cup race between 2003 and 2009.

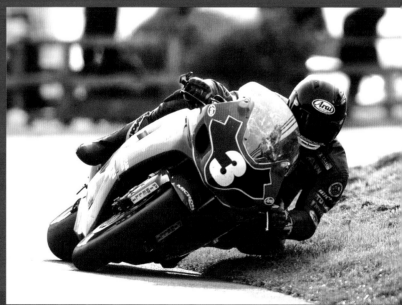

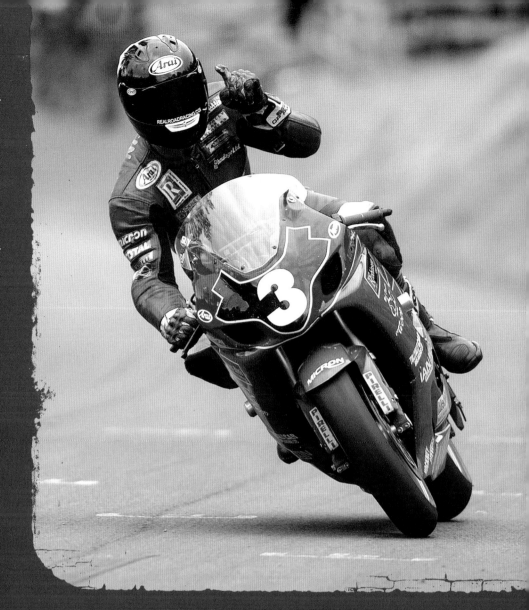

Guy punches the air with delight after winning the 2004 Gold Cup race.
Scarborough hosts three major meetings each season; the Spring Cup, the Cock O' the North and the Gold Cup. Guy has won the Gold Cup race a record eight times. He has also enjoyed four victories in the Spring Cup and lifted three Cock O' the North trophies at the Yorkshire venue.

Dodging the autumn leaves, Guy leads Ian Lougher (Black Horse Honda) into Mere Hairpin in 2004. Welshman Lougher, who has won more Scarborough races than any other competitor, was one of Guy's fiercest rivals during his early years at Oliver's Mount.

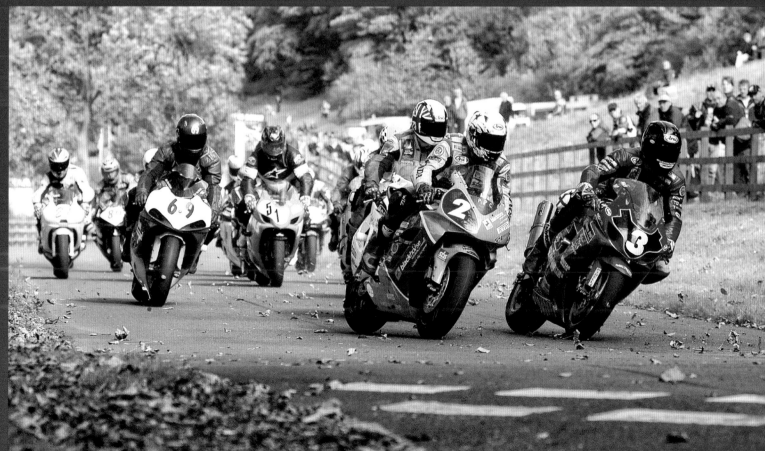

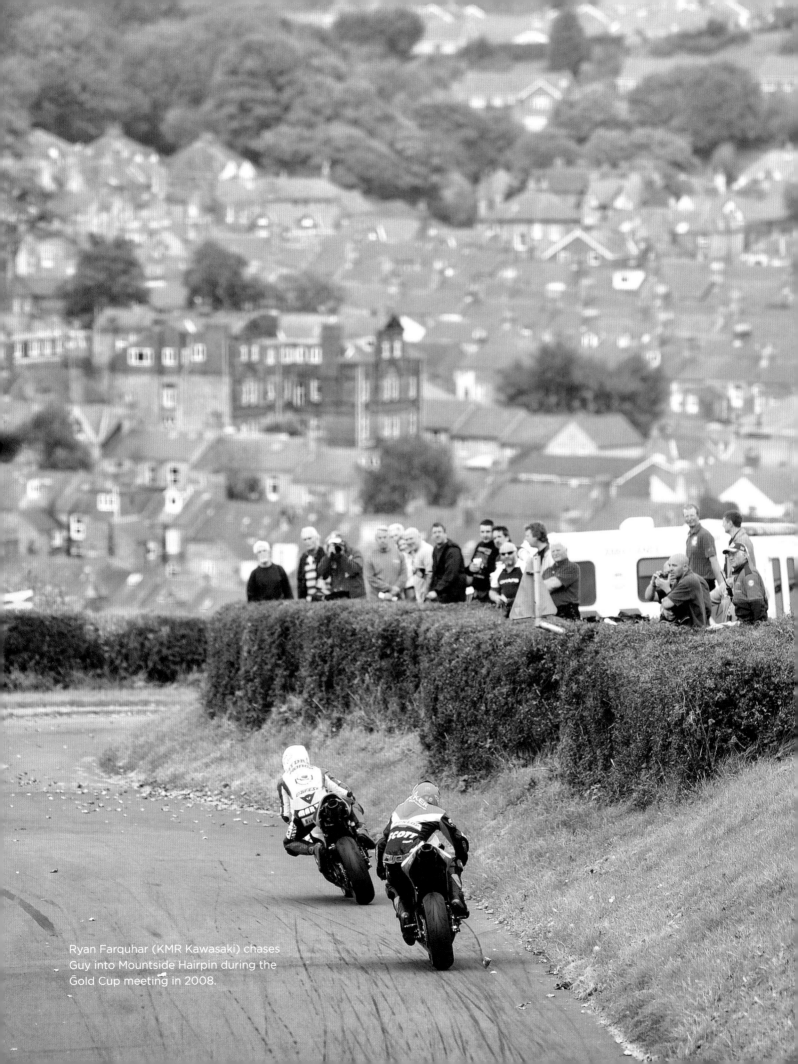

Ryan Farquhar (KMR Kawasaki) chases
Guy into Mountside Hairpin during the
Gold Cup meeting in 2008.

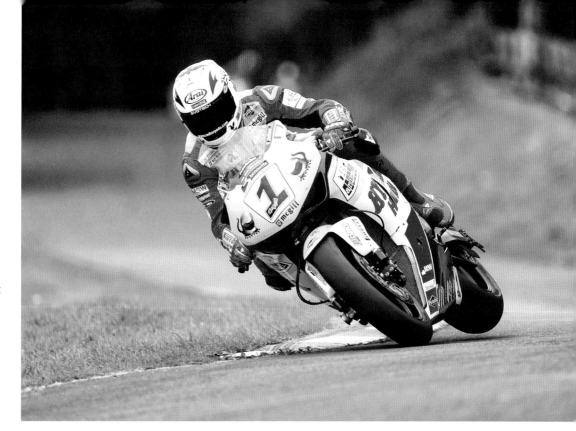

>> Guy has the back wheel of the Hydrex Honda in the air at Farm Bends as he leads Ryan Farquhar and Ian Lougher home in the 2008 Gold Cup race.

>> Exhausted after a weekend of hard racing, Guy savours another Gold Cup victory on the Hydrex Honda in 2008. That win brought to an end a season that had promised so much and delivered very little. A series of machine issues at the North West 200, TT and Southern 100 when he had been leading races had robbed him of the success he finally enjoyed at Oliver's Mount.

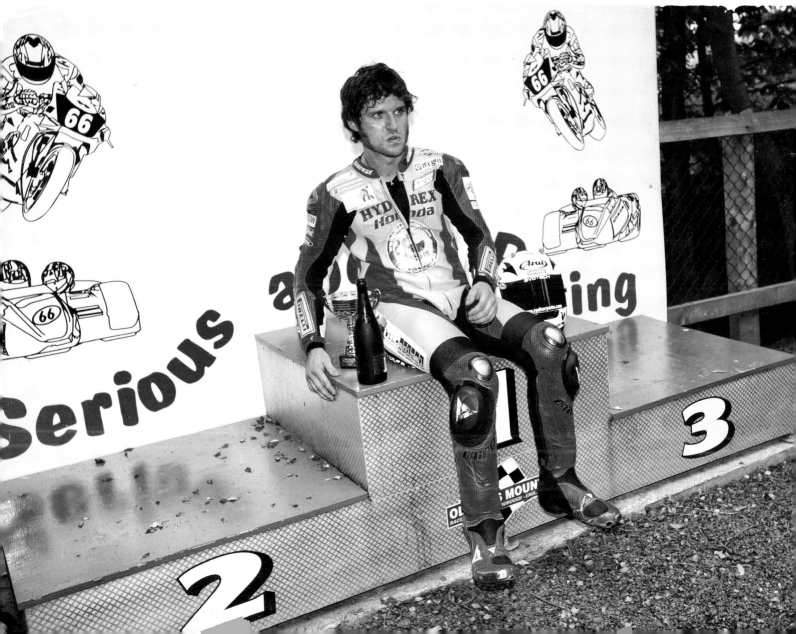

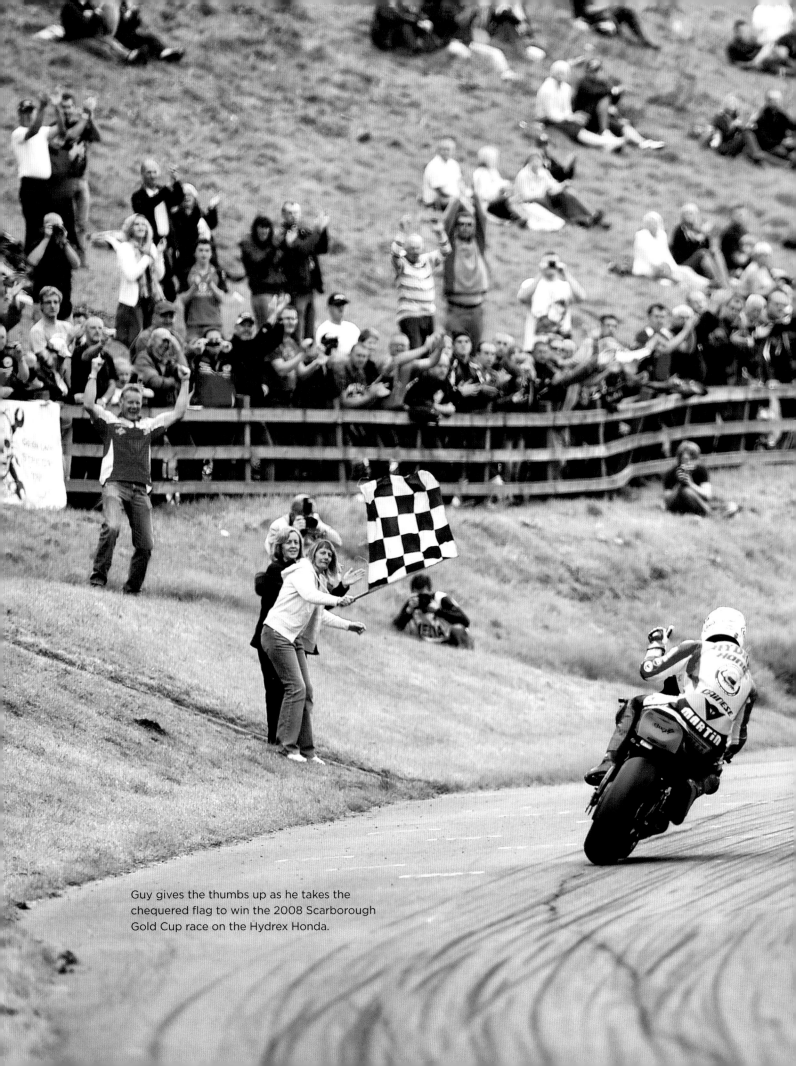

Guy gives the thumbs up as he takes the chequered flag to win the 2008 Scarborough Gold Cup race on the Hydrex Honda.

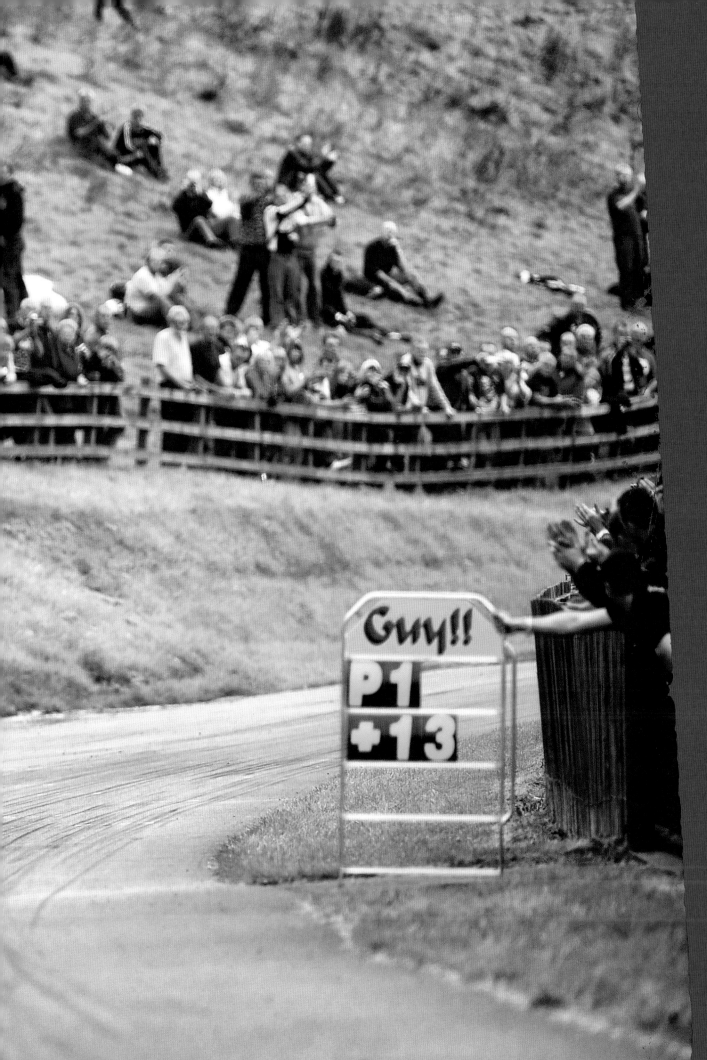

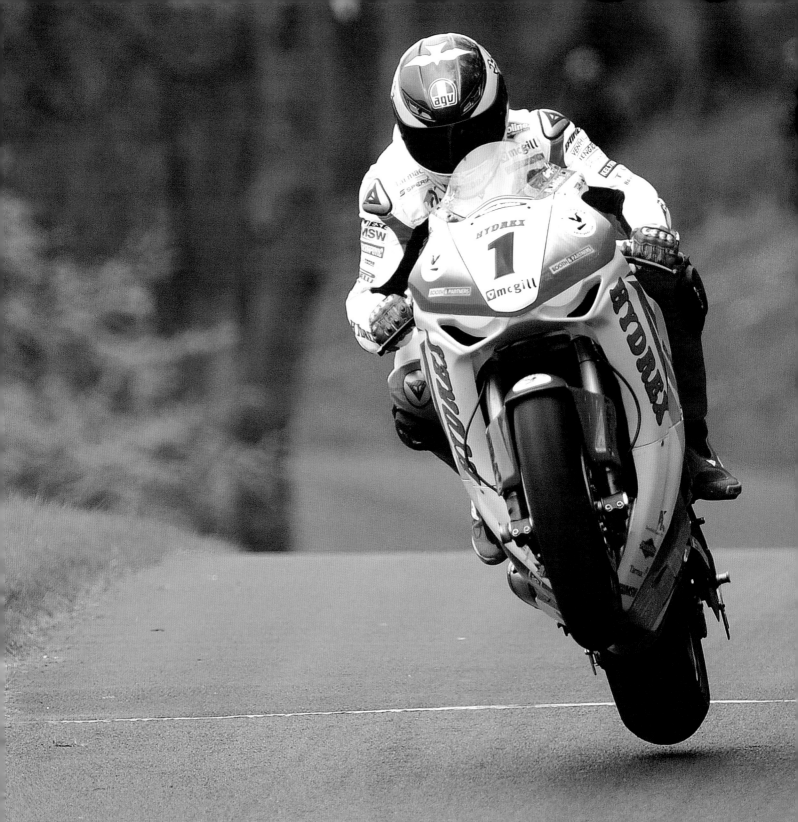

The disappointments of 2008 saw Guy demand
control of his own team for the 2009 season. He
still rode Shaun Muir's Hydrex-liveried machines
but under his own setup.

'When Guy joined us in 2007 his life was
uncomplicated but by 2009 he had a lot on his
mind and his plate,' Muir recalls.

Flying over Jefferies Jump, he enjoyed two
Superbike race wins at the Spring Cup meeting.

Calling on the services of family and friends to help him, Guy ran the Hydrex bikes out of a Transit van at Scarborough. His father Ian, a successful racer himself, helped prepare the superbike at the 2009 Spring Cup.

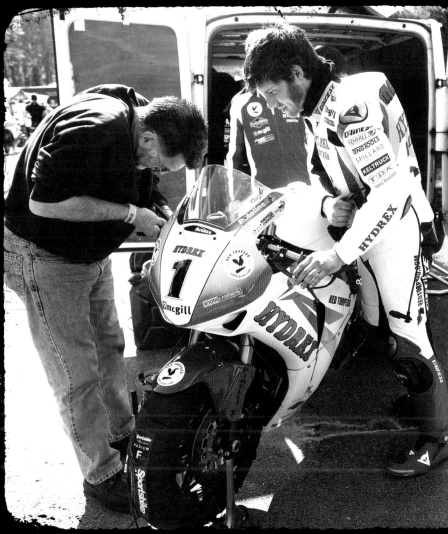

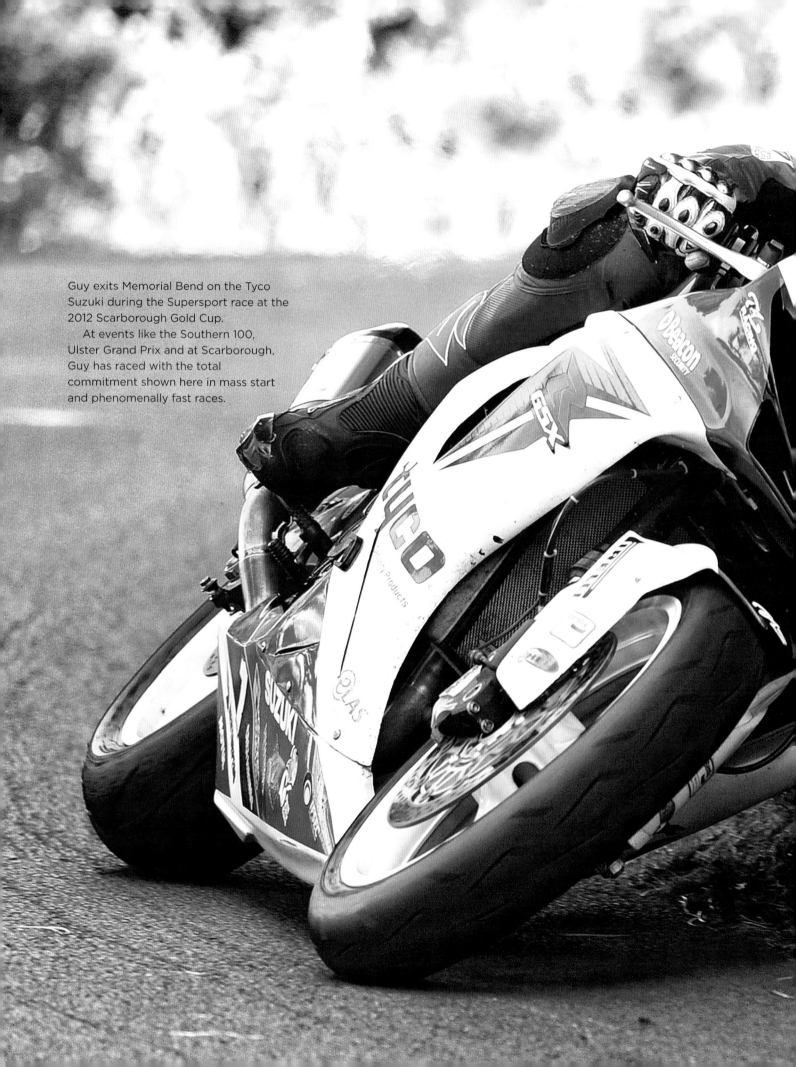

Guy exits Memorial Bend on the Tyco Suzuki during the Supersport race at the 2012 Scarborough Gold Cup.

At events like the Southern 100, Ulster Grand Prix and at Scarborough, Guy has raced with the total commitment shown here in mass start and phenomenally fast races.

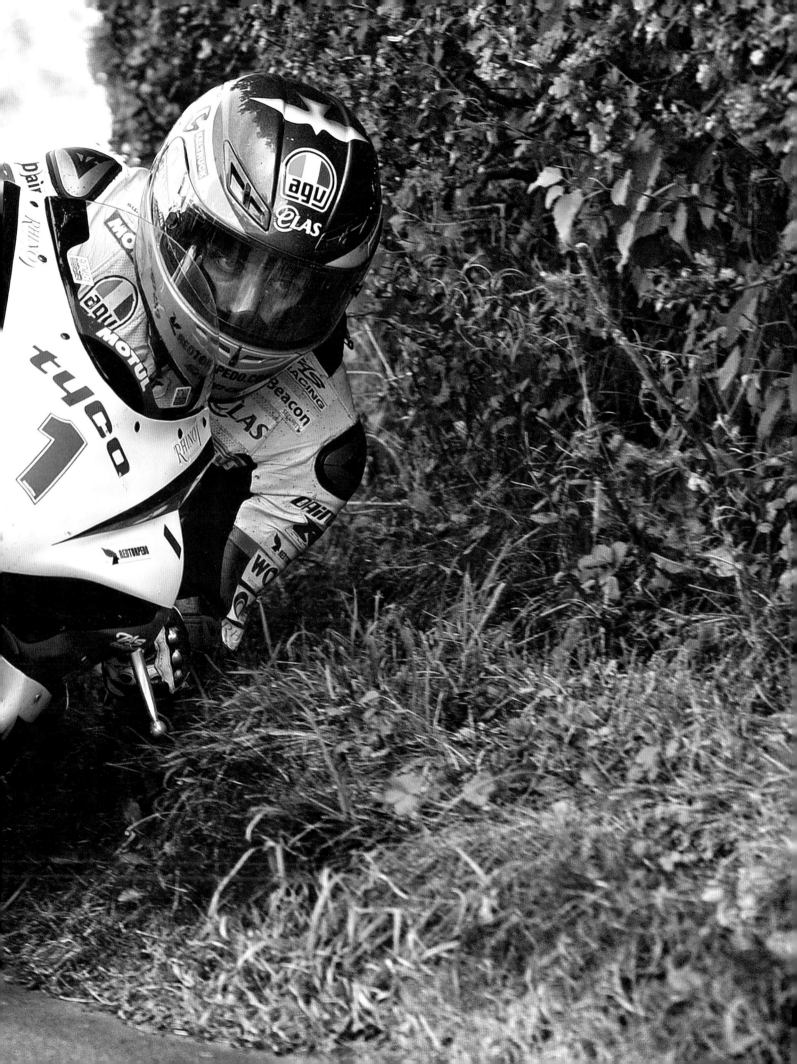

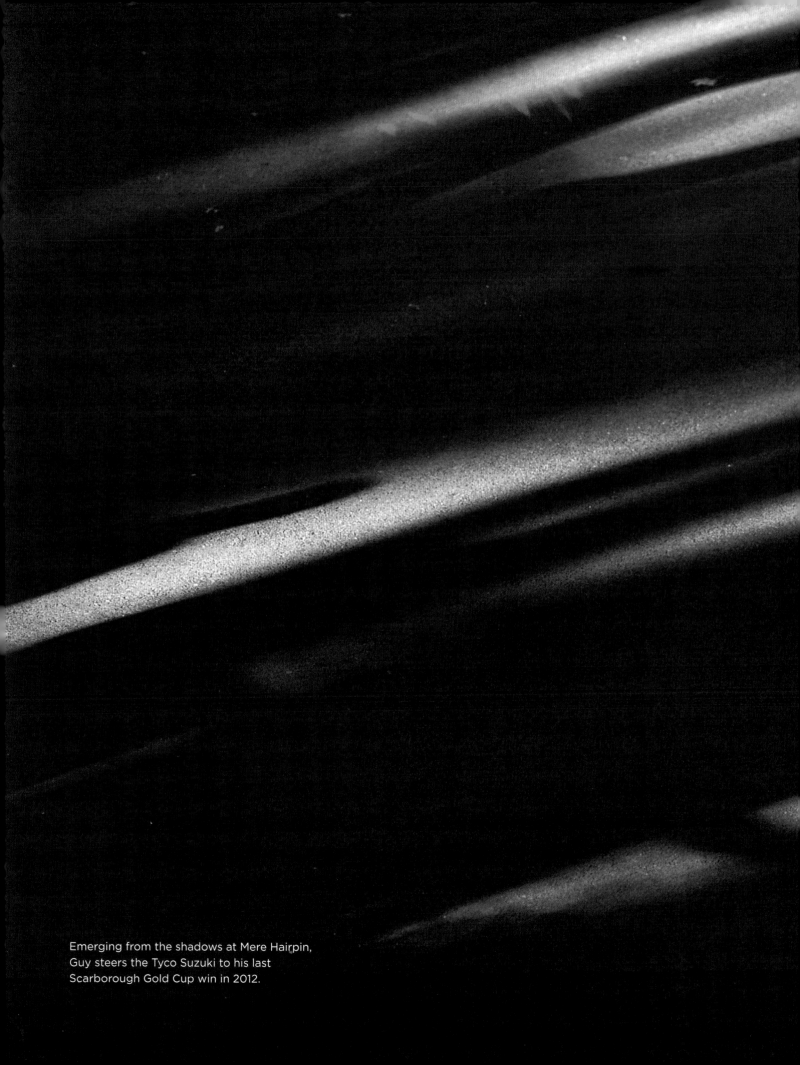

Emerging from the shadows at Mere Hairpin,
Guy steers the Tyco Suzuki to his last
Scarborough Gold Cup win in 2012.

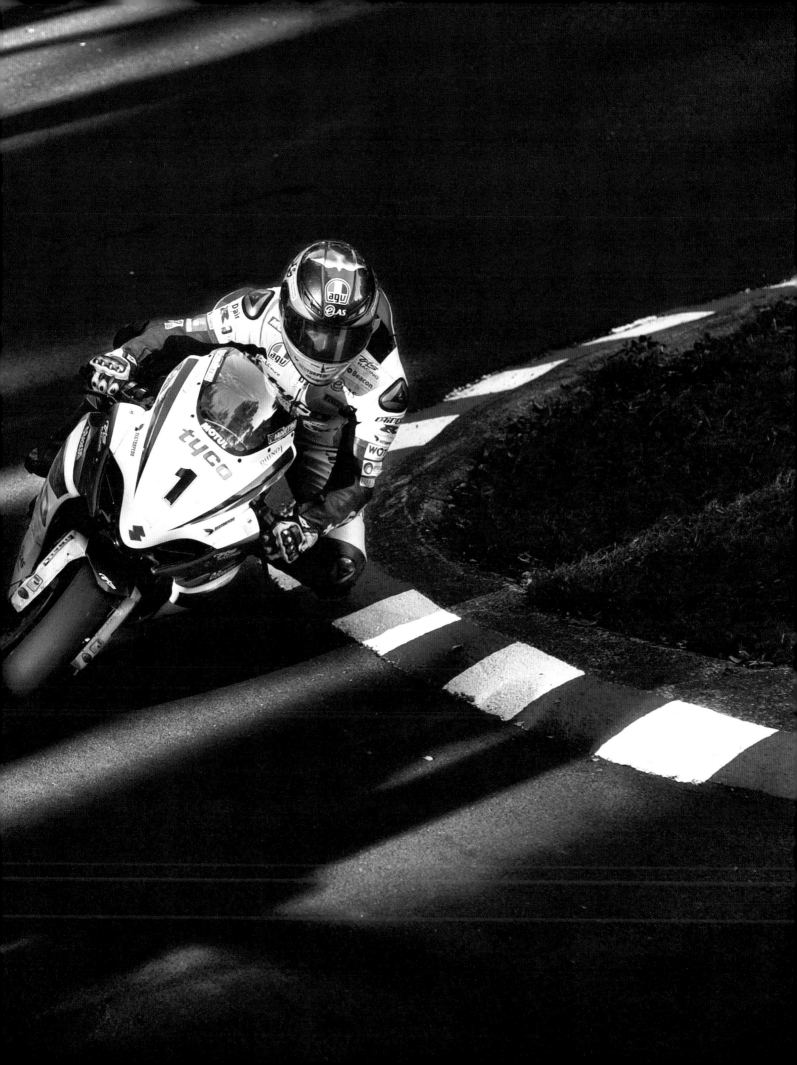

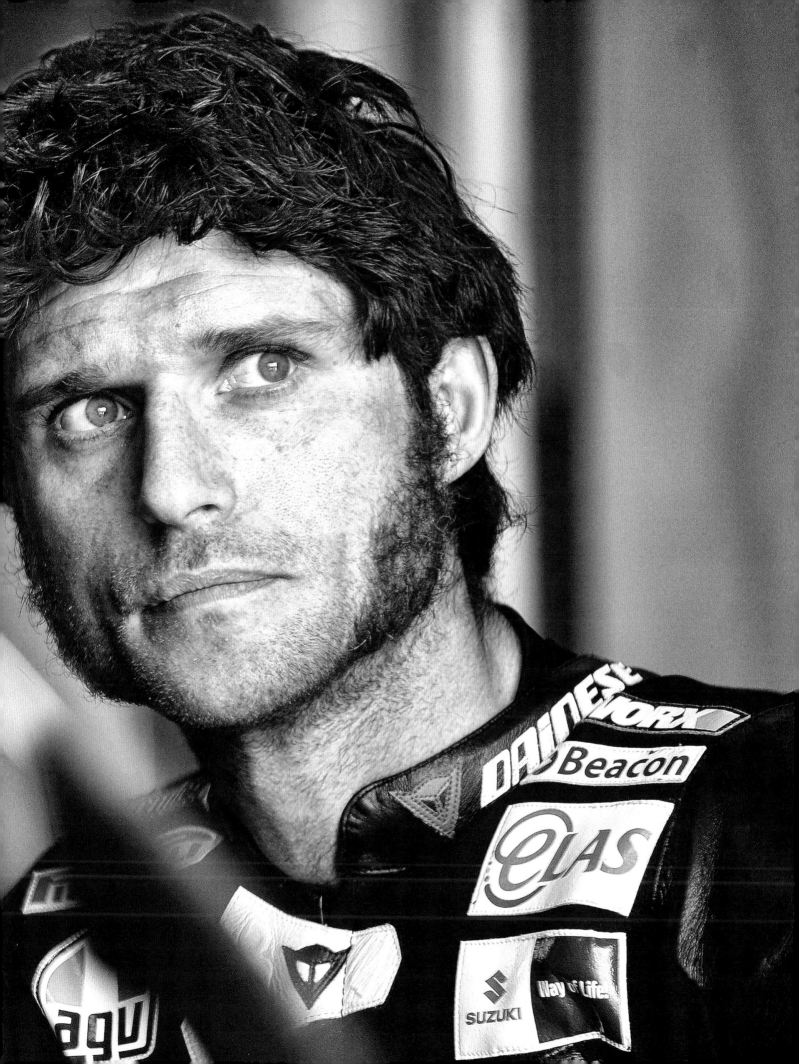

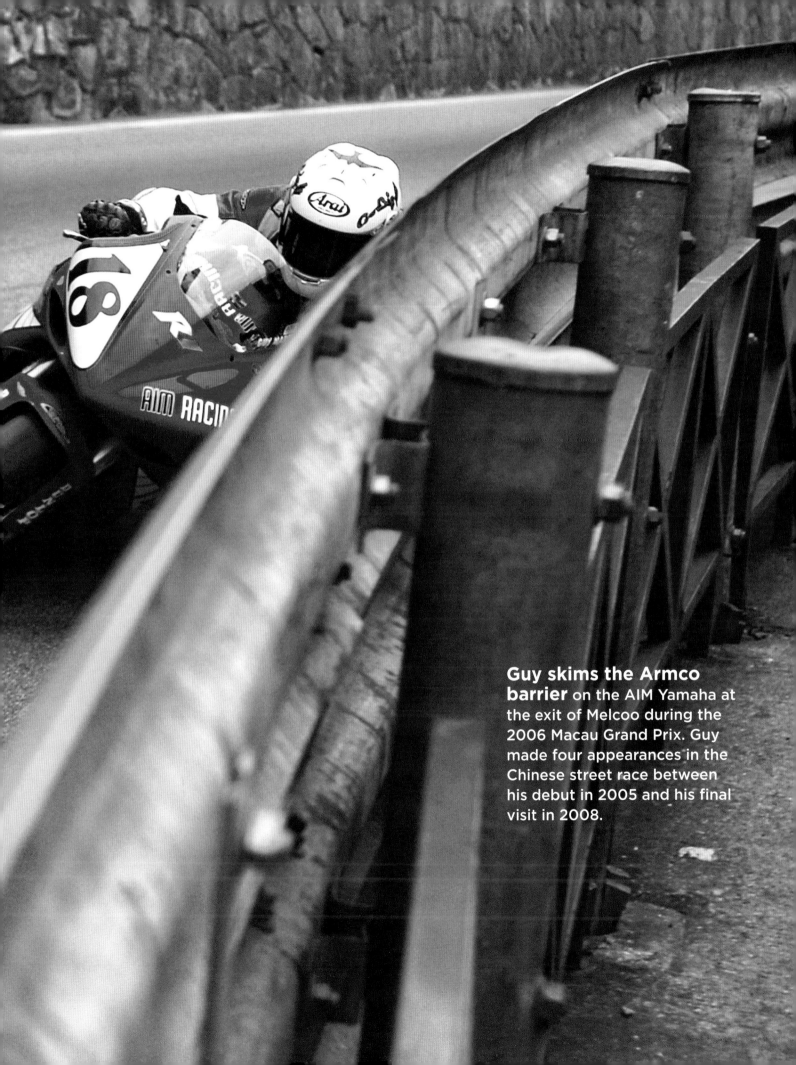

Guy skims the Armco barrier on the AIM Yamaha at the exit of Melcoo during the 2006 Macau Grand Prix. Guy made four appearances in the Chinese street race between his debut in 2005 and his final visit in 2008.

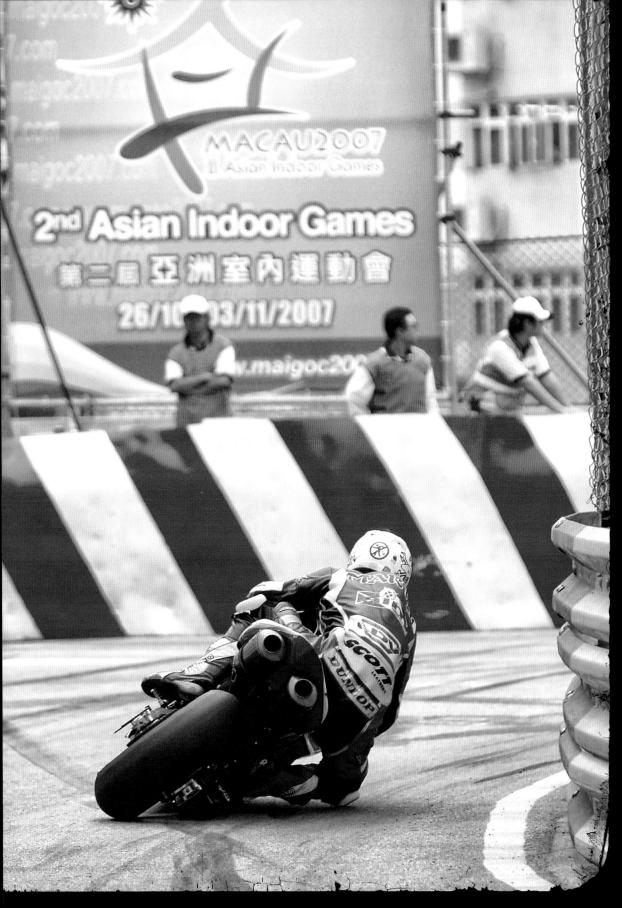

》
Guy is caught in a patch of sunlight as he steers between the city skyscrapers and the cemetery during the 2005 Macau Grand Prix. His debut on the streets of the former Portuguese colonial city, and now the gambling capital of Asia, was made on the Barron Transport Suzuki. He finished twelfth.

In spite of the threatening proximity of the walls and barriers, plus the lack of any escape route in the event of a mishap, road racers like Guy are totally committed to every Macau corner.
 Riding on streets that were filled with traffic just a few minutes before, Guy and the rest of the motorcycle field are the first competitors on track at 7.30 a.m. during both practice days at the Grand Prix.

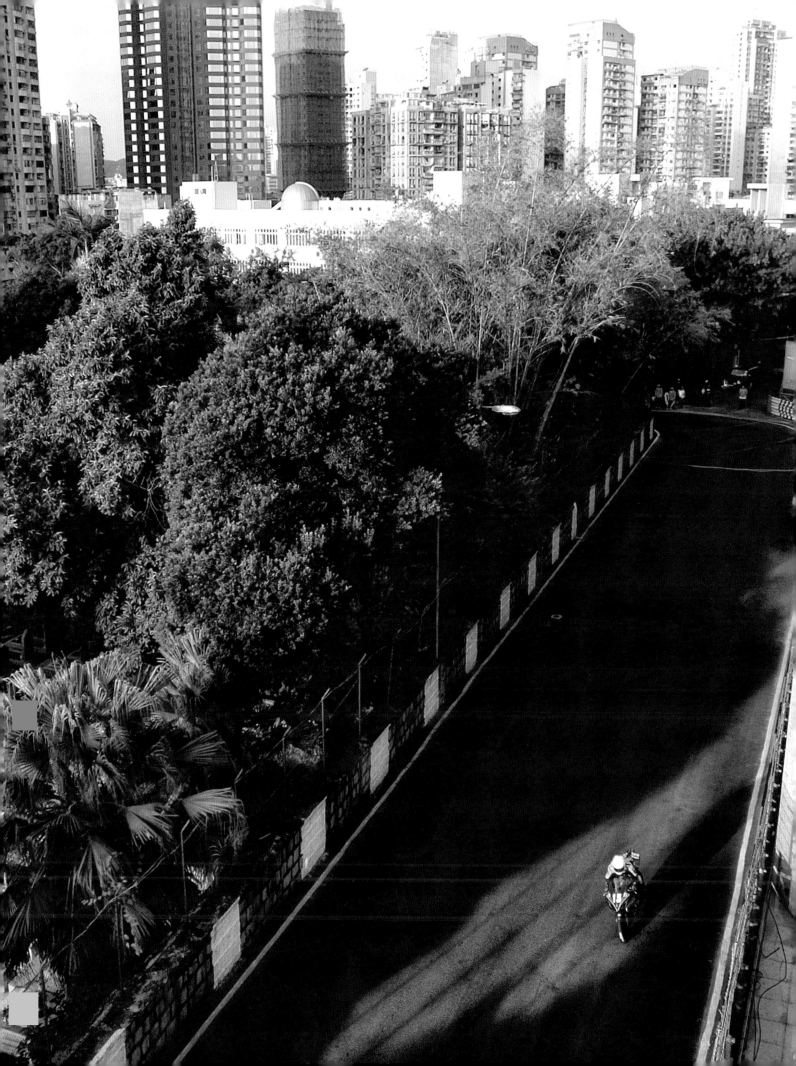

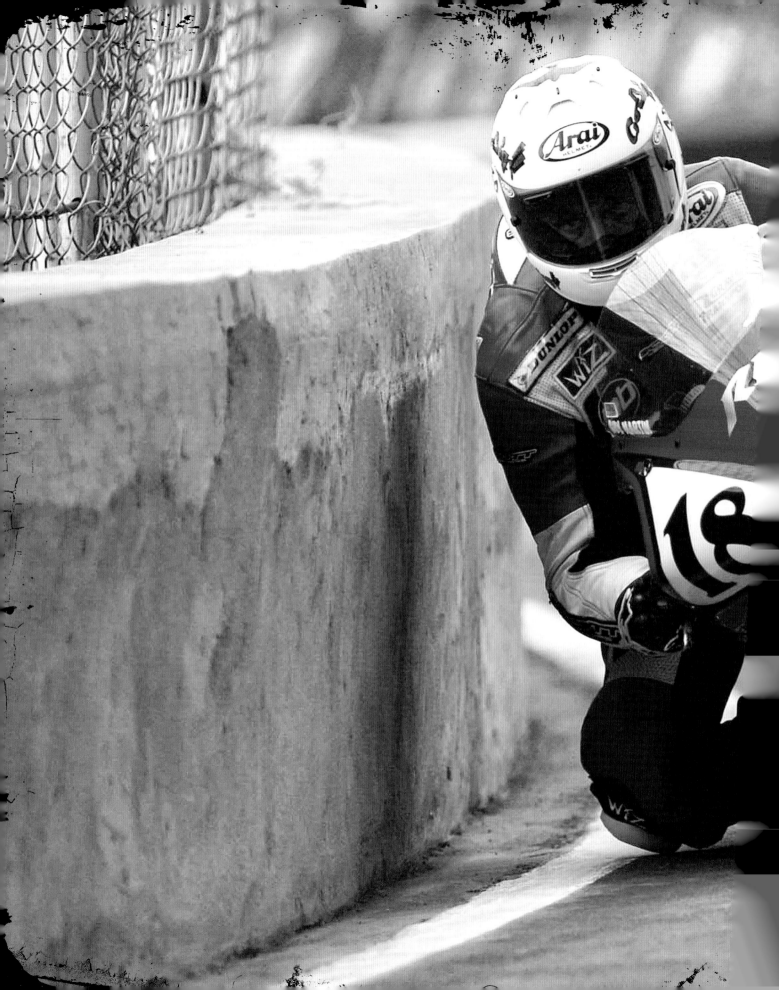

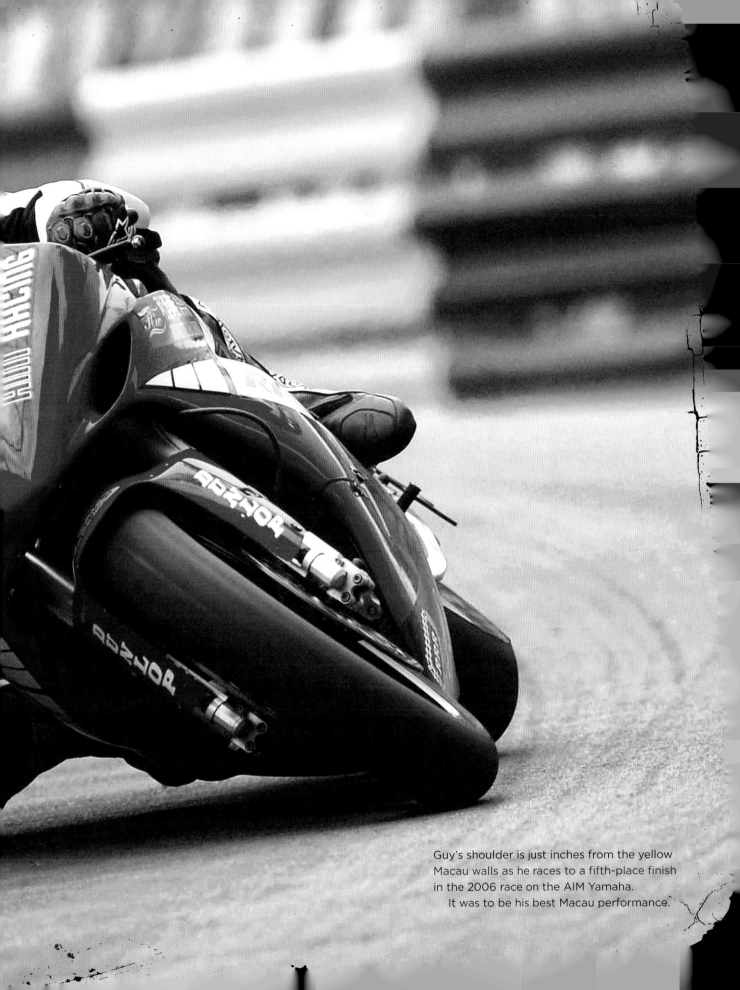

Guy's shoulder is just inches from the yellow
Macau walls as he races to a fifth-place finish
in the 2006 race on the AIM Yamaha.
It was to be his best Macau performance.

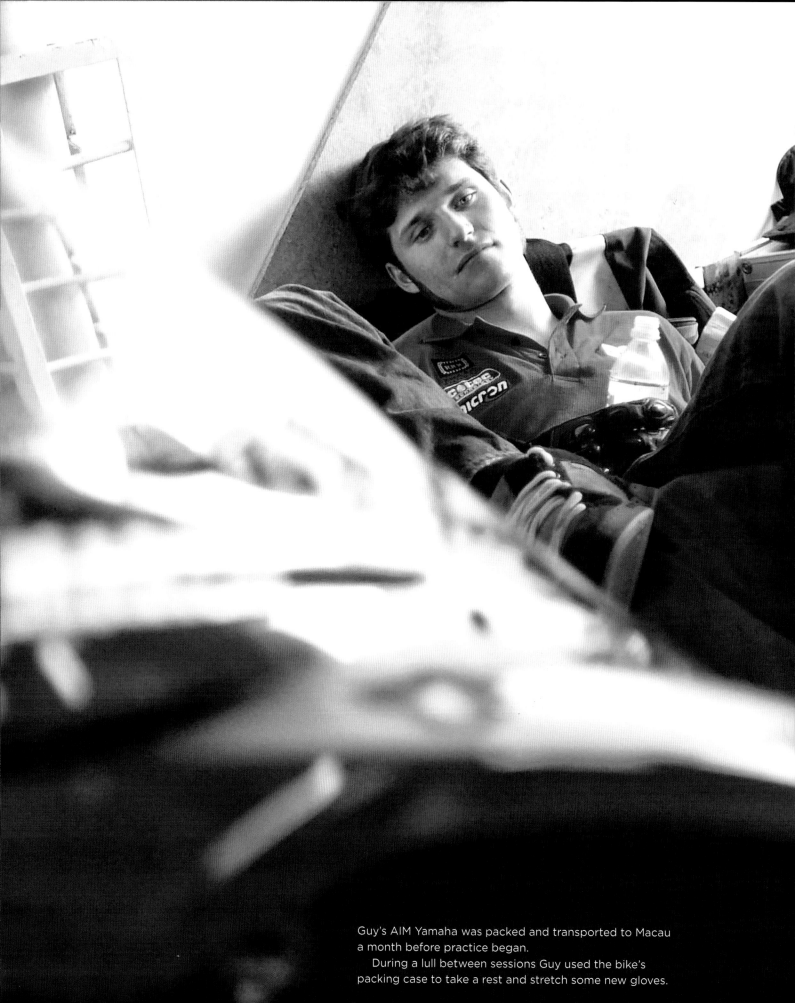

Guy's AIM Yamaha was packed and transported to Macau
a month before practice began.
During a lull between sessions Guy used the bike's
packing case to take a rest and stretch some new gloves.

Guy leads AIM Yamaha teammate, Steve Plater, around Melcoo Hairpin during practice for the 2006 Macau Grand Prix. British racers have dominated the event since the early eighties and Plater won the 2006 race.

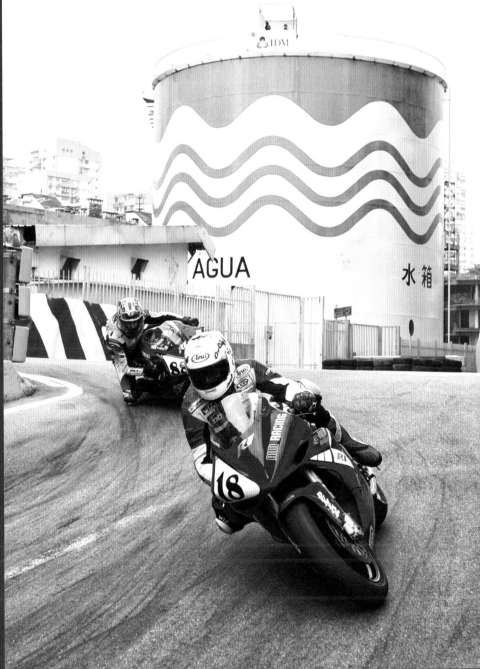

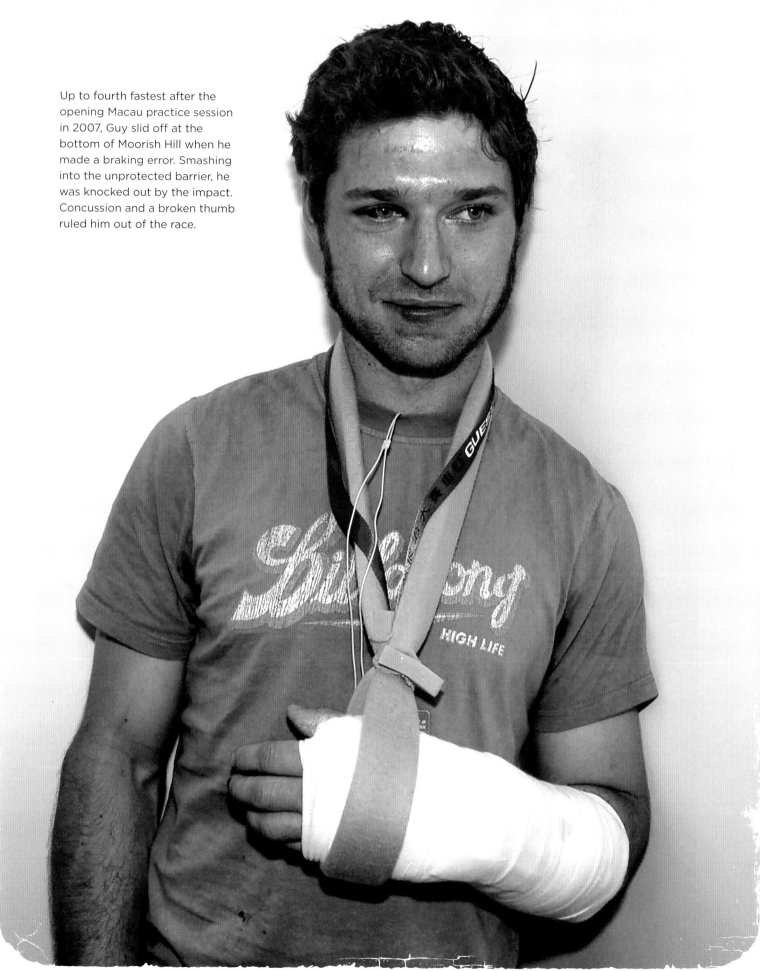

Up to fourth fastest after the opening Macau practice session in 2007, Guy slid off at the bottom of Moorish Hill when he made a braking error. Smashing into the unprotected barrier, he was knocked out by the impact. Concussion and a broken thumb ruled him out of the race.

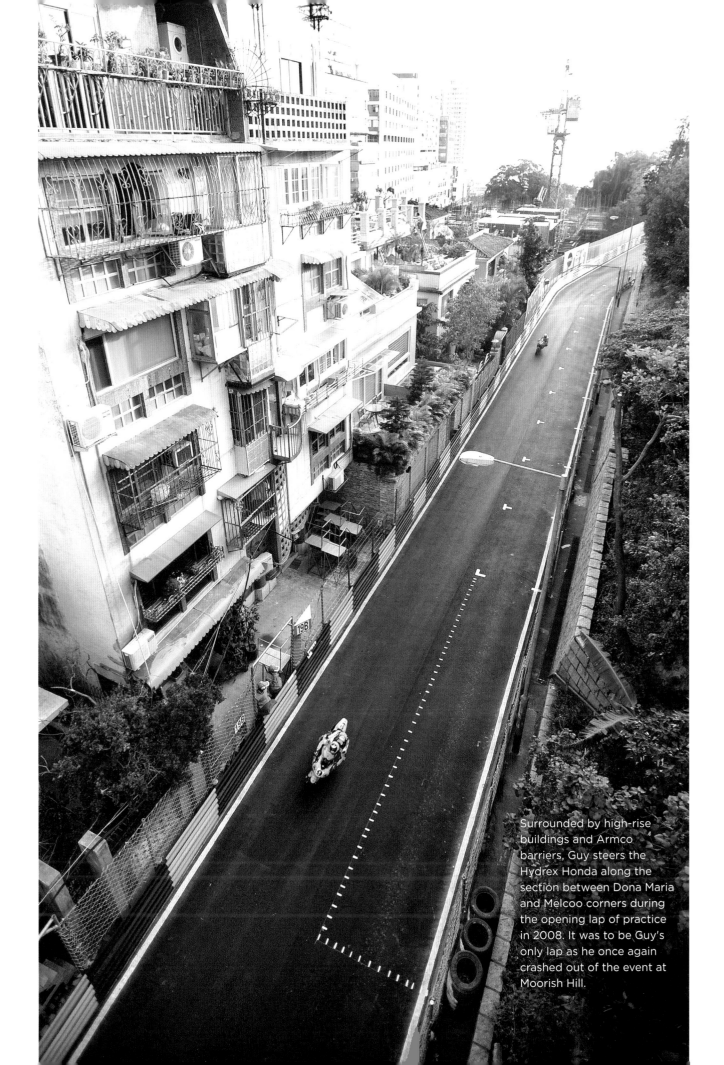

Surrounded by high-rise
buildings and Armco
barriers, Guy steers the
Hydrex Honda along the
section between Dona Maria
and Melcoo corners during
the opening lap of practice
in 2008. It was to be Guy's
only lap as he once again
crashed out of the event at
Moorish Hill.

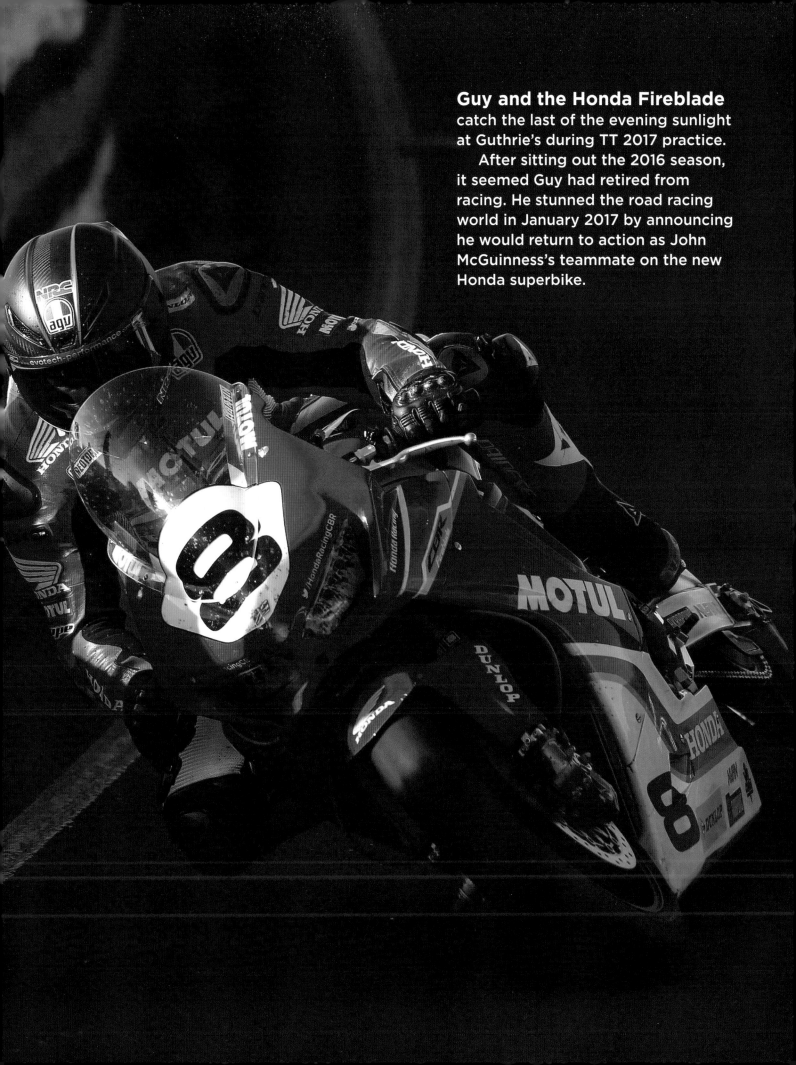

Guy and the Honda Fireblade catch the last of the evening sunlight at Guthrie's during TT 2017 practice. After sitting out the 2016 season, it seemed Guy had retired from racing. He stunned the road racing world in January 2017 by announcing he would return to action as John McGuinness's teammate on the new Honda superbike.

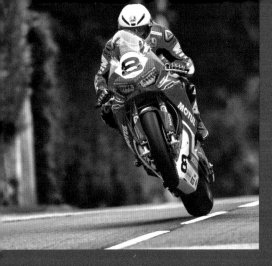

Guy wheelies the Honda Fireblade through Ballagarey during TT 2017 practice.

Lucky to escape a first lap crash at Doran's Bend in the Superbike race with little more than a bruised wrist, he subsequently withdrew from the Senior race.

Guy's only competitive outing at TT 2017 was the electric bike Zero TT race on the Mugen Shinden machine. He finished second to Mugen teammate, Bruce Anstey.

It was Guy's seventeenth TT podium finish.

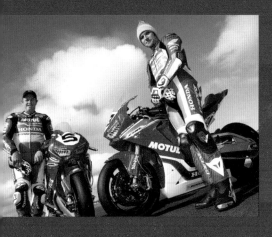

From the earliest tests in Spain and Castle Combe, it was obvious that neither the new Honda nor Guy were on the pace. To make matters worse, both Guy and John McGuinness suffered crashes that left McGuinness with a broken leg after a huge smash at the North West 200.

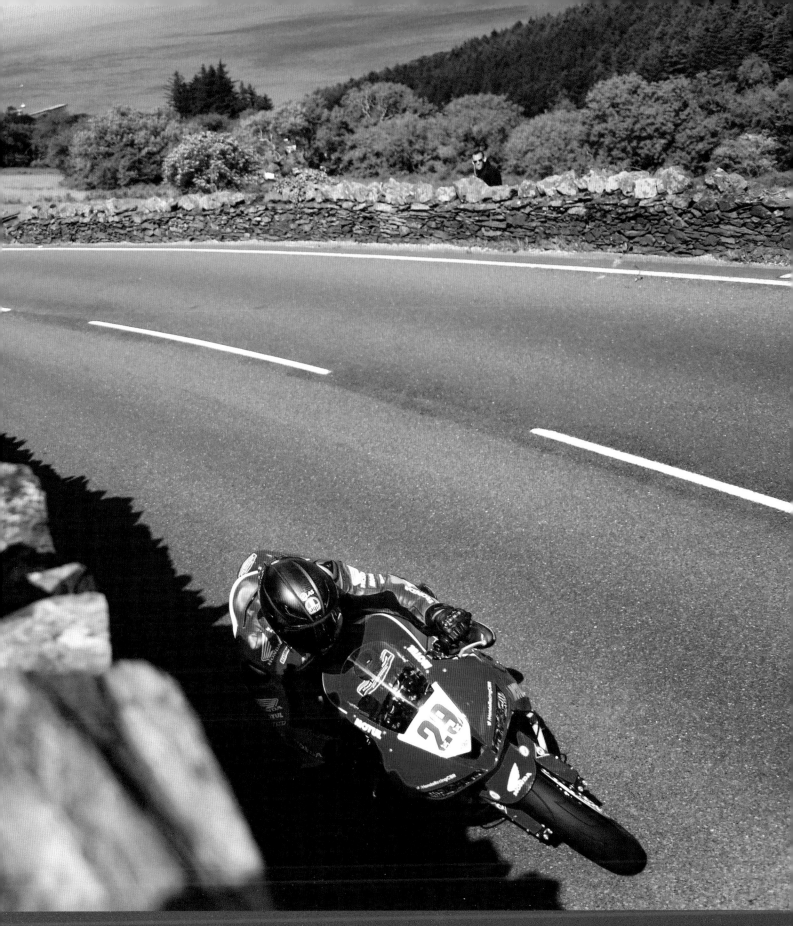

Guy was reunited for TT 2017 with former team boss Wilson Craig to ride one of the Irishman's CBR600RRs in the Supersport race.
 He practised on the 600cc machine but didn't take part in the race after his Superbike race crash.

First published in 2017 by Blackstaff Press,
an imprint of Colourpoint Creative Limited,
Colourpoint House, Jubilee Business Park,
21 Jubilee Road, Newtownards, BT23 4YH

Photographs © Stephen Davison,
2017, except where otherwise
indicated on the photograph
All rights reserved

Stephen Davison has asserted his right
under the Copyright, Designs and Patents
Act 1988 to be identified as the author
of this work.

Designed by seagulls.net

Printed in Italy by Rotolito Lombarda S.p.A.

A CIP catalogue record for this book
is available from the British Library

ISBN 978-0-85640-998-1

www.blackstaffpress.com
www.pacemakerpressintl.com